Picturing People

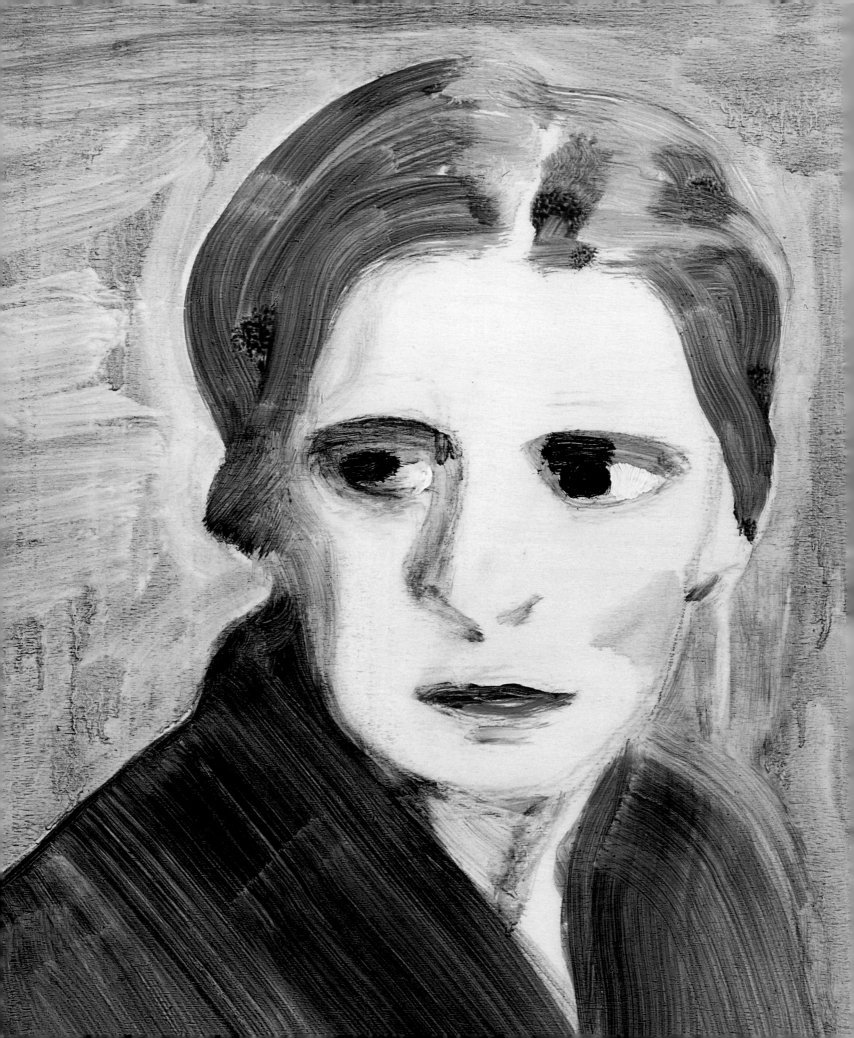

Picturing People

The New State of the Art

Charlotte Mullins

Thames & Hudson

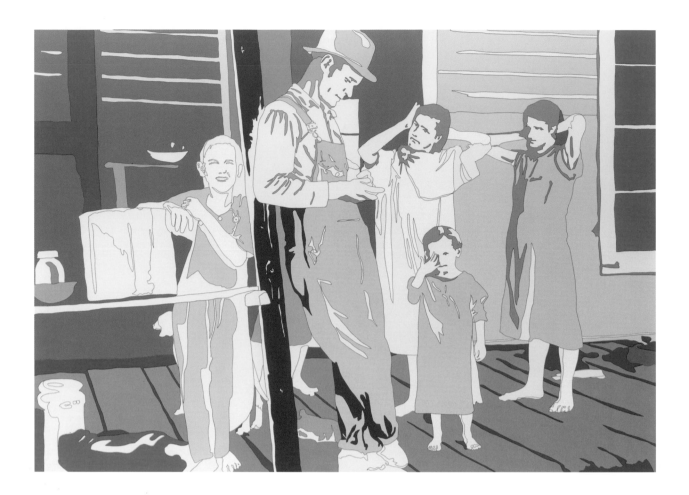

First published in 2015 in hardcover in the United States of America by Thames & Hudson Inc., 500 Fifth Avenue, New York, New York 10110

thamesandhudsonusa.com

Library of Congress Catalog Card Number 2015932468

ISBN 978-0-500-23938-4

Printed and bound in China by C&C Offset Printing Co. Ltd

Lisa Ruyter
Walker Evans 'Floyd Burroughs and Tengle children. Hale County, Alabama', 2011
Acrylic on canvas, 150 × 210 cm / 59 × 82⅝ in.

FRONTISPIECE
Eleanor Moreton
Young Rebecca from 'Absent Friends', 2013
Oil and pastel on board, 35.5 × 27.5 cm / 14 × 10⅞ in.

For Paul, with love

Contents

Introduction

Gillian Wearing
Me as Warhol in Drag with Scar, 2010
Framed bromide print
156 × 133 × 3.2 cm /
61⅜ × 52⅜ × 1¼ in.

On 12 November 2013 Christie's auction house in New York was packed out for their post-war and contemporary art sale. All eyes were on the triptych by Francis Bacon of his friend Lucian Freud, painted in 1969. In less than ten minutes it sold for $142.4m, easily breaking the previous record for the most expensive artwork ever sold at auction ($119.9m), held by Edvard Munch's pastel version of *The Scream* (1895). This work had in turn beaten the previous record of $106.5m achieved by Pablo Picasso's *Nude, Green Leaves, and Bust* (1932) two years earlier.

If we can draw any conclusions from these eye-watering amounts, it is that figuration is riding high in the zeitgeist. All three record-breaking works depict people – sitting, screaming, reclining – who viscerally connect with contemporary viewers. We feel their pain and ardour, helplessness and frustration; these works speak to us across the decades and help us as we try to understand our own place in the world.

The high prices recently paid at American auctions for modern and post-war figuration have been replicated around the globe, from London to Hong Kong. But the rise of figuration hasn't been confined to the auction houses. Highlights of the 2013 Venice Biennale, for example, were the vigorous self-portraits of Maria Lassnig, the Persian-inspired paintings of Imran Qureshi and Richard Mosse's infrared Congo photographs, which went on to win the Deutsche Börse Photography Prize 2014. Commercial gallerists such as Victoria Miro have long championed the work of figurative painters Alice Neel and Celia Paul as well as leading artists Peter Doig and Chris Ofili, while the Tate franchise has held recent solo exhibitions of work by Sylvia Sleigh and Rose Wylie, as well as retrospectives of Gerhard Richter (2011) and Richard Hamilton (2014). Wide-ranging painting shows across Europe have included a strong showing of figurative artists; 'Re-Painting' at SMAK, Ghent (2014), for example, included Karin Hanssen, Luc Tuymans and Michaël Borremans among others.

So what is it that drives artists to choose to work from the figure, and why is figurative art increasingly visible at a global level? Why do commercial galleries

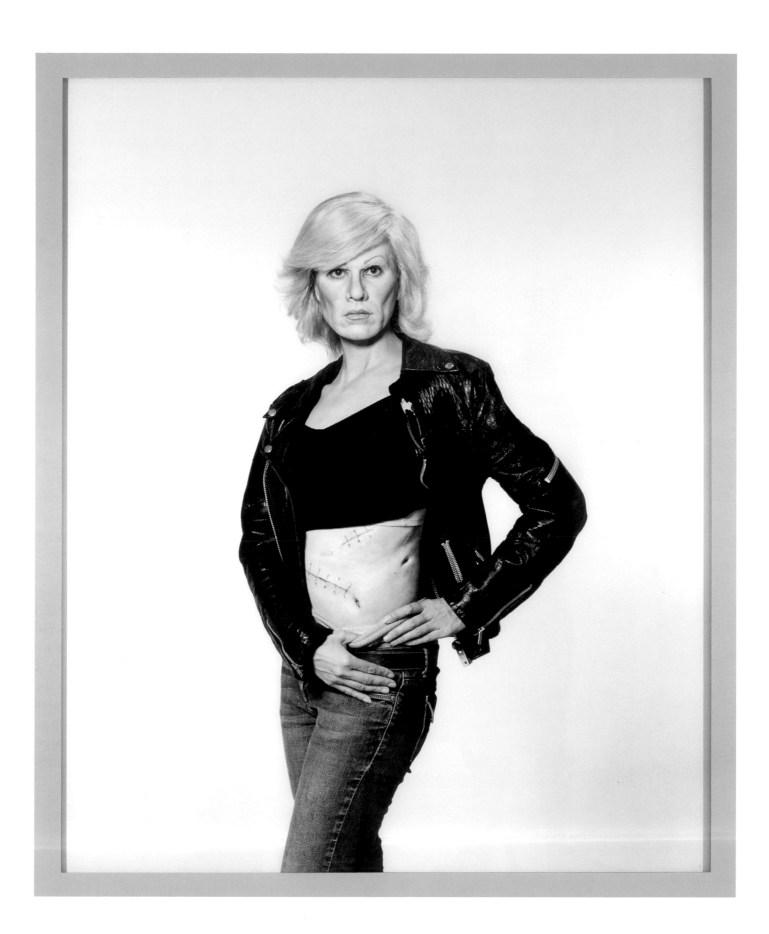

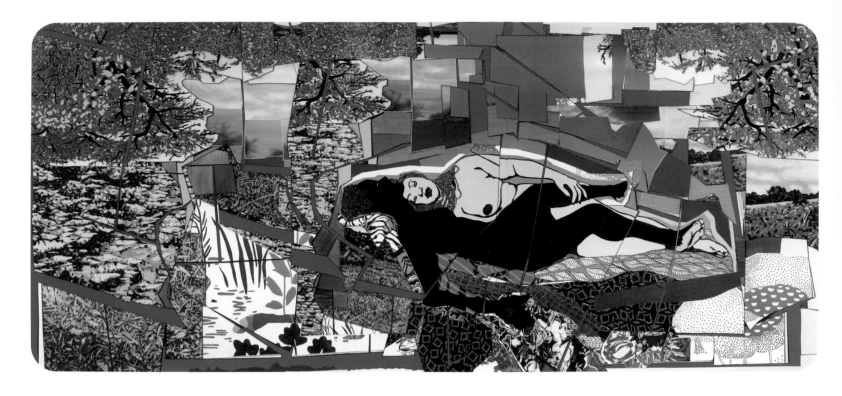

Mickalene Thomas
Sleep: Deux Femmes Noires, 2012
Rhinestones, acrylic and enamel on
wood panel, 274.3 × 609.6 cm /
108 × 240 in.

embrace it and collectors go crazy for it? Why is the market so interested and what might be the appeal? This introduction contemplates these questions, and raises a few more. It explores the sociological and geopolitical factors that have contributed to the current enhanced visibility of figuration, asks what role the global financial crisis has played, and what impact the war on terror has had. How has the shift in the geographical locus of vociferous collectors changed the marketplace? What role has social media played? And, most importantly, how have artists responded to these situations? But to start, let's recap on a little history…

Since the end of World War II many great artists have chosen to work figuratively, including Francis Bacon, Cindy Sherman, Lucian Freud, Marlene Dumas and Chuck Close. But this route has not always been free of debris or even well lit. In the 1960s the fresh bounce of pop art – with its brightly coloured celebrity portraits and cartoon narratives – was popular, in part because it was a rejection of both the Greenbergian cul-de-sac of 'art for art's sake' and the drink-fuelled machismo of Abstract Expressionism. But as artists pushed forward, land art, photography, performance and video expanded horizons far beyond pop. And then, almost as if dishing out an antidote, the Neo-expressionists – gestural, ambitious figurative painters – stormed the international stage. Paintings by Georg Baselitz, David Salle, Eric Fischl, Francesco Clemente and Sandro Chia pumped up the testosterone once more and blasted the figure back on to gallery walls, most notably in the 1981 exhibition 'A New Spirit in Painting' at the Royal Academy of Arts in London. Academics such as Yve-Alain Bois and Douglas Crimp, shocked by the rapid resurgence of painting, were quick to theorize it out of existence, metaphorically killing it off in a number of essays in the later 1980s. But meanwhile, artists including Thomas Struth and Jeff Wall were using

cameras rather than brushes to create ambitious salon-sized figurative tableaux. (Interestingly, the narrative advances made by such art photographers have now fed back into painting, just as painting continues to feed their practice.)

In Germany, throughout the post-war decades, Gerhard Richter, Sigmar Polke, Georg Baselitz and Martin Kippenberger continued to attack and salute the figure and its history in various ways, while in Belgium figurative painting quietly continued to be influential. Jan Vanriet and Luc Tuymans' rigorous conceptual practice has inspired generations of followers including Karin Hanssen and Michaël Borremans. And over the last decade, across Europe, Asia, Africa and the Americas, new clusters of figurative artists have become increasingly visible and sought-after. Germany, and in particular Leipzig, has been dominant for a decade; Chinese artists such as Yang Shaobin and Yun-Fei Ji have continued to choose to use the figure to convey their ideas. Artists in Romania and other former Eastern bloc countries – Serban Savu, Paulina Olowska, Mircea Suciu, Alexander Tinei – also show strong leanings towards the figure and its narrative potential, both in isolation and in cinematic *mise-en-scènes*.

This leads us to the inevitable question: so why now? Why is figuration becoming so prominent in contemporary art? The past may offer some guidance. In modern times, after periods of unrest, war or crisis, artists have traditionally found renewed interest in the figure as subject. After World War I Pablo Picasso turned his back on the near-abstract geometries of Cubist still life and embraced the classical figure, painting fecund women in white togas and nubile athletic boys, connecting with the continuum of art (and life) that the war had so significantly challenged. After World War II artists such as Jean Dubuffet and Jean Fautrier painted the figure as mutilated, raw, scarred, childlike and crude, rejecting the clean aesthetic lines of international modernism, responding to World War II with raging intensity.

So many people died in the World Wars that it is not surprising that artists used the figure, a loaded form, to convey their reactions, variously escaping into (art) history or attacking, scouring, cutting into the body, the head, the face. As Ralph Rugoff, director of the Hayward Gallery in London and curator of 'The Painting of Modern Life' (2007) noted: 'New art evolves not only in reaction to the achievements of a preceding generation, but also in response to the cultural landscape of the times.'[1] Events of the last fifteen years have created an environment that has seen artists turning to the figure as the most potent vehicle through which to express their concerns. The war on terror following 9/11, wars in Iraq and Syria, uprisings and unrest across the Middle East and Russia's borders, rapid modernization in China and India and the subsequent displacement of thousands of disenfranchised families, all coupled with a crippling financial crisis, has transformed the global climate for art into something unstable, political, fast-moving, even dangerous.

How have artists responded to this latest global unrest? In Eastern European countries such as Romania, artists have taken matters into their own hands, establishing artist-run spaces such as Plan-B in Cluj and hosting exhibitions of work by artists including Serban Savu and Adrian Ghenie. In the Middle East

artists such as Manal Al-Dowayan and Nermine Hammam use the camera –
portable and fast – to create work that is digitally transportable, even across
closed borders. China's so-called 'cynical realism' painters such as Yue Minjun
and neo-realists such as Li Songsong continue to employ the figure to record
current events and rapid societal change.

Even when using their own body or the bodies of close family, the artists in
this book use the figure as a cipher, a symbolic stand-in for aspects of the human
condition and the complexity of life beyond postmodernism (po-pomo?). The
figure is our marker in the world, the vessel from which we all look out, the shape
others see when they look at us, the home of our subjectivity, our personality.
German and Belgian artists like Jan Vanriet have continued to draw on family
memories of World War II, as in the series 'The Contract' (2013), which depicts
his mother and father after their release from Mauthausen concentration camp.
Gideon Rubin comments on Israel's ongoing volatility through his figures drawn
from photograph albums, their faces erased. A significant number of artists have
followed Picasso's example and turned to art history in order to communicate
something of the world they live in. The connection with the continuum of
painting sees Ali Banisadr drawing on the work of Renaissance masters as well
as his own childhood experience of the Iran–Iraq war. Other artists such as Kerry
James Marshall and Mickalene Thomas use the figure to confront art history's
Western subjects and traditions.

But there are other reasons for a renewed interest in figurative art and the
slow looking required to read its complex narratives and surfaces. 'Looking' as
a subject in itself has been out of fashion for decades, ousted by the application
of sociological theory – structuralism and post-structuralism – and a subsequent
postmodern focus on interdisciplinarity. But, as we somehow move beyond
postmodernism, it seems as if there's a refocusing of the gaze – both the artist's
and the viewer's – on the figure.

Interestingly, there seems to be strong affinities between the climate for art
now and that experienced in mid 19th-century Europe. That was also a time of
rapid industrialization, the empowerment of the middle classes, technological
advancement and significant developments in perceptual science and psychology.
And what happened? Everyone from John Millais and Gustave Courbet to Émile
Zola and Felice Beato became hot for depicting the authentic 'reality' of human
existence as they perceived it. As 19th-century philosopher Arthur Schopenhauer
declared: 'the world is *my* representation'.[2] In a rapidly modernizing world,
with industrialization and technology speeding up communication processes
(photography, the telegraph, railways, illustrated newspapers), artists and
writers felt the need to rethink how the modern world looked and seemed. The
latest scientific developments had led to breakthroughs in the understanding of
perception, and with this 'looking' became recognized as a subjective experience,
and 'truth' was no longer defined by the ruling aristocracy.[3] Coupled with
a burgeoning middle class who refused to toe the aristocracy's line, looking
became subjective and personal. Artists and writers wanted to redefine the
lived experience, to make it seem more real, alive and contemporary. Artists

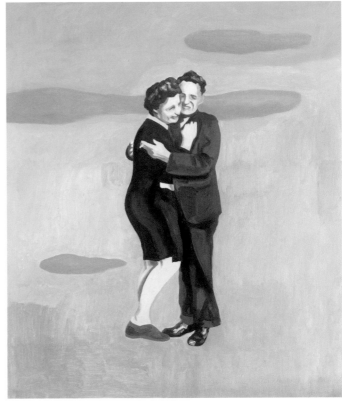

ABOVE LEFT
Nermine Hammam
The Metaphysics of a Flower from
'Eschaton', 2009–13
Hand-tinted photograph
60 × 60 cm / 23⅝ × 23⅝ in.

ABOVE RIGHT
Jan Vanriet
From 'The Contract', 2013
Oil on canvas
60 × 50 cm / 23⅝ × 19⅝ in.

no longer wanted to paint rural idylls, the unchanging Claudian landscape with mythological staffage. They wanted to look afresh and see the mud on a peasant's toes, the dirt under a prostitute's fingernails, the robin on the verdant riverbank, the bodies strewn like hay bales in the Crimean scat of war.

Scroll forwards 150 years and we find ourselves surrounded by a similar explosion of speed and technology that has again revolutionized communication processes and how the world can be observed: Google maps, Facebook, online news feeds, Twitter, Pinterest, Photoshop, Instagram. Artist Glenn Brown has commented on the overwhelming volume of source images that now offer differing viewpoints: 'Ways of expressing an individual view of the world have to reflect the myriad other opinions that surround us. We cannot construct a rational argument outside what has become an accepted language, and the images that flood the world become the words and phrases that make up our visual language.'[4] We are bombarded by imagery and messages 24/7, we are never 'off', the whole world is accessible and someone is always awake on the other side of the world, working, thinking, creating, playing harder than we are. The world is no longer *my* representation, it is *everyone's* representation. We can all become portrait 'artists' now, uploading family albums to Facebook and Flickr, taking selfies on Instagram.

A return to the figure at a time when we are relentlessly bombarded by pictures of people might seem strange at first. But what happens when a proliferation of images occurs like this? We stop looking, or at least stop looking properly. In the 19th century, illustrated newspapers and *cartes de visite* offered an unprecedented range of disposable, cheap reproductions. Since then,

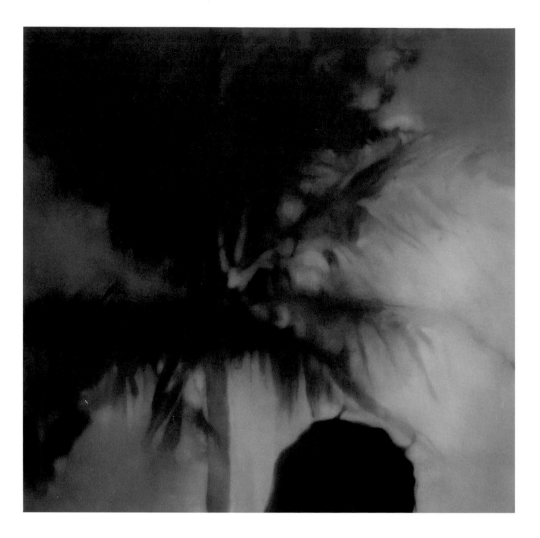

artists from Edouard Manet and Edgar Degas to Andy Warhol and Gerhard Richter have reacted to this proliferation of imagery. In an interview in 1972, Gerhard Richter stated: 'Photography had to be more relevant to me than art history; it was an image of my, our, present-day reality.'[5] What does he make of Instagram, Whatsapp and Snapchat, I wonder? Perhaps we can turn to the work of contemporary artists such as Justin Mortimer and Alexander Tinei for clues as to how artists are now influenced by internet imagery. In different ways they respond to this glut of material, this smorgasbord of visual sources. It is impossible to ignore it, so why not tackle it head on? For painting, drawing and art photography can offer a counterweight to the immediacy and breadth of our interconnected world.[6] They can slow time right down and ask us to start thinking, questioning, looking at what we see once more.

Artists today consciously engage with the slowness of painting, with the unique qualities of paint, its 'life', what Jerry Saltz calls 'the alchemy of painting'.[7] Paintings and drawings have time locked into their surfaces just as a printed novel has weight in your hands – even on the first page you feel the depth of words in your hands, a physical sensation that communicates the book's intent, whether it's a novella, magnum opus, graphic novel or penny dreadful. With paintings

ABOVE
Karin Hanssen
Full 20', 2009
Oil on canvas
90 × 210 cm / 35⅜ × 82⅝ in.

OPPOSITE
Johannes Kahrs
Untitled (dark palm), 2014
Oil on canvas
201 × 200 cm / 79⅛ × 78¾ in.

and drawings this depth comes from extended looking, from slowing down time and contemplating the image. And yet such works also offer something more than a novel, or a play, or a film, reliant as these art forms are on time passing before the full story is revealed. For while paintings and drawings (and art photographs) benefit from extended looking, they can simultaneously be experienced in their totality in an instant.

This immediacy and the simultaneous unfolding over time is part of the allure of painting and drawing. Painting in particular can be very slippery to look at. You sometimes feel as if you 'get' a painting immediately, but after multiple readings you have more questions than answers, and feel it has still more to give. Your reading of it can change with your mood, with the light, with knowledge, with company. You can see things you never noticed before, or overlook other aspects and suddenly view it completely differently. All these readings unfold over time, in your own mind. You are not directed towards a particular reading as you are when a film director edits a movie, for example, or a conductor interprets an hour-long score. Time is not theirs to control, it is yours – you, the viewer. The artist builds their ideas into the surface of the work, adding layers of complexity over time, but when the work is finished it is up to the viewer to interpret it, to read it, subjectively and contingently, at his or her own pace.

That said, cinematic time continues to shape contemporary art, as can be seen, for example, in the work of Judith Eisler, Karin Hanssen, Adrian Ghenie, Johannes Kahrs and Grayson Perry. There's a temporal narrative that artists add into their paintings, drawings and photographs that simulates the sequential development of a film. Karin Hanssen's *Full 20'* (2009) features a dying man observing a 20-minute nature documentary, based on a scene from the dystopic sci-fi *Soylent Green* (1973). Johannes Kahrs's *Untitled (dark palm)* (2014) offers a similar staging of viewing: the palm tree soft, diffused, filmic; the figure reduced

to a near-abstract silhouette framed by the luminous screen. These paintings are complex, considered canvases, with assured brushstrokes and rich colouration, the figure barely visible and yet central to the composition. Time is locked into their surfaces; it plays out far slower than a movie and holds your attention in an intimate, personal way. It is as if by painting the moment, the past, present and future are drawn together and held in suspension. This creates a palpable atmosphere, a compression of time and yet conversely it also offers a diachronic or ongoing experience that contrasts with the immediacy of the original film still or photograph that such artists work from.

In reality, the 'present' as we know it barely exists. Henri Bergson stated that the present is, in fact, the future becoming the past, and only when considered as a duration (*durée*) can the present be conceived with any accuracy.[8] A snapshot or film-still doesn't do this; it artificially creates a moment that we cannot register naturally. A painting, however, is created in line with Bergson's *durée*. Hanssen and Kahrs take the artificial 'now' moment and introduce time back into the image as they paint, conflating past visions of the future with memories, freeze-frames and personal experiences. Our reading of such complex images will never be straightforward, and works such as these can appear simultaneously beautiful, melancholic, mysterious and resolutely slippery.

Slow time also exists in drawings. Art photographs – photographs that have been planned, constructed, composed – can offer their own levels of depth, but often the image itself was made synchronically, at one moment rather than over time. However, the photographic collages of Vik Muniz, for example, or the recent work of Cindy Sherman challenge this interpretation of photography. For them the camera is a tool for creating art, like a paintbrush or a pencil, and it creates multiple images that can be manipulated or collaged to build in the time element that is intrinsic to painting and drawing.

This slowing down of time by artists, this questioning of materials and the surface of the image, has not always been easy for commercial gallerists to accommodate. One artist I spoke to recently had just had a blazing row with his gallery because the dealer wanted a forthcoming solo show to include only one particular type of work that sold well, while the artist wanted to explore new pathways (they parted company shortly after). Another artist told me he had stopped exhibiting commercially for five years in order to be able to find a new direction for his paintings. Others have found commercial success at a pensionable age but have been painting, undaunted, for decades. Still others made pieces that are bone-crushingly slow to finish, or work in pencil on paper, a fragile and under-valued medium.

Until relatively recently, to represent artists who worked from the figure was largely seen as woefully conservative or commercially unwise. Galleries such as David Zwirner in New York, Victoria Miro in London and Zeno X in Antwerp were early champions of contemporary figuration, visible through their commitment to representing figurative artists of international significance. These galleries continue to offer significant support: in this book Kerry James Marshall shows with Zwirner, Grayson Perry with Miro and Johannes Kahrs

with Zeno X. But the art map has changed, and now most international dealers – for example, White Cube, Hauser & Wirth, Gagosian, Simon Lee, Blain/Southern, Michael Werner – regularly host solo shows by successful figurative artists. Major commercial galleries now see financial benefits in representing figurative artists as the changing base of collectors clamour for their work.

Art and image-making, as with any other immersive environment, is subject to fashion, to change, to progress and to natural cycles of rise and fall in popularity. If this were not the case we would all still be collecting *cartes de visite* instead of using Instagram, studying Albertian perspective instead of Kara Walker's 'sampler' cutouts, contemplating the Parthenon Frieze instead of Robert Smithson's *Spiral Jetty* (1970) or Tracey Emin's *My Bed* (1998). But over the last 150 years figurative art has been repeatedly challenged, the figure eroded, observed from multiple perspectives, savaged and mutilated, denied by abstraction or overlooked by the expanded field of installation art, land art and performance. And yet…all these relatively new trends still rely on the figure, the human experience and the subjectivity of the viewer. *Spiral Jetty* is all about scale in relation to the viewer's body; *My Bed* is just that (a woman's retreat, a figure's sanctuary). Installations by Mike Nelson require human navigation; performances by Marina Abramović connect the artist to others through human interaction. All this expansion beyond flat figurative art seems to have finally looped back around again, and collectors once more are keen to put the figure back on their walls. As artist Dorothea Tanning once said: 'I don't see why one shouldn't be absolutely fascinated with the human form, there are so many reasons to be. Besides, we are living in human bodies, we go through life in this world envelope. Why not acknowledge that and try to say something about it?'[9]

I would say there's still some way to go in the curating and purchasing of figurative contemporary art by museums. Just because painting and drawing (and, in its own way, photography) connect to a millennia-old continuum of mark-making rather than being 'new' media, this doesn't mean they shouldn't have a credible presence in contemporary programming in museums and galleries. Contemporary painters who expand the notion of what one artist's practice can be – Merlin James, Wilhelm Sasnal, Anton Henning – can and should stand alongside those who paint in series, follow a tighter conceptual path, or investigate painterly figurative concerns – Njideka Akunyili Crosby, Judith Eisler, Ged Quinn, Susie Hamilton.

This book celebrates the diversity and strength of contemporary figurative painting, drawing and photography that can be found around the world today. Chapter one considers what it means to use paint to depict the figure. Jordan Kantor has written on the visual tension present in the work of Luc Tuymans, 'between the depiction of deep space through the use of perspectival rendering and the refusal of that space by the overt display of its painterly construction.'[10] While Tuymans featured in my previous book, *Painting People*, this observation applies equally to many of the artists in this chapter, who engage with Albertian perspective as well as the legacy of abstraction and the acceptance of painting as object, of the surface as a flat plane. These artists, including Adrian Ghenie,

Magnus Plessen and Yuma Tomiyasu, engage in painting at an essential level. Gerhard Richter recently stated: 'I'm still very much sure that painting is one of our most basic capacities, like dancing and singing, that make sense, that stay with us, as something human.'[11] The artists in this chapter are paint's champions.

In chapter two artists such as Paulina Olowska and Uwe Wittwer point to the range of work artists can create when using photographs and media reproductions as source material. Jerry Saltz, in his essay 'The Richter Resolution', noted: 'The camera, which was supposed to supplant painting, didn't. Instead, painting – ever the sponge and always elastic – absorbed it and discovered new realms to explore.'[12] Photographs and other media imagery have now become accepted as subjects in themselves, as in Maria Kontis's drawings. They are also valid sources for the figure that have all but supplanted physical observation and the life-drawing class, once held up as the summa of artistic training.

The proliferation of photography on the web has led to what Glenn Brown has called the image 'flood'. Julian Stallabrass, in his influential 1996 essay 'Sixty Billion Sunsets', stated that around 60bn photographs were taken each year.[13] That number has risen to 400bn today, largely thanks to smartphones and affordable digital cameras. The photographic image and its ever-growing archive dominate recent figurative painting and drawing. Chapter two considers this trend, and reflects on Richard Hamilton's observation of his own influential practice: 'I felt that I would like to see how close to photography I could stay yet still be a painter in intent.'[14]

Chapter three looks at the canon of art history, the vast image bank that artists seem increasingly keen to draw upon, both transparently and obliquely. Ed Ruscha once described the connectivity between works of art as a silver thread that ran through history.[15] There's a strong sense of engaging with this continuum of image-making as seen in the work of Mark Alexander, Ged Quinn and Ryan Mosley, but also rewriting history through reimagining its visual record, as seen in the work of Kara Walker and Kehinde Wiley. Chapter four looks at parallel worlds, where the figure is transported variously to dystopic futures, as in the work of Gordon Cheung, or imagined pasts, as in Nigel Cooke's canvases. In this chapter you can enter worlds of doppelgängers and coincidences in the paintings of Simone Haack; float into dreamscapes in the photographs of Annelies Štrba. Chapter five closes *Picturing People* with a look at the observed figure, and considers a range of artists who work with their own body – Cindy Sherman, Gillian Wearing – and those who study the rituals, costumes and habits of others, including Tala Madani, Jessica Craig-Martin and Imran Qureshi.

Picturing People includes the work of seventy contemporary artists. Many more artists working with the figure were considered than I have had room to include, while those selected vary hugely in terms of experience, technique, style and exposure. Many of the artists who appear in certain chapters could also have appeared in others, and the chapters are certainly not intended to be read as constraining the works included within them. More, they are designed to open up a dialogue between each artist and the viewer, to challenge expectations and ask questions of what figurative art can and should be in the 21st century.

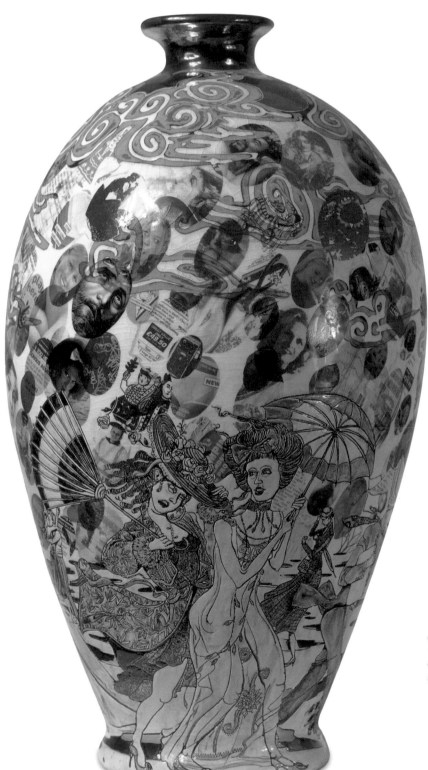

Grayson Perry
The Modern Condition, 2009
Glazed ceramic
57 × 30 cm / 22½ × 11¾ in.

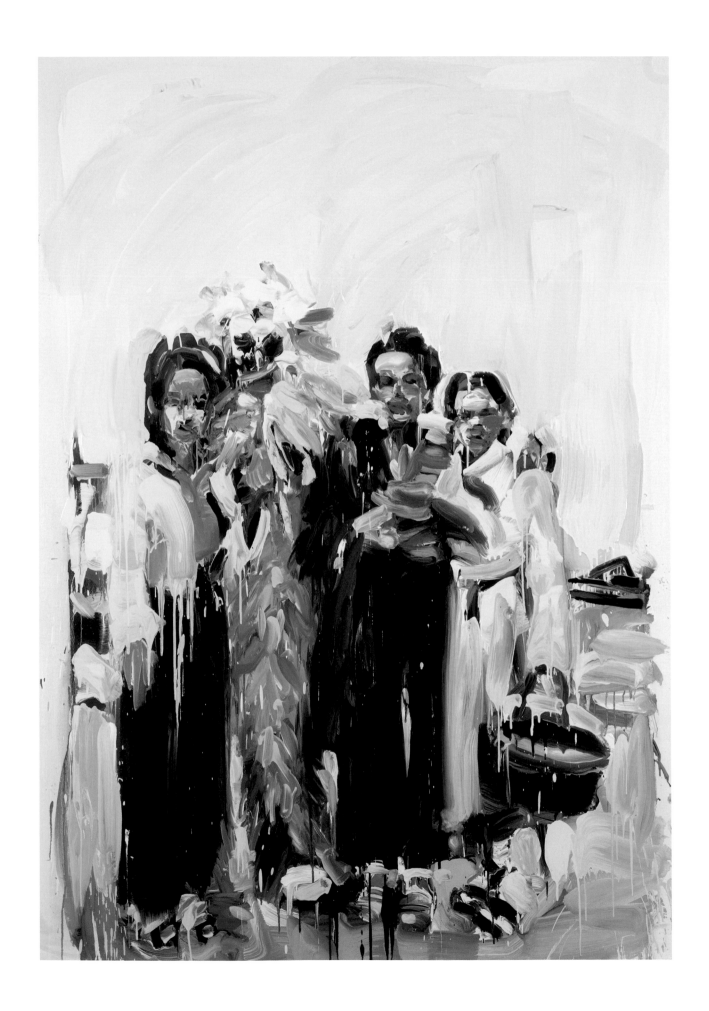

1.

Susie Hamilton / Tim Stoner / Njideka Akunyili Crosby / Yang Shaobin / Justin Mortimer / Adrian Ghenie / Magnus Plessen / Y. Z. Kami / Marilyn Minter / Judith Eisler / Yuma Tomiyasu / Laura Lancaster / Johan Van Mullem

The figure as an investigative device to explore what it means to paint.

People as Picture

Laura Lancaster
Bearsuit, 2012
Oil on linen
230 × 160 cm / 90½ × 63 in.

Paintings, drawings and photographs are all abstract in essence: two-dimensional picture planes covered in marks. Even the most hyperreal portrait or *trompe l'oeil* fresco is a fabrication, a manifestation of marks on a surface, a canvas or a wall, made by a pencil, a brush or a camera. Many post-war painters – Lucian Freud and Gerhard Richter; Marlene Dumas and Luc Tuymans – have explored the visual tension that can be created from the illusion of perspectival space coupled with the exposure of the work's manufacture: ground, surface, brushstrokes. Paintings and drawings start with these marks, and so this first chapter explores how contemporary artists build their surfaces, at times flirting with figurative abstraction (or abstract figuration).

In Susie Hamilton's paintings the figure constantly hovers on the boundary of abstraction. Her broad, fast brushstrokes in salmon pink and citric yellow conjure solitary figures that walk and shop, illuminated by the glow of consumerism in the marketplace or supermarket aisle. The body and its arena are outlined with the sparest of moves and the figure oscillates between being read as an object in space and an arrangement of colours and marks on the canvas. Tim Stoner's silhouetted figures – involved in group activities such as acrobatics and dancing – have recently given way to more attenuated forms, shadows barely distinguishable from the brushstrokes that depict slender trees or lampposts. Whether seen in coruscating morning sunshine or the flat grey light of New England, his figures are no more than promises, their identities never revealed. Njideka Akunyili Crosby's figures are more substantial, overlaid with the archive of their own making, a patchwork of photographs from her family albums and Nigerian magazines that she prints on to the skin of the paintings.

In the works of Yang Shaobin, Justin Mortimer, Adrian Ghenie and Magnus Plessen, the figure's spatial relationship with the painting's ground is similarly complex, an amalgamation of collaged imagery painted into existence and yet retaining a spatial ambiguity. Plessen's paintings allude to figures – a pair of lips; the curve of a shoulder or breast. They resemble bodies constructed from

torn-out scraps of magazines, their limbs stuck together with tape. But Plessen works solely in oil on canvas, the bodies and faces he paints purposefully loosely configured against an unremittingly shallow ground as if to challenge the viewer's perception of what is real. Ghenie and Mortimer offer more generous spatial environments for their figures, but any illusion of space is quickly limited by smears of paint that cling resolutely to the surface in Ghenie's paintings, or by balloons that obscure half the picture plane in Mortimer's work. While Ghenie explores identity – the paint purposefully masking aspects of each face or body – Mortimer allows the paint to sweep him along. Their paintings invoke the sensation of being inside a frenetic mind, a 21st-century digitally active brain, references from disparate sources sparring with each artist's physical painterly abilities. Yang Shaobin's paintings are equally fragmentary – he splices statuesque heads with glimpsed views, all in the intense blue penumbra of the subconscious.

There's a different kind of ambiguity in the work of Y. Z. Kami, Marilyn Minter and Judith Eisler. Kami's paintings at first appear as straightforward portraits of people in nondescript clothes, their eyes often closed, their faces blurry as if observed from a distance. But no matter how close you view the paintings they never sharpen, the closed eyes or diverted gaze offering no clue as to the identity of each sitter. The figures stand against a plain, pale ground, lifted out of everyday surroundings. Kami works from life but Eisler prefers to use photographs. She reproduces a film still repeatedly, each time choosing a different colour to paint it in – pink, green, gold – and exploring how the pigment influences our reading of the image. The monochrome palette transforms the original still, creating a flattened semblance of it, reducing its depth, tonal range and content in the process. Minter, by contrast, takes photorealism to its end point, creating giant canvases of figurative details such as a blackened heel in a silver stiletto or the red pout of a woman biting a string of pearls. Minter is fascinated with reflection and surface, often creating scenes where water (or mercury) splashes around subjects.

At the other extreme, the figures in Yuma Tomiyasu and Laura Lancaster's work threaten to disappear entirely. Tomiyasu's spectral knights hover hesitantly, translucent faces washed over strange markings. Lancaster's loosely painted figures drip and ooze over the canvas, arms completed in one brushstroke, faces dashed in. At times they threaten to depart the canvas entirely, ushered out by the energy of the mark, by paint itself. The faces that loom out of the dark ground in Johan Van Mullem's paintings are simultaneously fleshy manifestations of heads and a series of exploratory strokes and scratches across the surface of the canvas. Hollow eye-sockets and mouths lost in shadow coalesce to form faces that seem to question the viewer, despite their ongoing entropy.

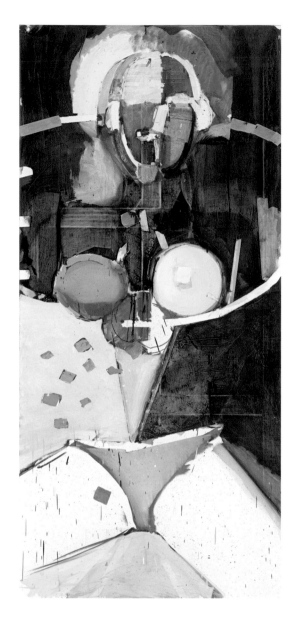

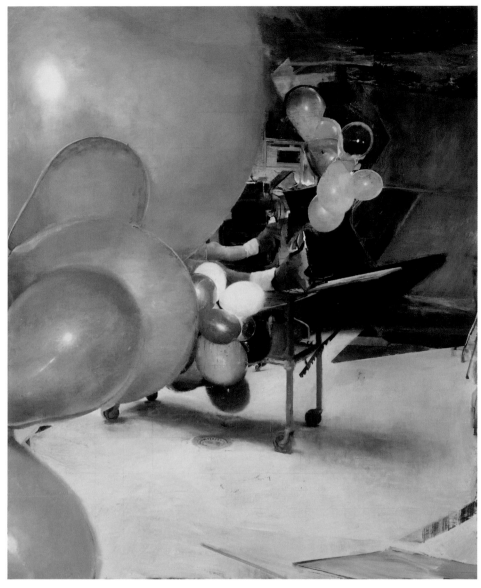

ABOVE LEFT
Magnus Plessen
Eis (*Ice*), 2012
Oil and charcoal on canvas
203.5 × 93 cm / 80⅛ × 36⅝ in.

ABOVE RIGHT
Justin Mortimer
Crèche, 2012
Oil on canvas
220 × 180 cm / 86⅝ × 70⅞ in.

Susie Hamilton

Whether under the hot sun in Marrakech or the artificial glare of a shop's strip light, Hamilton's figures stand alone. She interrogates the figure until she can reduce it to just a few brushstrokes, placing it in a psychological wilderness – a barren landscape, a supermarket aisle. But still each person stands solidly, credibly, despite being transformed, mutated, dislocated. A man casts purple shadows on a Moroccan street in *Jemaa-el-Fna* (2014); another walks briskly under a covered walkway, dappled sunlight striking the path, in *Souk* (2014). Often the figures are silhouetted or reduced to blocks of colour, as with the corpulescent woman in *Freezer* (2012), the light around them threatening to absorb or dissolve them. But despite all the assaults on their identity – they are often genderless; always featureless – they still exist, alone and hunched, melancholic but alive. When Hamilton does cluster figures together, on beaches or escalators in shopping malls, there is no interaction between them. We exist in isolation, Hamilton seems to say, made up of nothing more than a few strokes of a brush. Life is cruel and fragile, and yet, somehow, we as a species remain alive. Resilient, even.

'The representational image being overtaken by abstraction is important to me, partly because it feels like a way of challenging the figure's secure identity but also because it is a way of showing the familiar tipping over into the unfamiliar, of reaching a point where the recognizable gives way to something unnamed.'

— Hamilton

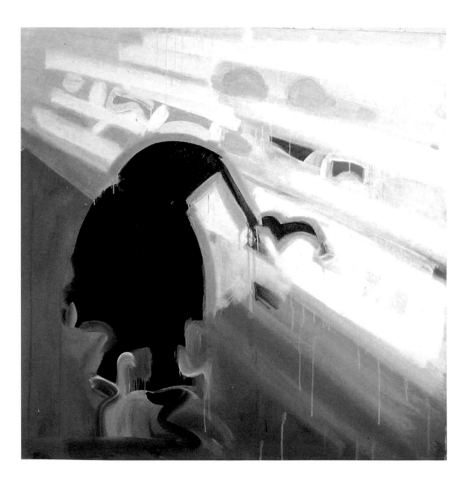

LEFT
Aisle 2, 2012
Acrylic on canvas
132 × 132 cm / 52 × 52 in.

OPPOSITE, ABOVE LEFT
Jemaa-el-Fna, 2014
Oil on canvas
40 × 40 cm / 15¾ × 15¾ in.

OPPOSITE, ABOVE RIGHT
Marigot 5, 2013
Oil on board
30 × 30 cm / 11¾ × 11¾ in.

OPPOSITE, BELOW LEFT
Jemaa-el-Fna / 3, 2014
Oil on canvas
101 × 101 cm / 39¾ × 39¾ in.

OPPOSITE, BELOW RIGHT
Souk, 2014
Oil on canvas
70 × 70 cm / 27½ × 27½ in.

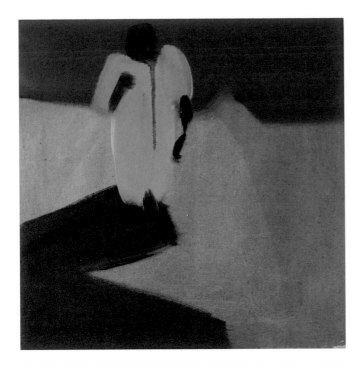

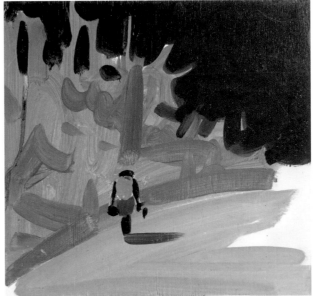

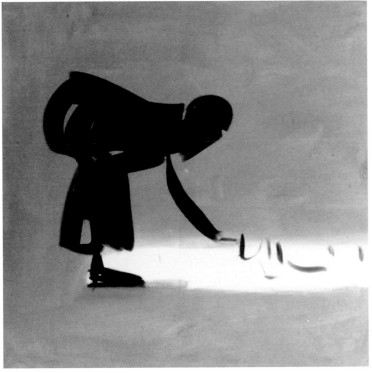

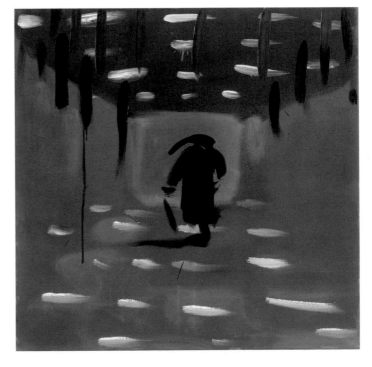

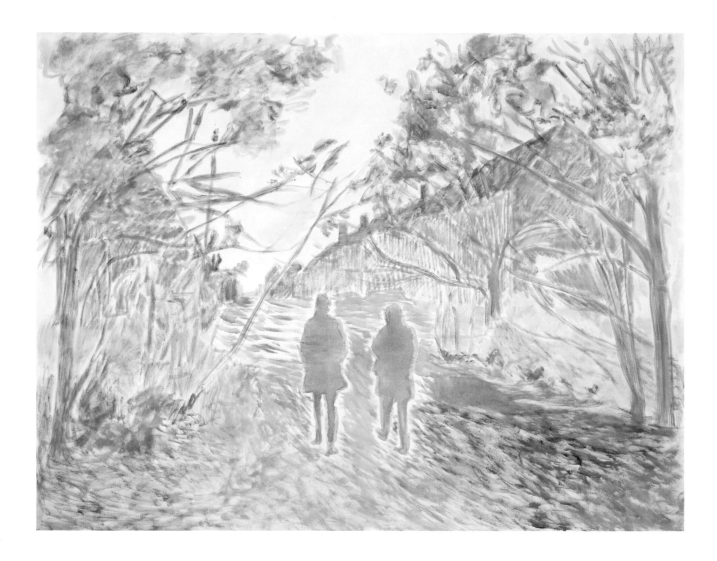

Tim Stoner

Stoner made a name for himself with paintings of silhouetted figures enveloped in golden auras, all engaged in group activities that the viewer was excluded from: balancing acts, national dance routines, acrobatic displays. Recently, however, his figures have lost their solidity and now appear as attenuated brushstrokes rather than concrete forms. *Bridge* (2012–13) and *Music* (2010–13) span the change, groups of people still clustering together in displays of bravura or enjoyment, but each figure more sketchy, less firm, less solid. In *Essex* (2014) the group has been reduced to a pair, walking – not touching – along a country lane that seems enveloped in a luminosity last seen in Matisse's *Luxe, Calme et Volupté* (1904). But in other 2014 works such as *Bloom* and *New England* the figure is no longer illuminated. A grey melancholy penetrates each stooped and solitary

form as they walk over a wintry road junction or pass a fountain in a public park. In *Keski* and *Town* (both 2014) a grey form – a man? – is a shadow of himself, a dark spot among the enhanced colours of his surroundings. In *Keski* he becomes one with the marks on the canvas, a red Monet sunset reflecting in water that seems to ripple between the denuded trees. The picture plane is held in tension between perspectival depth and painterly surface; the paint weeps, as if in sympathy.

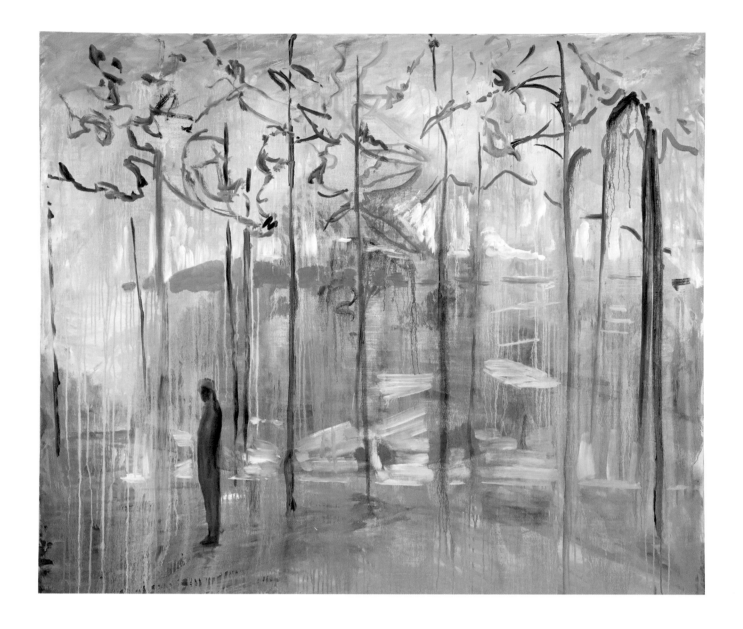

'Subject matter finds its way into a painting through activity,
process and application, but not as a starting point. I rework
the paintings until they reveal unforeseen meanings that exist
beyond any preconceived model (because life just isn't like that).'

— Stoner

ABOVE
Keski, 2014
Oil on linen
135 × 160 cm / 53⅛ × 63 in.

OPPOSITE
Essex, 2014
Oil on linen
206 × 266.5 cm / 81⅛ × 104⅞ in.

People as Picture 25

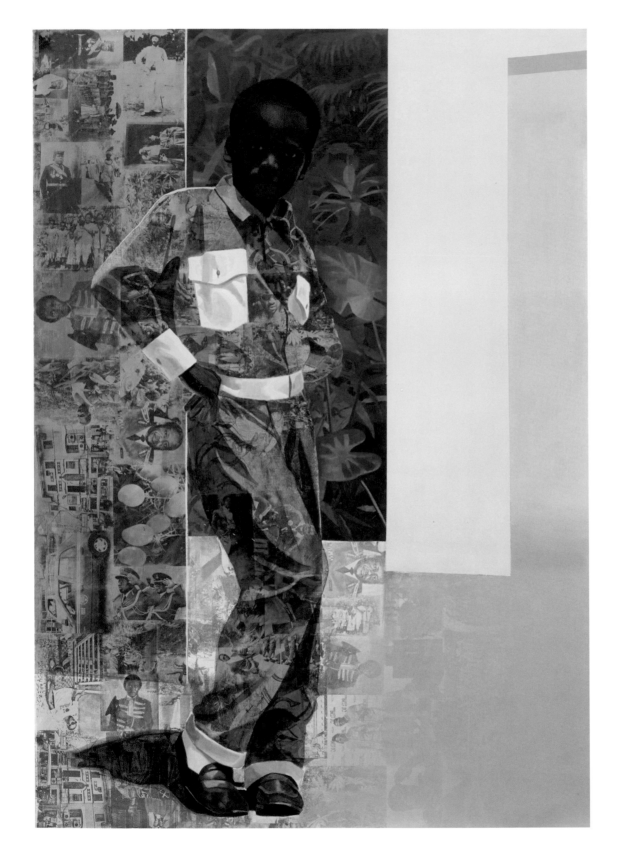

LEFT
'The Beautyful Ones' #2, 2013
Acrylic, colour pencils, pastels and
transfers on paper
155.4 × 106.7 cm / 61¼ × 42 in.

OPPOSITE
Something Split and New, 2013
Acrylic, charcoal, pastel, colour
pencils, marble dust, collage and
transfers on paper
213.4 × 282 cm / 84 × 111 in.

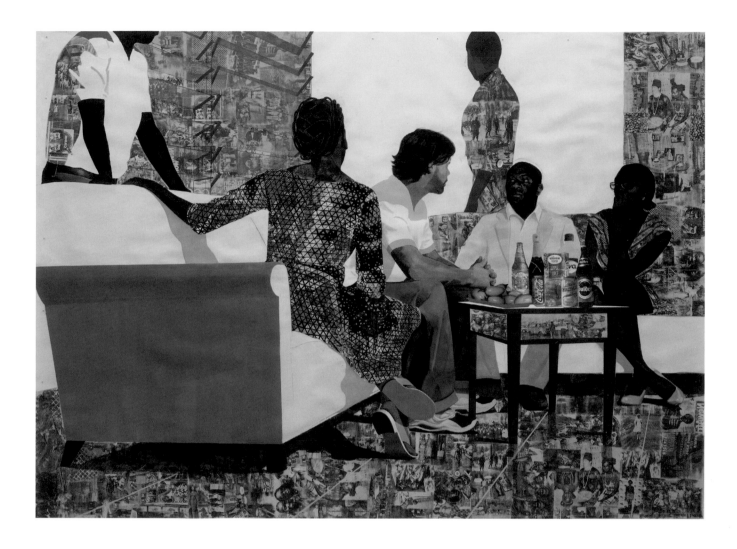

Njideka Akunyili Crosby

The complex surfaces of Akunyili Crosby's paintings comprise Xerox transfers from family photographs and the media, collaged elements and layers of charcoal and acrylic paint. They speak of her own history – a Nigerian who moved to America, where she now works and lives with her American husband. Her paintings also speak of the complexity of modern identity, and the displacement that can be felt when straddling two cultures. Often the figures in her paintings are autobiographical – Akunyili Crosby and her husband in bed or scenes from her wedding in Nigeria. Traditional hairstyles, dresses and hats are on display alongside Western brands – a Coke can on the coffee table; Weetabix in the kitchen. Underpinning each painting is a layer of collaged archival material drawn from her personal collection of family photographs and Nigerian popular culture, such as magazine covers. It is as if her past, her memories, coexist with her present, feeding into and shaping the surfaces of each new painting. As if to emphasize this jostling of memory and contemporaneity, each surface is held in tension. At times the photographs crowd the surface of the painting, flattening the picture plane, as in 'The Beautyful Ones' #2 (2013). Walls, clothes, floors, windows – all are filled with grainy transfers of her history. And yet over this surface, domestic rooms and *mise-en-scènes* come into being: her husband in T-shirt and trainers sitting on the sofa with her family in *Something Split and New* (2013). These images speak directly of Akunyili Crosby's own personal history and her current life, but through these images and her paintings she connects with all of us, with all our racial and cultural integrations.

ABOVE
Blue Room 20, 2010
Oil on canvas
195 × 217 cm / 76¾ × 85⅜ in.

LEFT
Blue Room 5, 2010
Oil on canvas
195 × 223 cm / 76¾ × 87¾ in.

*'Globalization has made the world flat, through all
these interconnections. It's like the world isn't spherical
anymore; it's a plane.'*

— Shaobin

OPPOSITE
Travel Island, 2013
Oil on canvas
180 × 140 cm / 70⅞ × 55⅛ in.

Yang Shaobin

In 2010 Yang exhibited his series 'Blue Room'
at UCCA in Beijing. It featured large close-
range portraits of many of the world leaders
who had attended the 2009 climate-change talks
in Copenhagen. These blue monochromatic
portraits filled an entire gallery wall, and
faced a similar installation of paintings on the
opposite wall, this time featuring portraits of
victims of the rising tides and extreme weather
situations associated with global warming.
Yang has previously explored the plight of
Chinese coalminers, and the ongoing struggle
for survival in his 'Red Violence' series. 'Blue
Room' similarly explored the difficulties of
day-to-day existence, confronting politicians
with the victims of their climate dithering. In
recent work Yang has retained his monochrome
palette, which in 'Blue Room' evokes both
maritime calm and the destructive power of the
sea. In *Travel Island* (2013) the rich blue tones
infuse his complex, fragmentary painting with
a dreamlike sensibility. Yang has gone beyond
the earth's atmosphere in this work, mapping
star constellations (or are they circuitboards?)
over fragments of culture, bringing together
disparate ideas that coagulate to suggest our
hyperconnected yet fragile world.

Justin Mortimer

In *Joker* (2014) tea towels appear to swing on washing lines stretched across the foreground; simultaneously these lines bite into the surface, grubby scars cut into a gestural white ground. The white ground turns to snow under the feet of masked women protestors, who navigate their way down the height of the canvas. A pollarded tree provides handholds; a Tyrolean lodge a backdrop. Mortimer has said he wants to 'play with the bandwidth of paint' and canvases such as *Joker* and *Parasol* (2014) show the extent to which he achieves this. Using figures drawn from post-war history – medical experimenters, communist leaders, Pussy Riot campaigners – he subjects them to amputations, fragmentation and distortion, cropping heads from bodies and isolating limbs. But it is the paint that is always in charge – at times flat and brooding like the Rothko sky in *Parasol*; at other times swelling into shiny balloons that restrict access to the picture's perspectival depths, as in *Crèche* (2012; page 21). In his collaging of techniques and subject matter, Mortimer responds to the cacophony of imagery we all have to sift through in our minds each day: memories, experiences, news feeds, advertising, research, social media, photographs and dreams. Disjointed fragmentation is the best we can hope for.

OPPOSITE
Joker, 2014
Oil on canvas
240 × 190 cm / 94½ × 74¾ in.

BELOW LEFT
Chamber, 2011
Oil on canvas
240 × 180 cm / 94½ × 70⅞ in.

BELOW RIGHT
Parasol, 2014
Oil on canvas
240 × 190 cm / 94½ × 74¾ in.

'The unsettling crunch and crackle of unknown shapes, the bizarre push and shove of odd misalignments, amount to a certain voodoo that puts a painting outside the perimeter of expectations into its own, separate dimension.'

– Mortimer

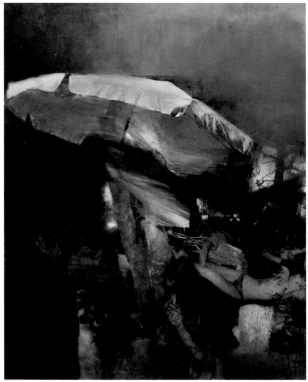

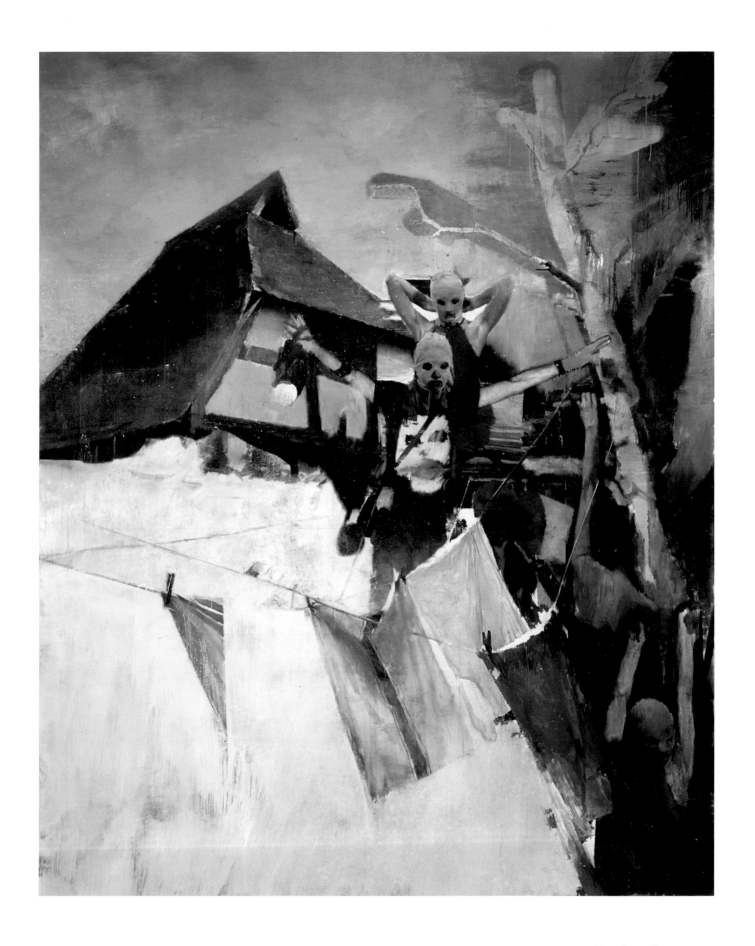

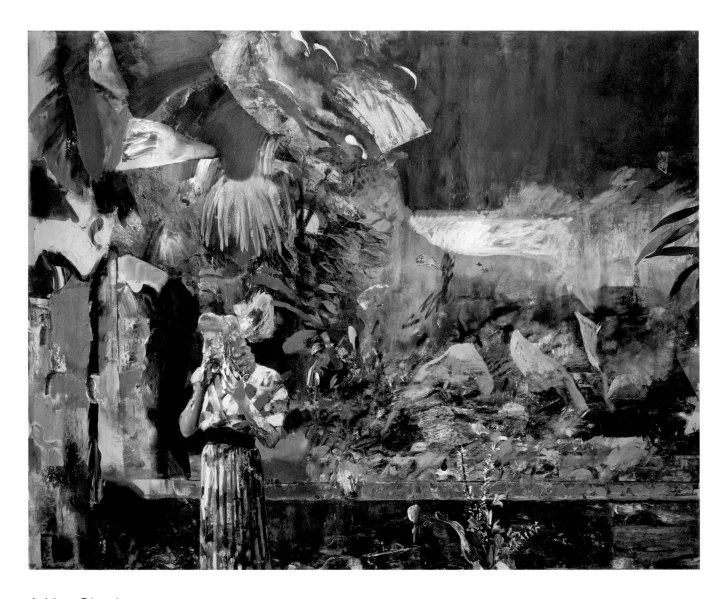

Adrian Ghenie

Ghenie is fascinated with evolutionary theory and its bastard progeny, eugenics. Charles Darwin has become somewhat of a cipher for the artist, and through Darwin's scientific theories and personal health issues Ghenie explores complex issues surrounding the morality of identity and the science of humanity, from evolution to genocide. In his London exhibition 'Golems' (2014) Darwin was a leitmotif, and paintings based on media representations of Darwin showed him throughout his life, from young botanist to old man. In *Charles Darwin at the age of 75* (2014) the scientist's figure appears frail and static at the centre of a maelstrom of paint, the energy (of the artist's making) in marked contrast to the swaddled figure seated in a chair and wrapped in a blanket. Darwin

suffered from a vomiting disorder and terrible eczema, both of which stand in contradistinction to the maxim 'survival of the fittest'. Ghenie muses on this: brown paint seems to be eating into Darwin's face in *Charles Darwin as a young man* (2014), a purple smear all that is left of an eye. Ghenie's figures always seem assaulted by paint. In *Pie Fight Interior 12* (2014), paint (aka the pie) hits a woman squarely in the face. A multitude of frames confuse inside and outside; flowers in a vase vie with palm fronds and blue skies above. The woman's yellow dress looks like a painter's overall and her mouth screams like Francis Bacon's *Study of Velázquez's Portrait of Pope Innocent X* (1953): despite the narrative, painting itself is Ghenie's ultimate subject.

Pie Fight Interior 12, 2014
Oil on canvas
284 × 350.5 cm / 11¾ × 138 in.

Charles Darwin at the age of 75, 2014
Oil on canvas
200 × 270 cm / 78¾ × 106¼ in.

'For centuries nature was the place where you got your information, psychologically speaking. But in the 20th century we developed a third space, a virtual space, which now is the place where we spend most of our time…. I feel it is absolutely natural to refer to this virtual reality and take something from it and put it into painting.'
— Ghenie

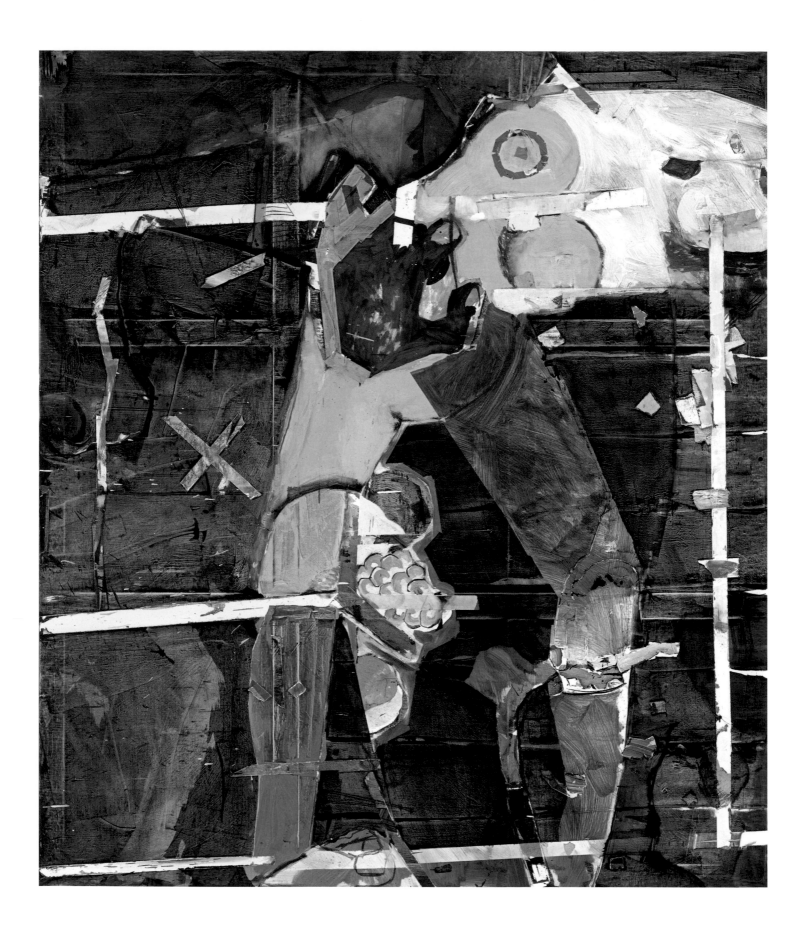

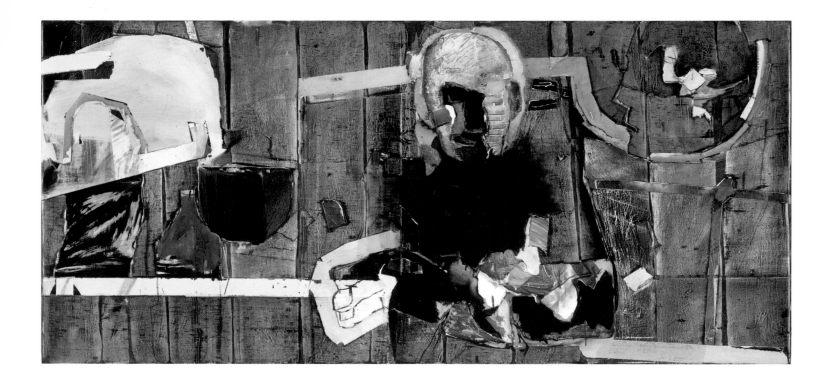

ABOVE
Ohne Titel (3), 2014
Oil on canvas
93 × 203 cm / 36⅝ × 79⅞ in.

OPPOSITE
Sarah in rot (*Sarah in red*), 2012
Oil and charcoal on canvas
221.5 × 192.5 cm / 87⅕ × 75¾ in.

Magnus Plessen

Plessen has long been interested in the slippage between representation and abstraction. In *Sarah in rot* (2012), for example, an approximation of a woman's body arcs across a shallow blue ground, wearing her body parts like clothes. White stripes of paint overlay her body, and similar bands of white, like masking tape, show through beneath the blue background. This visual collage – in fact all created with oil on canvas – pins the work on the surface. Plessen is interested in how we see: fragments of bodies half-remembered or glimpsed, feet and hands, the swell of a calf or breast. But he also wants to paint how we experience bodies, less visually and more sensorially, from the inside out. Recently his work has darkened, and his latest series, '1914', draws on horrific imagery of World War I

veterans who were disfigured by explosions and war incidents. Faces now appear blackened, charred, empty sockets where eyes once saw the world, jaws distended or missing entirely. Bodies appear as mere suggestions, heads skull-like and scarred. The mutilations of the figure are reminiscent of Jean Fautrier's 'Hostage' series (1943–45), while the occasional profile, watching from the margins as in *Ohne Titel (3)* (2014), reminds the viewer of Picasso's Cubist experiments with perception. This silhouette could be the pre-war profile of the injured man, or the culpable observer/viewer. Plessen's canvases never offer clear readings but this ambiguity, this tension – between familiar body parts, abstraction and a sense of an unknown narrative – is what keeps us coming back to them, what draws us close.

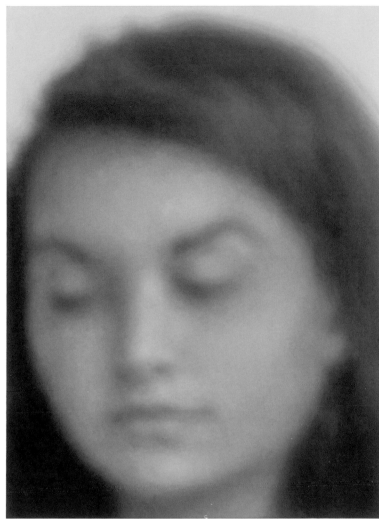

Y. Z. Kami

ABOVE LEFT
Untitled, 2010
Oil on linen
251.5 × 144.8 cm / 99 × 57 in.

ABOVE RIGHT
Untitled, 2011–12
Oil on linen
251.5 × 182.9 cm / 99 × 72 in.

OPPOSITE
Untitled, 2009–12
Oil on linen
284.5 × 190.5 cm / 112 × 75 in.

Kami's larger-than-life portraits of family, friends and strangers deny the viewer's gaze. They most often sit with their eyes shut, or averted. Even when they look out at the viewer their eyes rarely meet ours. Kami strips his sitters of personality; they pose in everyday neutral clothes, with minimal jewelry, piercings or tattoos. But he gives them an inflated presence by painting them as giant heads, towering over us, such as *Untitled* (2009–12), which is nearly 3 metres (10 feet) tall. Despite the scale, no matter how close (or far away) you stand to these paintings, they resist conforming to expectations and remain out of focus, the unnamed subjects refusing to offer clues as to who they are or what they are doing. We are

forced to absorb them rather than 'scan' them, to pick up on the meditative quality that Kami aspires to achieve, created in part by his sfumato technique that blends each area of the face into the next, creating an all-over surface as if the ground (linen) had drawn the sitter deep within itself. Each sitter is lost in their own world, existing in isolation, head fusing with the blank background that surrounds them. In the past Kami has painted hands clasped in prayer and portraits of faith leaders, but in his recent figurative paintings spirituality is more diffuse, and somehow more melancholic.

Marilyn Minter

ABOVE RIGHT
Stranded, 2013
Enamel on metal
152.4 × 182.9 cm / 60 × 72 in.

OPPOSITE
Teeter, 2009
Enamel on aluminium
91.4 × 91.4 cm / 36 × 36 in.

Minter, a 1970s feminist, painted hardcore porn scenes in the late 1980s before being slowly drawn to the brittle world of fashion and glamour. Now she is increasingly interested in the perceived trappings of mediated female sexuality: rhinestone stilettos, shimmering eyeshadow, glossy red lipstick, gold teeth, wet-look hair, oiled bodies. Her meticulously painted hyperreal women bite strings of pearls, teeter in silver sandals as they splash through puddles or coat their tongues in gold paint as if it were honey. Her canvases dwarf observers, the details of plump lips, bare heels and ecstatic eyes seducing and intimidating us like giant billboards offering products designed to get our juices (and cash) flowing. Often the women appear as if seen through wet glass or mirrors.

Where and who are the real women? Do they exist or are they fantasies of a pornographic and consumption-driven media? Minter is fascinated by the layering she can achieve in these works, her source photographs often viewed under greased glass, defaced by graffiti, tagged and daubed, altered by the translation of each image into layers of glossy enamel paint. Works such as *Stranded* (2013) feel both seedy and seductive. The clichéd biting-pearl, come-hither pout seems dated and tawdry, all surface and no depth. And yet the sheer scale of Minter's near-forensic technique seduces the eye even as the body wants to turn away, sated, nauseous from over-indulgence.

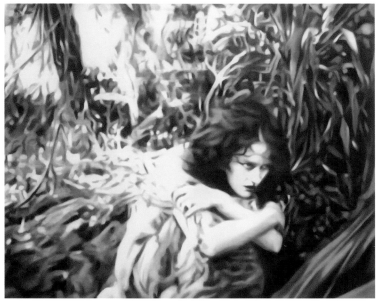

Judith Eisler

Eisler's paintings are based on films, but she is not interested in the film's narrative content. Instead, she watches them through her camera, taking still photographs of aspects she finds interesting. She doesn't choose key scenes but rather looks for liminal or ambiguous moments. By freezing the action she becomes aware of fleeting elements or details that she would otherwise have missed. Eisler is interested in the way the realism of a film breaks down when it is paused, when the distortions and fabrications embedded in the 'reality' it sells can be seen. She translates the still images she takes into paintings, engaging with how photographs morph and change under a painter's brush but also allowing herself to further mould the film's

subject, cropping areas out or concentrating on details. Initially, the finished paintings can have the semblance of a film still, but often they disintegrate into abstraction when viewed up close. Eisler is interested in the layers of technology and reproduction that now shape our understanding of the world – photographs, films, YouTube, Facebook. This mediated experience becomes our (virtual) reality, fictions appearing as credible sources of information. By playing with the surface of the image – where it dissolves into paint patches, for example, or becomes monochrome – she asks us to question the reality of what we are looking at one more time. All is never as it seems.

ABOVE LEFT
GS 1919 (gold), 2013
Oil on canvas
120 × 150 cm / 47¼ × 59 in.

ABOVE RIGHT
GS 1919 (rosa), 2013
Oil on canvas
120 × 150 cm / 47¼ × 59 in.

OPPOSITE
Red Margit 2, 2013
Oil on canvas
100 × 140 cm / 39⅜ × 55⅛ in.

'Within my work I attempt to paint the spirituality of objects.... My intention is to prompt viewers to rethink the importance of spirituality for human life through aesthetic representation.'
— Tomiyasu

Yuma Tomiyasu

Young artist Tomiyasu works from photographs found in flea markets, painting figures that seem otherworldly. At her Masters exhibition, thin washes of white oil paint formed the ghostly armature of spectral knights while flickering after-images of women straight out of Sargent paintings appeared against black triangles, whitewash dripping down like an ectoplasmic discharge. At times the paint threatens to obliterate the figures, as in *Family in Purple (sephirot)* (2012); at other times the paint illuminates and frames the subject, as in *Man Wearing Glasses* (2012). The man smiles for an unknown camera, his spectacles, hand-tied bow-tie and white tuxedo suggesting a life lived some time ago, now spent. Tomiyasu's sketchy outline resurrects his seated form, the glowing diamonds of neon-pink and orange drawing him out of the deep blue ground. Occult symbols, alchemical shapes, triangles and diamonds appear throughout her work, as if there are codes at play that are conjuring these figures from our collective past, from the spirit world. But we are not privy to their symbolism and must content ourselves with observing the layers of history, mystery and paint that comprise her promising paintings.

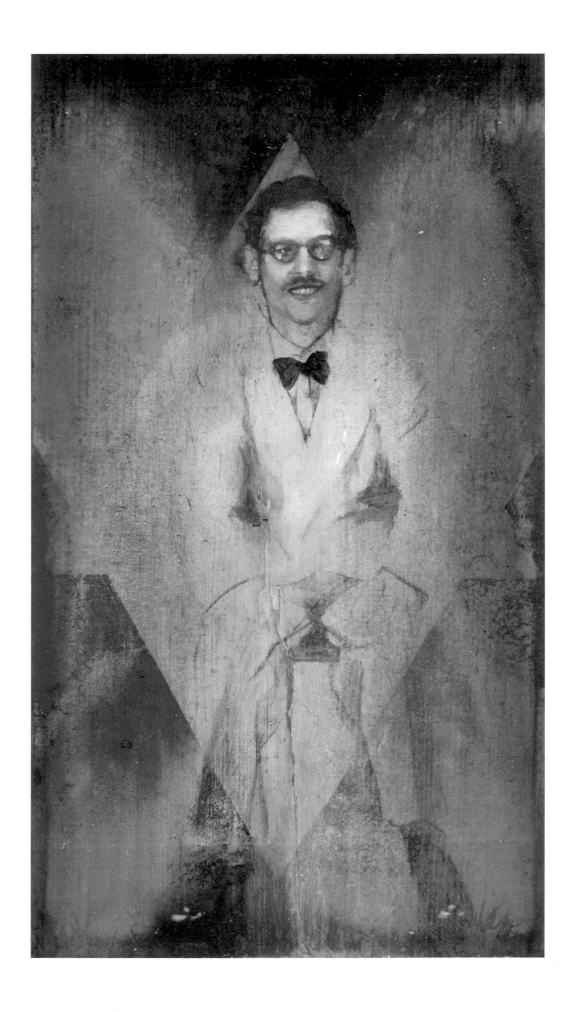

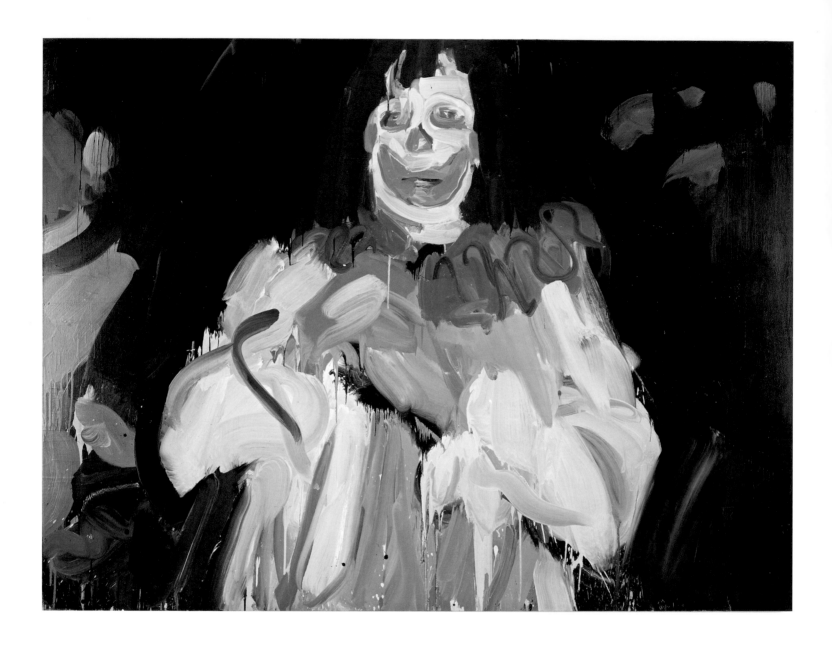

Laura Lancaster

Using found photographs bought in markets and on eBay, Lancaster transcribes each one into paint, interested in how these images become material objects and how translating them into paint can further rupture their content. She is drawn to the macabre and the diabolic, interested in how costumes transform people, choosing photographs of people dressed up as clowns, bears, Dracula. They wear wigs, face paint and costumes, but in her paintings the happy snapshot feel of the family album – 'look, there's Mum in a red wig and clown suit at carnival!' – has been erased. Instead each figure,

much enlarged, seems isolated and sinister, exposed. Children become threatening and uncanny in their Halloween costumes; face paint starts to slide under cheap disguises. Lancaster works fast and loose, paint dripping down faces, bleeding from eyes and elbows. At times the paint threatens to engulf and overwhelm the bodies, leaving us searching for figurative clues: the crook of an arm; the colour of naked flesh. Her subjects are forever in disguise, either under costumes or paint, uncanny approximations of their former selves.

ABOVE
Untitled, 2014
Oil on acrylic on linen
160 × 210 cm / 63 × 82⅝ in.

OPPOSITE
Untitled, 2014
Oil on acrylic on linen
150 × 120 cm / 59⅛ × 47¼ in.

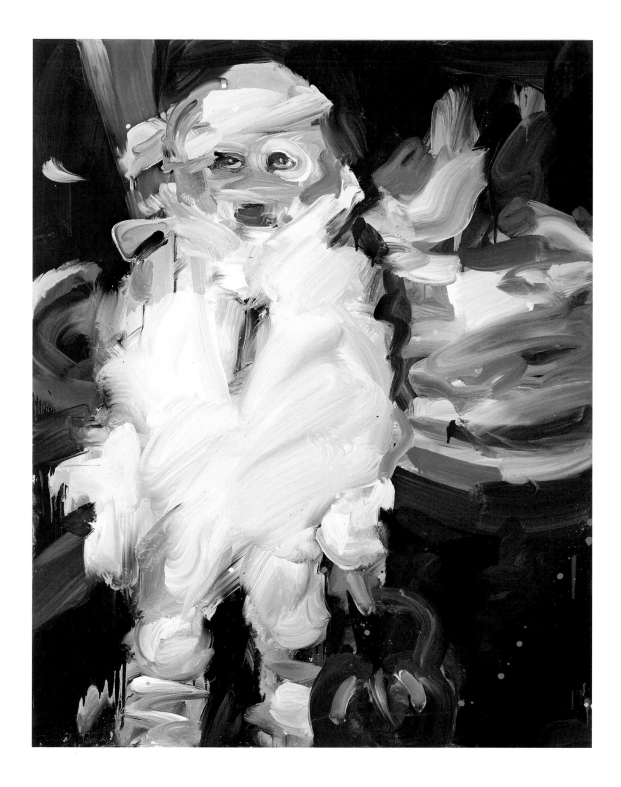

'I like to think that my paintings somehow open up the subject matter. I like to experiment with my level of control over the paint through manipulating its consistency, brush size, etc. so the end result hangs in the balance between the source image and the paint's plasticity. I think this sense of limbo adds to the atmosphere.'

— Lancaster

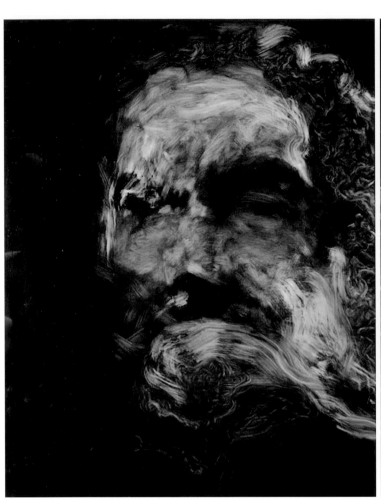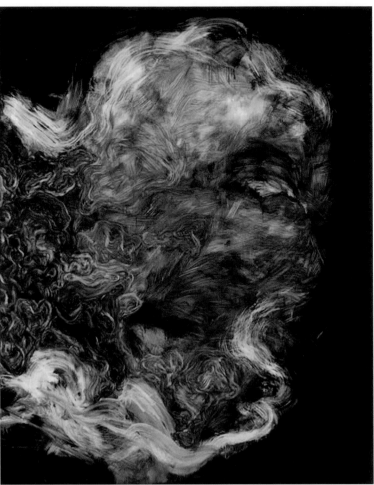

Johan Van Mullem

In *Sans Titre* (2011) a man's face, painted in sepia tones, looms out of a black ground. In places the paint appears scratchy and agitated, swirling over his right eye, his left cheek, looping over the tendrils of his hair, tugging at his beard. These marks seem to coalesce again on the right-hand side of the canvas, conjuring an amorphous form with a toothless mouth. It is as if the stoic figure's soul has been teased out, revealing a subconscious manifestation of his inner thoughts, fears and dreams. Van Mullem is an emotional artist, often bypassing the physical realities of the human face to explore our hidden depths and emotions. Paint replicates sensations

that go beyond words, dropping plumb lines to capture the fugitive nature of souls (ours and his own). At times the full figure appears, a naked man bound to a table by skeins of paint. But most often Van Mullem concentrates on the face: broad brushstrokes of primary colours blinding profiles; blooms of cells shaping eyeless faces as surface scratches try to obliterate them. These psychological portraits question our own emotions, our feelings, as they simultaneously reveal facets of the artist's own psyche.

ABOVE
Sans Titre, 2011
Ink on board
180 × 280 cm / 70⅞ × 110¼ in.

OPPOSITE
Sans Titre, 2013
Ink on board
140 × 100 cm / 55⅛ × 39⅜ in.

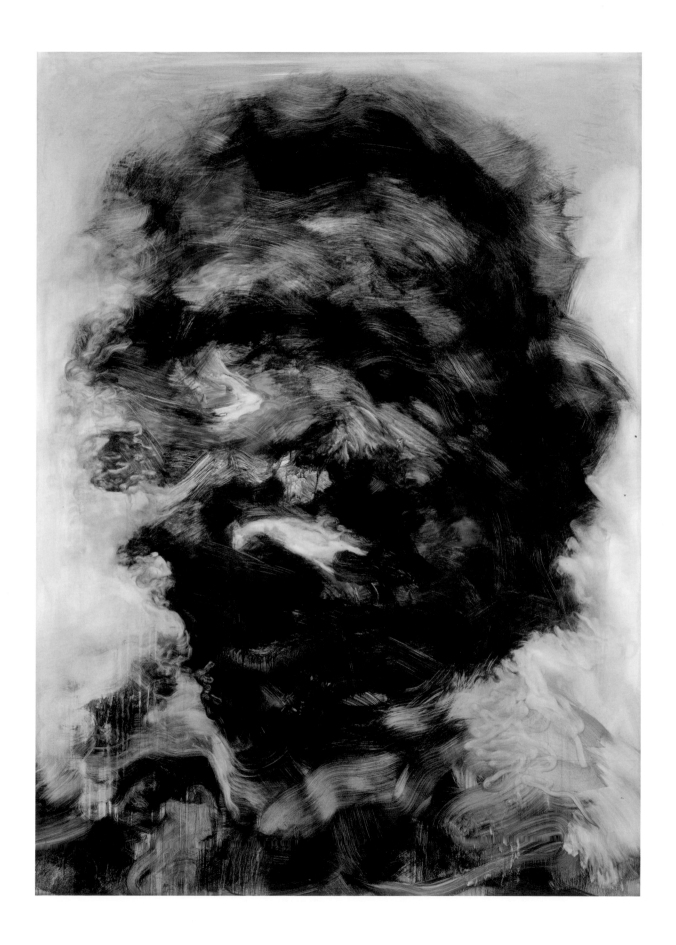

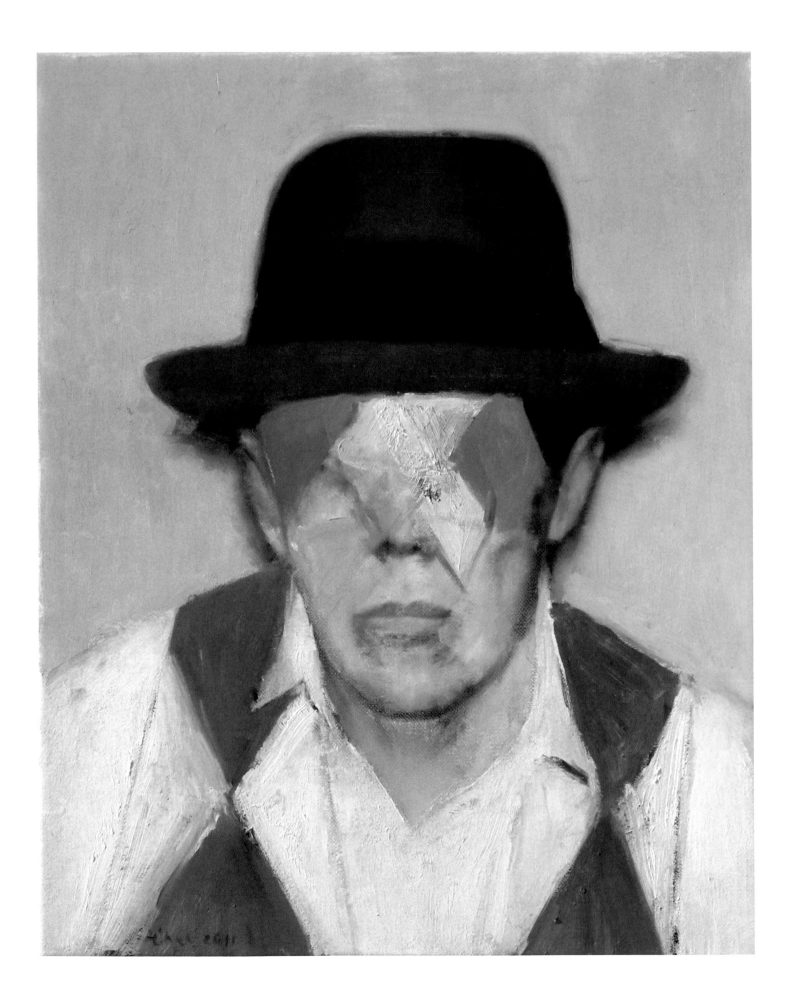

2.

Maria Kontis / Gideon Rubin / Eleanor Moreton / John Stezaker / Karin Hanssen / Uwe Wittwer / Jan Vanriet / Lars Elling / Johannes Kahrs / Li Songsong/ Paulina Olowska / Mircea Suciu / Serban Savu / Alexander Tinei

The continued importance of photographic source material and the aesthetic mining of the archive.

Image Hunters

Alexander Tinei
Hat, 2011
Oil on canvas
50 × 40 cm / 19⅝ × 15¾ in.

Photographs, with their indexical relationship to the subject they contain (what Roland Barthes termed 'literally an emanation of the referent') continue to beguile and trick us into believing that what we see is how things were. We know we should challenge their authenticity, but somehow we continue to be seduced by their verisimilitude. And, as Victor Burgin noted in his influential essay 'Looking at Photographs' (1977), it is the apparent transparency of the photographic image and our conviction that we can choose what to make of it that 'hides the complicity to which we are recruited in the very act of *looking*'.

The artists in this chapter, in differing ways, draw on the ever-growing archive of photography to question what we see when we look at a reproduction of a person or people, and how this changes when translated into a painting, a drawing or a photograph. Whether offering materially different copies, images that have been defaced or erased in some way or new works made from composite parts, each artist questions our relationship with history, memory and the 'truth' of the image.

Maria Kontis deals directly with the materiality of archival photography, exploring the phenomenon that allows photographs to be at once historic artefacts and simultaneously objects present in the world today. Kontis's small pencil drawings record family moments lost to time, or people that made it into public consciousness but who can no longer be identified in the images she chooses. Gideon Rubin similarly works from old photographs. In his paintings the faces of children and adults are always blank, erased. The family photographs on which his paintings are based – once proudly displayed on a mantelpiece perhaps, or in an album – have become anonymous over time. The people in each photograph are long dead, the parents' guiding role over, the child's life now only a memory. Eleanor Moreton also draws on the photographic archive, painting portraits of women who have inspired her, their features seeping into the grain of her untreated wood panels. John Stezaker prefers to work directly with found photographs, splicing together flea-market finds of promotional headshots of

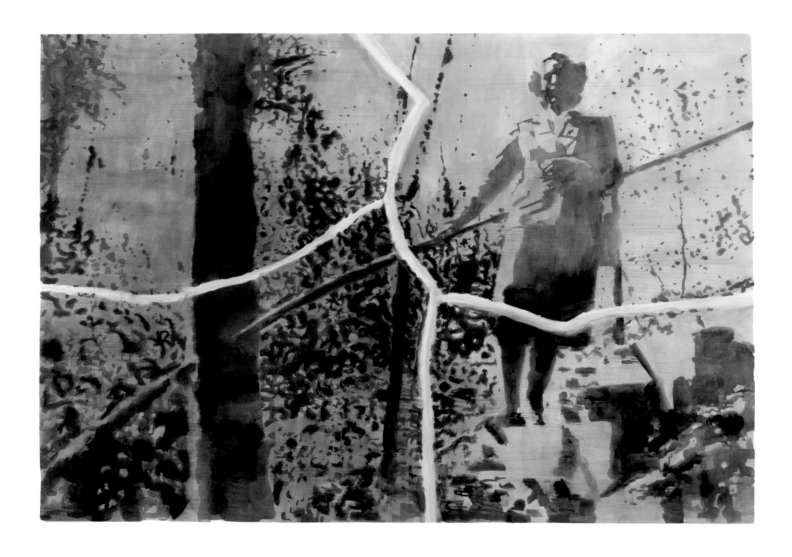

movie-star wannabes from the 1950s. He creates surreal hybrids: furrowed brows morph into arched, plucked eyebrows; a curled up-do becomes a brilliantined crop of hair.

Karin Hanssen uses found photographs torn from magazines such as *Life* and *Time*. In a recent series she fragmented a 1950s advertisement into a dozen or so smaller images, which she then translated into paintings. Coffee cups are liberated from their domestic role to become still lifes; a schoolgirl drawing on a blackboard becomes the creator, the artist herself. Hanssen uses found imagery to draw our attention to the roles men and women play in order to conform with societal expectations. Her figures have a comforting solidity to them, but lack identifiable features – they are stereotypes, not individuals. Uwe Wittwer's figures are even more nebulous, appearing as ghostly traces – children on carousels, women in forests – their features lost in shadow or bleached by time. Wittwer has taken his subjects from found photographs for decades, asking where the true subject

lies: in the image itself? In the reproduction? In the new painting? Jan Vanriet similarly works from found photographs, but his are largely drawn from his own family archive. In his paintings his parents embrace awkwardly, his uncle clutches the arms of a chair, an old friend scans the horizon. Often Vanriet's figures are missing facial features, as if we can't see them properly, and they are dislocated from their original contexts. A melancholy sense of foreboding emanates from his work, supported by his use of a muted palette and the strange half-life his figures seem to possess.

Lars Elling's canvases juxtapose men and women appropriated from different source photographs and contexts. He brings them together in incongruous settings – on a golf course, in a drawing room, in a twilit garden – creating tense situations that we can't quite fathom but that send a tingle of fear up our spines. Violent acts and predatory behaviour threaten Elling's paintings; in Johannes Kahrs's paintings the violence has already been meted out. Bodies appear bruised and bandaged, their injuries documented as if by a covert camera, the violence inflicted for unknown reasons on unidentifiable victims. Kahrs's photographic source material is often his own, reframed and altered to suit his needs, but Li Songsong and Paulina Olowska prefer to use images first published in the media. Generals, terrorists and muscle men appear in Li Songsong's impastoed canvases, black-and-white newspaper photographs transferred to a patchwork of paint that holds the image on the encrusted surface. Paulina Olowska's practice includes reworking photographs from old knitwear catalogues and fashion plates, investigating, renegotiating, questioning the depiction of women in the media.

For Romanian painters Mircea Suciu and Serban Savu, and Alexander Tinei – born in neighbouring Moldova – the images that inspire them feature grey concrete communist-era apartments, pale flesh under flat grey skies, the aerial perspective of surveillance cameras. Savu uses his camera like an archaeologist, digging away at an area, photographing details and points of view until the final (painted) image begins to coalesce in his mind. Tinei absorbs internet images like a voyeur, exploring the boundary between private and public, drawing on people's digital albums for his awkwardly balanced figures. Suciu's paintings, however, seem rooted in the past, as if evidence of a totalitarian state where files were held indefinitely and people queued for unknown reasons.

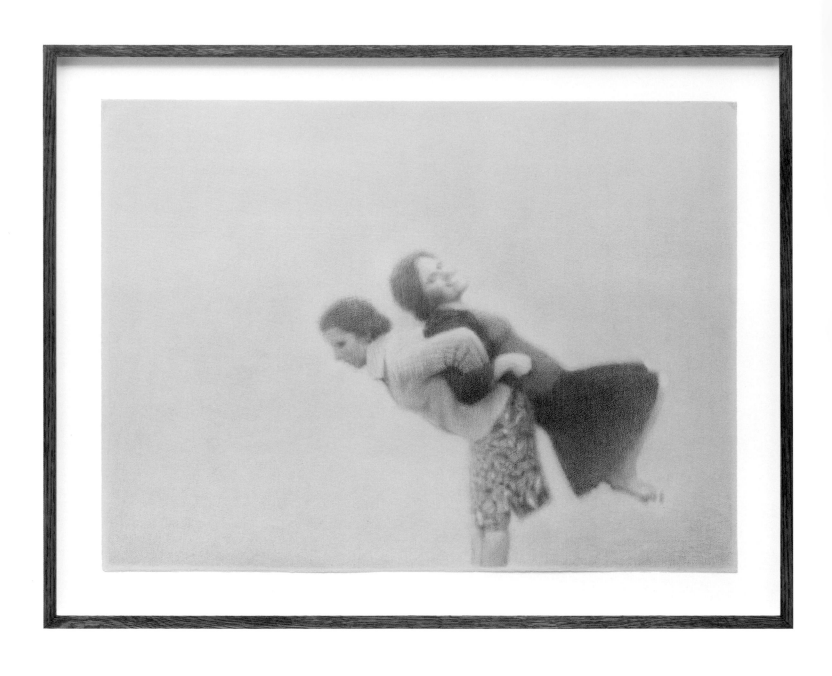

ABOVE LEFT
Manfred Fritsch, 2012
Pastel on velvet paper
79 × 76.5 cm / 31⅛ × 30⅛ in.

ABOVE RIGHT
The Great Doval, 2012
Pastel on velvet paper
79 × 76.5 cm / 31⅛ × 30⅛ in.

OPPOSITE
*Argument for a stationary
earth*, 2012
Pastel on velvet paper
56.5 × 76.5 cm /
00⅛ × 00⅛ in.

Maria Kontis

There is something incredibly fragile about Kontis's drawings, as if they may be erased in front of your eyes at any moment. Often worked up from old photographs, and engaging with the materiality of photography, they seem to speak of the transience of life, of forgotten pasts. Some are based on photographs from her own family albums, and others draw on found black-and-white photographs or other traditional means of record such as handwritten letters. Some feature famous men: Manfred Fritsch, tightrope walker, and Captain Scott, polar explorer. But the men appear distanced, unrecognizable, preserved in their moment in history – on the high wire; in the Antarctic. Yet through her pastel translations she succeeds in transporting the analogue photographs, the objects themselves, into the present. They appear faithful reproductions, but Kontis willfully deceives her viewers. As with all accounts of history, these are subjective, and she has cropped and manipulated the figures captured within the frame to suit her own purposes.

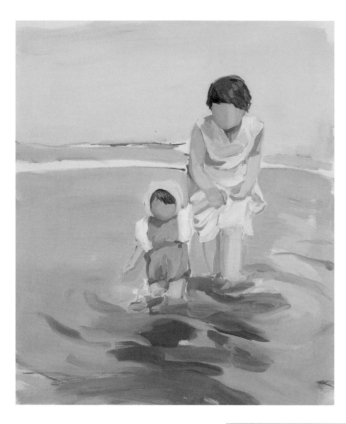

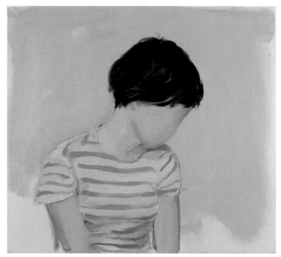

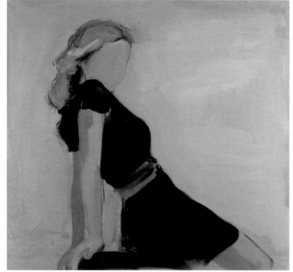

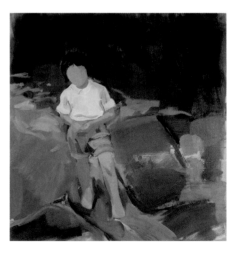

ABOVE LEFT
Mother and Child, 2010
Oil on canvas
122 × 102 cm / 48⅝ × 40⅛ in.

ABOVE RIGHT
Red stripes, 2014
Oil on canvas
51 × 56 cm / 20⅛ × 22 in.

RIGHT
Black dress, 2014
Oil on linen
102 × 107 cm / 40⅛ × 42⅛ in.

FAR RIGHT
Pond, 2010
Oil on linen
107 × 102 cm / 42⅛ × 40⅛ in.

OPPOSITE
Boy with dog, 2010
Oil on linen
60 × 55 cm / 23⅝ × 21⅝ in.

'Painting from old anonymous family photographs feels like tracing a lost past or unearthing forgotten histories. In some way I believe this obsession answers a deep need within me to replace or fill in my own family's missing albums.'

– Rubin

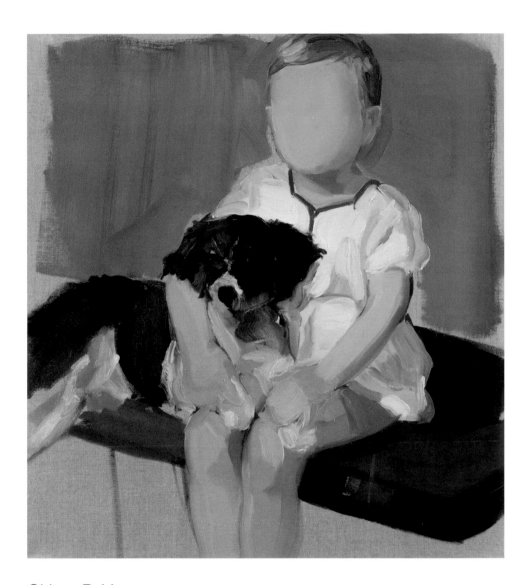

Gideon Rubin

As the world's population compiles fewer and fewer physical photographic albums each year, Rubin's paintings should sound a warning bell in our increasingly virtual lives. He mines Victorian and Edwardian albums for anonymous photographs of families and children, painting them as if they were replacements for his own Israeli family's lost albums. A girl walks through the shallows of the sea in *Mother and Child* (2010); a boy holds on to a black-and-white dog so his photograph can be taken in *Boy with dog* (2010). Rubin wants the people he paints to evoke memories in the viewer, but there is no chance of facial recognition – for the last decade all the people he has painted have been devoid of features. It is as if the decades between the photograph's origin and our contemporary world have eroded each nose,

mouth and pair of eyes, slowly buffing away the contours like pebbles worn smooth in a stream. On to these blank faces the viewer must project imagined characters and narratives – is the sunbather happy or sad? Is the mother delighted with her child's progress through the water or fearful of unseen sea creatures? At times glimpses of previous paintings can be seen under the current image, as if layers of family history existed, one on top of another, each obfuscating the one before. At other times the raw canvas can be seen, prodding the viewer into the recognition that these are first and foremost made from paint, two-dimensional fictive semblances of figures once known but now long forgotten.

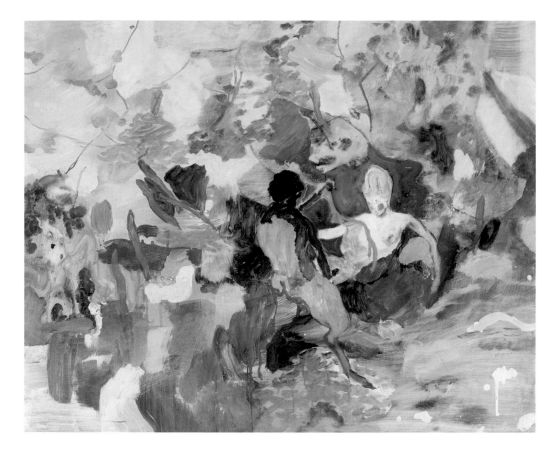

'I can't pretend that my sources are not important. They are hugely important, though not in a didactic way. They drive my painting and maybe more than that. Maybe I even want to put questions into the public realm. How do you let the painting have its head, as well as keeping in touch with your source?'

— Moreton

ABOVE
The Love of Beasts (3), 2014
Oil on canvas
70.5 × 88.5 cm / 27¾ × 34¾ in.

OPPOSITE
Gillian from 'Absent Friends', 2014
Oil and pastel on wood panel
61 × 50.8 cm / 23 × 20 in.

Eleanor Moreton

In her ongoing series 'Absent Friends' Moreton paints portraits of women who have inspired her. Singers Gillian Welch and Nina Simone and writer Rebecca West all feature, women who are celebrated primarily for their creativity rather than their bodies or fashion sense. Moreton builds each portrait using thin washes of oil, working on unprimed wood to enable the paint to be absorbed by the panel so it physically occupies the ground. Concurrently, Moreton has also been exploring mythologies, rituals and manifestations of love, reworking Pre-Raphaelite paintings of Victorian morality as well as exploring British folklore. In her most recent series she looked at the tension in mythology between the spiritual and the animal, for example in *The Love of Beasts (3)* (2014).

A Bacchanalian faun seems to have discovered Madame de Pompadour (by way of Fragonard), who is hiding in a glade of foliage that doubles up as a riot of abstract marks. Moreton works from photographs and historic paintings, exploring the relationship between her subject matter, the imagery she has purposefully sourced and sought-out and the materiality of paint itself.

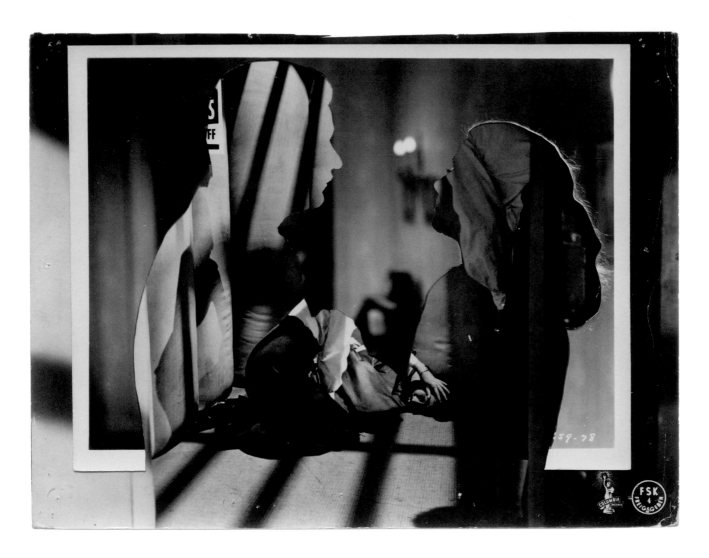

John Stezaker

Stezaker has been making photo-collages for forty years. Working in series, such as 'Masks', 'Marriage' and 'Third Person Archive', he creates new and arresting portraits and figures from photographs found in flea markets, specialist fairs and the internet. Picasso and Braque made use of collage in their Cubist paintings, pasting on letters from newspapers, but the technique was used most notably by Surrealist and Dada artists such as Hannah Höch, and her influence is visible in Stezaker's work. Each series he makes has different parameters. 'Masks', for example, pairs black-and-white film stills of wannabe actors with picturesque postcards, rolling hills and sprouting trees standing in for noses, chins and ears. In his ongoing 'Marriage' series he takes photographs of male and female actors, cutting one of the images and splicing the two faces together, creating a new transgender star. He uses photographs of hopefuls who never made it and raises questions about the fickleness of celebrity, their anonymous yet expectant faces now combined to form hybrid beings. These works also point to the gendered expectations experienced by those who originally posed for the publicity photos – the alluring pout for women; the furrowed brow and strong chin for men. In an age when anyone can Photoshop images or play with filters on Instagram, there is something material and real about the clean-cut lines of Stezaker's collages and their fragmentation and reconstruction of the face that compels us to return to them again and again.

ABOVE
Double Shadow I, 2014
Collage
22.5 × 29.8 cm / 8⅞ × 11¾ in.

OPPOSITE
Marriage (Film Portrait Collage)
LXXXII, 2013
Collage
27.6 × 23.4 cm / 10⅞ × 9¼ in.

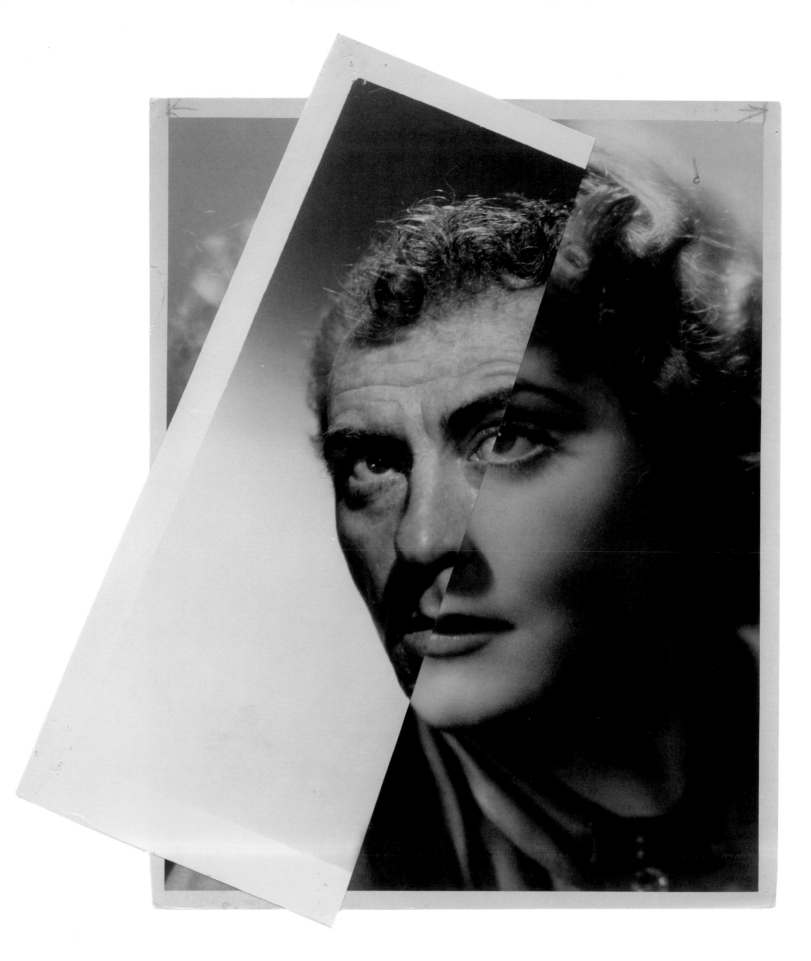

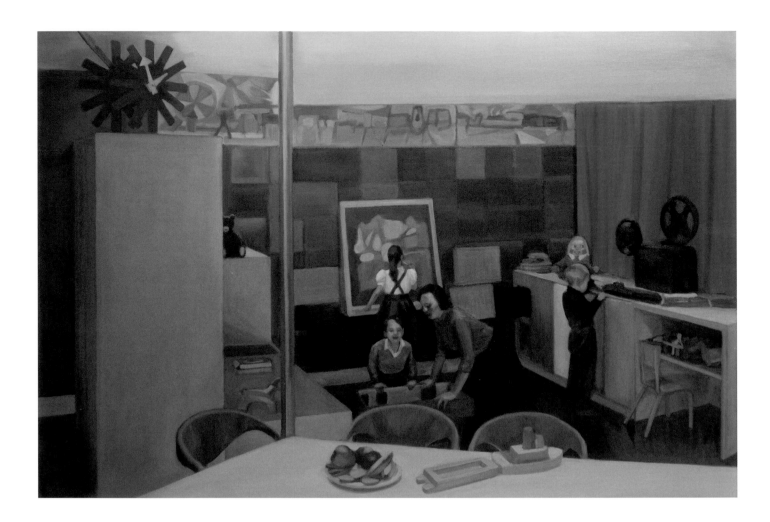

Karin Hanssen

Hanssen's figures often stand alone, isolated in their surroundings. Turned away from the viewer, or absorbed in an activity, they offer themselves to our gaze. She repeatedly paints the *Rückenfigur* (a figure viewed from behind) so we can physically occupy them, take on their gaze and see through their eyes. Perception is central to Hanssen's work – how the figures she selects from old magazines and photographs were once perceived, how we see them today, and how the translation into paint alters them, liberates them. Their existence changes, they enter a new contemporary world, still clothed in period dress and surrounded by dated home furnishings but perceived in a new present, as with *Recreation Room* (2013–14). This sense of time, a conflation of past and present, underpins all her work, as does the sense that a woman's role is always conditioned by the society in which she exists. *Recreation Room* is based on a 1950s advertisement from *Life* magazine and is one of two central images in her recent series 'A Room of One's Own'. For this series Hanssen chose nine details from the original 'recreation room' image and painted them again, this time individually, interested in how each subject changed when isolated. In *A Room of Her Own* (2013) the young girl who had been overlooked at the back of *Recreation Room* now appears to be offered an escape from her gendered destiny. She picks up the chalk and becomes an artist. The series 'A Room of One's Own' is named after Virginia Woolf's proto-feminist essay of 1929. For Hanssen, as for Woolf, escape (both mental and physical) is not always possible, but is so often desirable…

ABOVE
Recreation Room, 2013–14
Oil on canvas
140 × 210 cm / 55⅛ × 82⅝ in.

OPPOSITE
A Room of Her Own, 2013
Oil on canvas
60 × 45 cm / 23⅝ × 17¾ in.

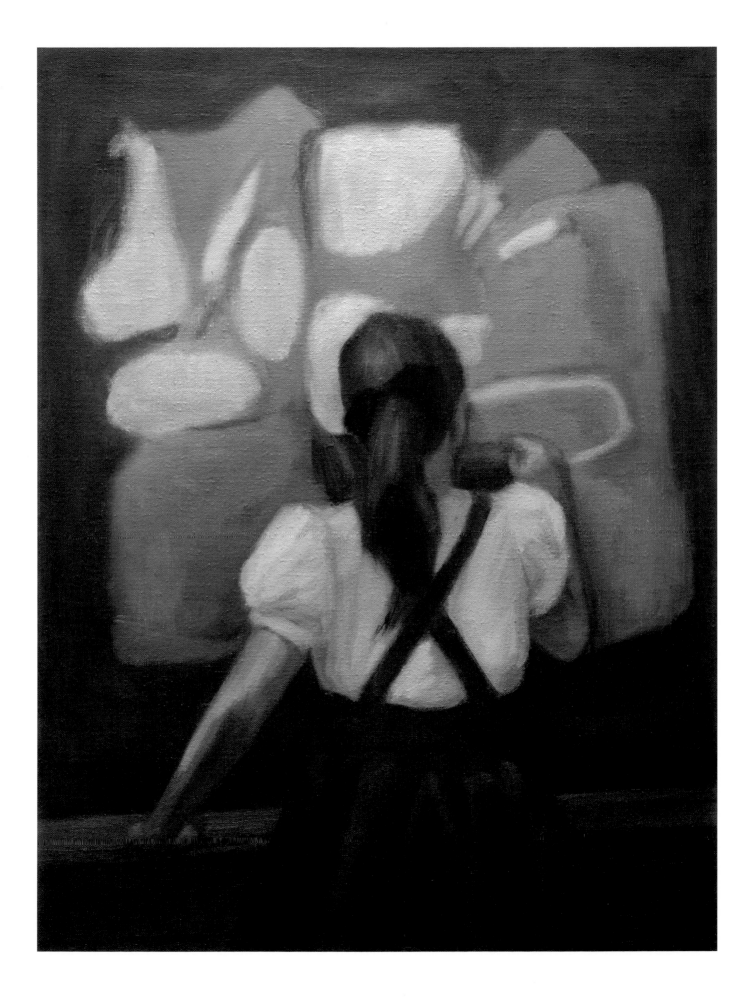

ABOVE
Battle After Uccello, 2013
Oil on canvas
182 × 320 cm / 71⅝ × 126 in.

OPPOSITE
Portrait, 2013
Watercolour on paper
130 × 114 cm / 51⅛ × 44⅞ in.

Uwe Wittwer

Wittwer has appropriated, questioned and fragmented found images for forty years. Working predominantly in watercolour or thin layers of oil, his paintings ask the viewer to question everything they know about everyday images. Using a diverse range of source materials including old photographs, postcards, Renaissance paintings and still lifes, Wittwer investigates the authenticity of the image. In *Battle After Uccello* (2013), for example – based on the Louvre's version of Paolo Uccello's *Battle of San Romano* (1440) – we see Wittwer including certain aspects of the original work, such as the vertical lances, but dialing down the rich tapestry of colour and detail that processes across the surface. In *Forest Stairs* (2013; page 50) he has worked from a found photograph, simplifying the strong sunlight

in the landscape scene into a fragmented flat surface marked by black watercolour strokes – a column for a tree, a slender triangle for an arm. His reduction of imagery is redolent of memory, when subjectivity and time distort or even alter original events, blurring faces and dissolving landscapes. The subsequent paintings have a sombre aura, as seen in *Portrait* (2013), the young smiling boy on the cusp of disappearing from view, the sepia outlines of his baggy trousers, his braces, his cowlick hair, so pale when contrasted to the three red explosions alongside him. Were these marks on the original photograph, a problem with processing perhaps? Or is Wittwer annihilating the figurative subject to return painting to its most abstract form?

Jan Vanriet

Vanriet's figures often appear as silhouettes or fragments, missing telltale details that would perhaps allow us to identify them, to see who they were, where they belonged. They appear as painted memories, half-remembered, or recurring dreams, the subject present and yet simultaneously distant, intangible, the context of their existence fragile and transient. Vanriet's parents met in the Mauthausen concentration camp during World War II and reflections on this period and its immediate aftermath have infused Vanriet's work for nearly two decades. In *Home Coming 1* (2012) a man in a grey suit, hair slicked back, sits in a chair behind a polished table. His pose appears confrontational, his stare penetrating, his features hardened against the world, sharpened by past events. The armchair speaks of a domestic setting, the lopsided antimacassar suggesting the disruption to family life caused by his absence (and return). Only his reflection alludes to the

young man he used to be, the shiny surface softening his harsh features as if offering an inner portrait of a man who has seen too much too young. Without knowing that this painting is based on a photograph of his mother's twin brother (who died shortly after the war), we can still sense the trauma of his past, smell his desperation. Painted a year later, *Bella* (2013) depicts a woman in a smart veiled hat. As if the visualization of a memory, her grey face appears clearly defined but her eyes are missing, no longer visible, and her floral jacket is reduced to sparse brushstrokes on a white ground. *Bella* is from the series 'Losing Face', and is based on a photograph of a World War II deportee from Dossin, a German assembly camp where Belgian Jews were held before being sent to concentration camps. All we are left with in this painting of her are fragments of a face half-remembered, half-realized, an identity lost to time, destroyed by circumstance.

OPPOSITE
Bella, 2013
Oil on canvas
80 × 60 cm / 31½ × 23⅝ in.

BELOW LEFT
Home Coming 1, 2012
Oil on canvas
150 × 110 cm / 59 × 43¼ in.

BELOW RIGHT
The Ceremony (singer), 2012
Oil on canvas
50 × 40 cm / 19⅝ × 15¾ in.

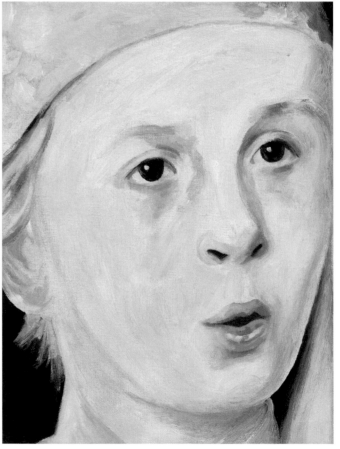

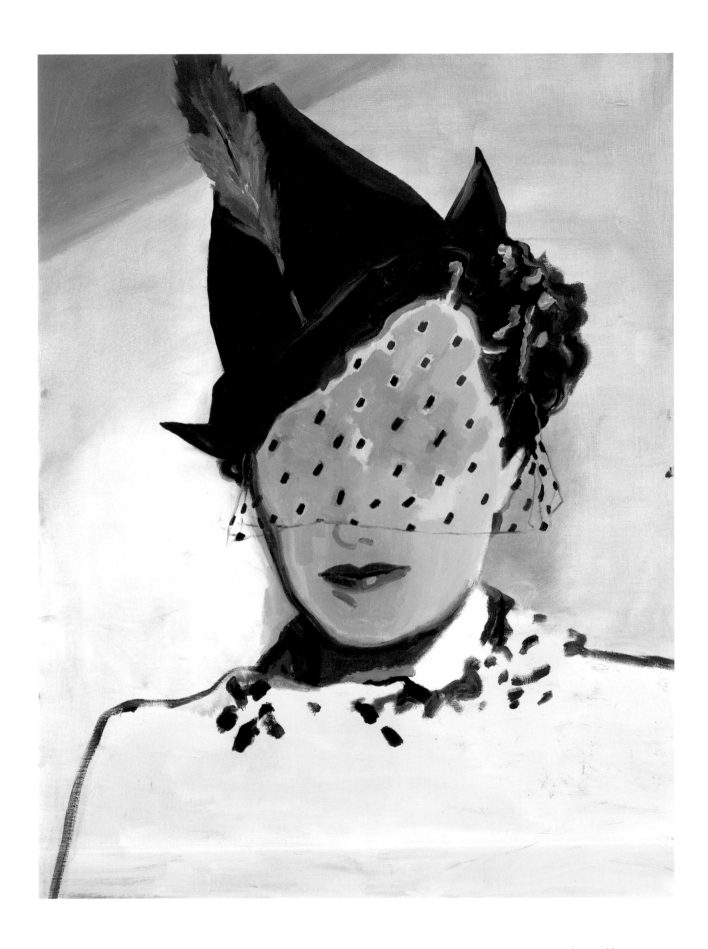

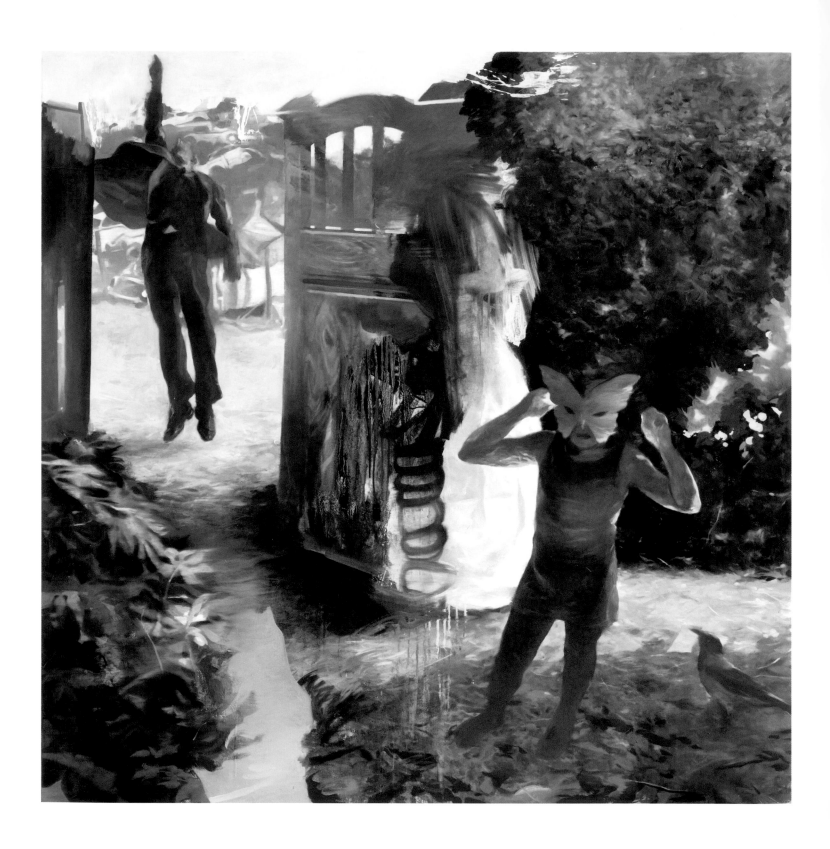

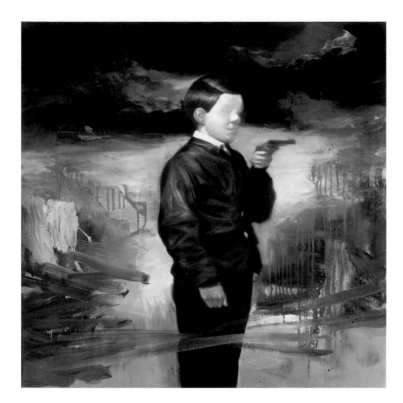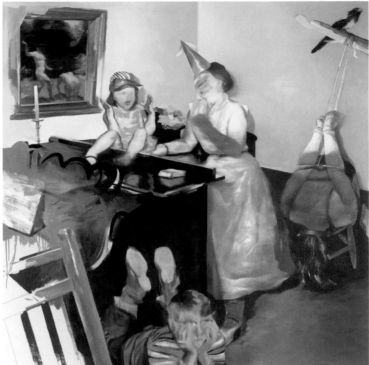

'I believe that fiction is very close to reality....Reality is evasive — you don't see it. I am not keen on documenting what I see in contemporary life. Everything in my paintings comes out of an experience — everything means something — but it has changed on the way.'

— Elling

Lars Elling

ABOVE LEFT
Falangist, 2012
Egg oil tempera on canvas
100 × 100 cm / 39⅜ × 39⅜ in.

ABOVE RIGHT
Mother's Day, 2010
Egg oil tempera on canvas
170 × 170 cm / 66⅞ × 66⅞ in.

OPPOSITE
Oppenheimer's Garden, 2010
Egg oil tempera on canvas
200 × 200 cm / 78¾ × 78¾ in.

The paintings of Elling appear like dreams, half-remembered family parties spliced together with everyday events and distant memories of childhood. But all too soon these dreams segue into nightmares, as dark narrative fragments cloud the atmosphere. In *Mother's Day* (2010) attention is quickly diverted from the satin dress and party hat of the faceless mother to the trussed figure behind her, the S&M couple in the painting on the back wall and the boy's eyes held shut as he lies under the piano, a blind witness. Elling's paintings — richly worked in tempera and oil — allow for multiple readings, the viewer's consciousness completing each suggestive tableau. Loss of sight in childhood is a recurring motif as in *Falangist* (2012), where a sightless pallid boy points a pistol at an unknown victim (or assailant). Children often feature in Elling's works and the threat of adolescence, of innocence lost, drifts through his paintings like fog at twilight, as in *Oppenheimer's Garden* (2010). Spectral and fantastical, frightening yet somehow beguiling, *Oppenheimer's Garden* asks us to step through the garden gate and enter the dreamscape. Will we ever return?

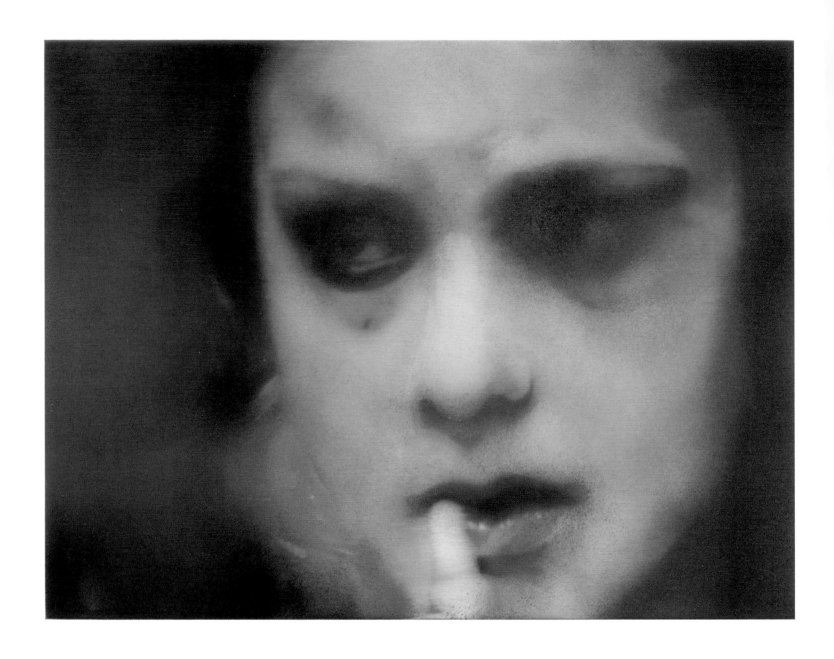

'For me the photographic image becomes more physical, more
personal, when it is translated into a painting. It may be more clear
in a way as well. But the reality of painting is not the reality of
daily life. The presence of painting is about a different reality.'

– Kahrs

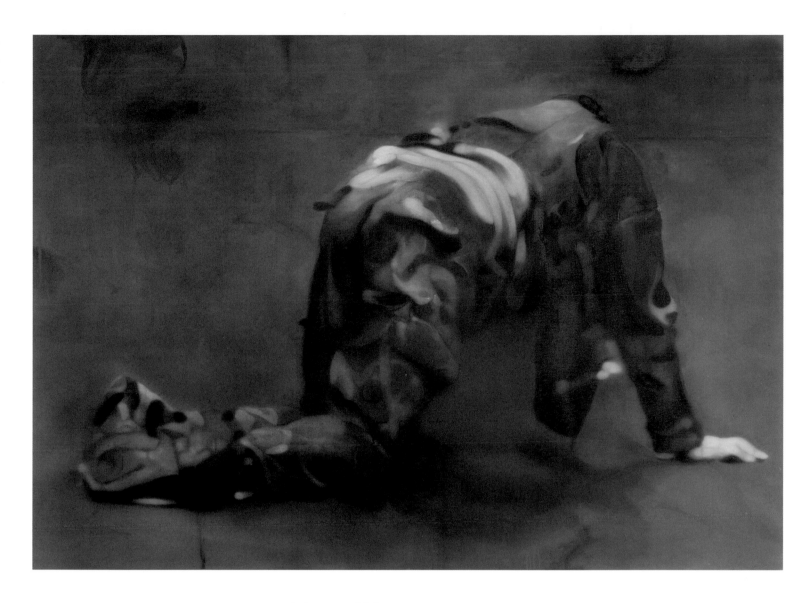

ABOVE
Untitled (man crawling 1), 2010
Oil on canvas
175 × 244 cm / 68⅞ × 96⅛ in.

OPPOSITE
Untitled (portrait mädchen mit lippenstift), 2011
Oil on canvas
47 × 61 cm / 18½ × 24 in.

Johannes Kahrs

Violence, or more accurately the effects of violence, permeate Kahrs's recent paintings. Faces and bodies are often cropped by the painting's edge, a further violation of the body, leaving the viewer to complete the figure. In *Untitled (portrait mädchen mit lippenstift)* (2011) the soft palette and sfumato brushstrokes that depict the woman's face are undermined by the purple bruising that engulfs her left eye. We see the after-effects of violence, imagining how she received the injury. It is a snatched moment between the violence of the act and the recovery of the victim, a charged atmosphere, when time momentarily stands still. *Untitled (man crawling 1* (2010) shows a man in a leather jacket and trainers dragging himself along the floor in what looks like a grey concrete room. We cannot see his head; it's as if this is painted from a covert image, from surveillance footage in a cell perhaps, or a spy camera. Something must have happened to him; we can feel his pain, his head down, shoulders tense, right arm extended to carry his weight, the slow shuffle of his legs. The purposeful angle of the figure directs us to a non-personal reading of violence and its victim – it could be us gasping for breath on all fours, trying to crawl away.

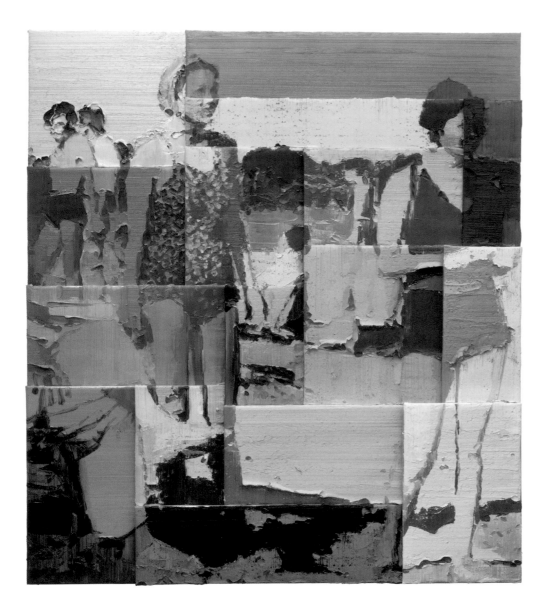

LEFT
Big Girls, 2013
Oil on aluminium panel
280 × 250 cm / 110¼ × 98⅜ in.

OPPOSITE
Marshal, 2011
Oil on aluminium panel
260 × 170 cm / 102⅜ × 66⅞ in.

Li Songsong

Li's paintings are clearly based on photographs, but each heavily impastoed surface now denies the indexicality of the original source image. Tessellated colours overlay each subject – men posing in uniform; women smiling on a beach – and further distance the viewer from the original photograph. Who are these women? Why is the man posing for the camera? They offer glimpses of China's history, memories that can no longer be conjured with any crispness or reliability. Li's palette is often compared to that of the analytical Cubism of Picasso and Braque – somber grisaille with the occasional muted rectangle of sage or rose or peach. But it is the Cubists' interest in perception, in the fourth dimension of looking at a subject over time,

that seems most pertinent. For Li uses paint to suggest the silted layers of time that now stand between us, the contemporary viewer, and the initial frozen moment of the found photograph. The past is gone, the paintings seem to say, and yet we cannot let go, even though we can no longer remember who we are looking at, what they are doing or why they were important.

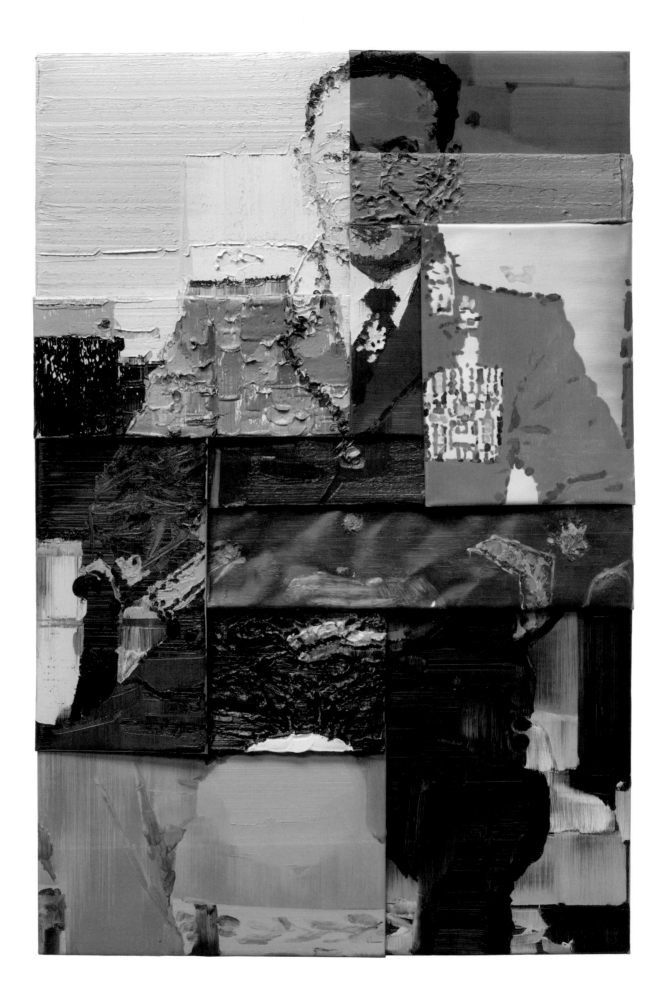

'Painting for me is a manifesto. I would like it to be read like a manifesto: both a manifesto of women's independence but also a manifesto of fashion and "utopian optimism", as a way of surviving the mediocrity of things.'

— Olowska

Paulina Olowska

Olowska is an artist, curator, performer and editor, but at the heart of her varied practice lies painting. Living and working in her native Poland, she responds to images from the country's modernist past when Soviet socialism dominated visual display, from advertising and magazines to signage and architecture. Olowska draws on Poland's communist past, reproducing old knitting patterns as modelled by peroxide blondes in *Wooly Jumpers* (2010), or recreating avant-garde salons with herself as the host. In a strand of her paintings she harks back to a time when female creativity was central to earlier Western art movements – Vanessa Bell and the Bloomsbury set, for example – and she celebrates the multiple and complex roles of women in painting, as subject, artist, model and muse. Coupled with female poses straight out of fashion magazines, Olowska brings the past into our present and asks us to consider it as something far more complex and gendered than the official history books suggest.

ABOVE
There's Nothing Not After Daisies, 2013
Oil on canvas
200 × 230 cm / 78¾ × 90¼ in.

OPPOSITE
Wooly Jumpers, 2010
Oil on canvas
175 × 125 cm / 68⅞ × 49¼ in.

ABOVE RIGHT
Hello, 2012
Oil on canvas
150 × 130 cm / 59 × 51⅛ in.

ABOVE LEFT
The Monument, 2010
Oil on linen
190 × 160 cm / 66 × 75 in.

OPPOSITE
Ghost (2), 2014
Oil and acrylic monoprint
on linen
100 × 92 cm / 39⅜ × 36¼ in.

'For me art is dramatic. I try to wring out emotions, to build disturbing images, because human history is made up of a series of extreme events that have contributed to our evolution. Art can reflect these things: events, atmosphere, the dark depths of humanity.'

– Suciu

Mircea Suciu

Suciu's canvases hark back to the grey days of communist Romania, the country in which he was born and still lives. Men in suits rifle through card indexes, searching for names (ours?) while telephones ring unanswered, and there's a bleakness, a sadness, to his near monochrome paintings. In *The Monument* (2010) twelve people appear to wait quietly in rows of four for something to happen. They are turned away from us, facing the wall. There's nothing to see; this regimented arrangement of figures does not seem a voluntary grouping, and Suciu's palette is, as always, muted and sombre. By 2012 his palette had reduced to grisaille, and his oils on canvas were joined by charcoal drawings. The uneasy atmosphere of post-war communism

was replaced by World War II subjects, the manhandling of fellow humans and the abuse of power. In the painting *Hello* (2012) a suited (Ayran?) man is on the telephone, unsmiling, listening. Or is he? There's no telephone flex, no connection to HQ. Even his suit appears less than credible, his hands sketchy. *Hello* represents a world breaking down, inhuman and cracked. The man in *Ghost (2)* (2014) can't bear it – turned to the wall with his head in a box he is purposefully oblivious to what is perpetrated in his name, voiceless and helpless.

'I watch a place and what happens in it. Often the space itself has a certain energy accounted for by the way in which the landscape itself is built....I always carry my camera with me in order to quickly capture an interesting scene; I am like a worker digging the same hole deeper, deeper and deeper.'

<div align="right">– Savu</div>

Serban Savu

Nothing much happens in Savu's paintings. Men unload a truck or play cards; people gather at a funeral or in front of a row of garages. In line with Courbet, who took as his realist subject the rural poor in the 1850s, Savu focuses on the industrial workforce in his native Romania, twenty-five years after the end of the Cold War. Despite the proliferation of capitalist must-haves in towns such as Cluj where he lives – shopping malls, neon signs – Savu's paintings imply nothing is that different from the communist years for most people. In his paintings the mise en scène plays out against a backdrop of communist-era apartment blocks and abandoned building projects, as in *The Card Players* (2011). Savu works from his own photographs, collaging elements together prior to painting. He often presents his scenes from elevated perspectives, as in *Pleasant Chat* (2010). This viewpoint replicates the historic imperial framing of landscape, the ownership of all captured by lens or brush. But who owns these Romanian streets and fields now? Certainly not the people in the paintings. They talk, play cards, pass time together until things finally, hopefully, change for the better.

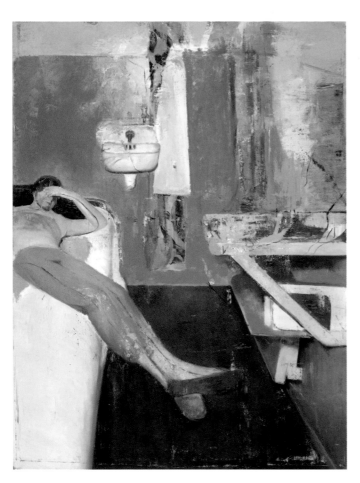

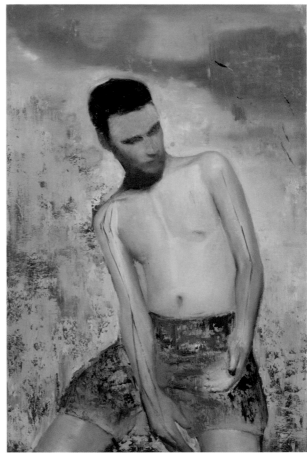

Alexander Tinei

In *Portrait of a young man* (2014) Tinei has painted a pale-skinned youth lost in his own thoughts. Naked to the waist, we can see thin blue lines like tattooed veins that run down his arms. He is hemmed in by the shallow ground that offers a partial illusion of depth while simultaneously pinning the eye to the surface, the paint scraped away across the lower section and the youth's shorts. In *What a dream* (2014) another young man is caught unawares by the viewer, his eyes downcast, his body presented at an awkward angle, self-absorbed. Again, his body appears scratched and scuffed, paint dragged over his elbow and nose, thin blue lines appearing and dissolving over his arm, his forehead. Tinei finds many of his source images on the internet and questions the boundaries between private photographs and the collective public gaze. He marks his figures, the blue tattoos a visible manifestation of lived experience and the memories that shape us. In other works Tinei draws on images from art history. *Hat* (2011; page 48) is a reworking of an iconic photograph of Joseph Beuys, staring out in his trademark felt trilby. Tinei masks him using the diamond pattern of the harlequin, disguising the artist-shaman and empowering his artistic freedom (a pertinent recurring motif by an artist born in the former Soviet state of Moldova). Artists from Watteau to Picasso have been drawn to the harlequin, a performer who operated on the fringes of society, free to entertain while hiding his own identity. The diamond configuration of the harlequin's costume makes frequent appearances in Tinei's work, appearing in the blue lines that vein the arms of his pale subjects. His figures 'perform' their own identities, as Beuys did, while occupying grey, windowless spaces on earth.

ABOVE LEFT
Long legs poet, 2014
Oil on canvas
200 × 150 cm / 78¾ × 59 in.

ABOVE RIGHT
Portrait of a young man, 2014
Oil on canvas
120 × 80 cm / 47¼ × 31½ in.

OPPOSITE
What a dream, 2014
Oil on canvas
50 × 60 cm / 19⅝ × 23⅝ in.

3.

Tom Hunter / Yue Minjun / Vik Muniz / Lisa Ruyter / Mickalene Thomas /
Kerry James Marshall / Kehinde Wiley / Nicole Eisenman / Kara Walker / Ged Quinn /
Wolfe von Lenkiewicz / Ryan Mosley / Ali Banisadr / Yun-Fei Ji / Mark Alexander

*The increased visibility of painting's history within contemporary art
practice, and the figurative continuum.*

Picturing History

Vik Muniz
*Wanderer above the Sea
of Media, after Caspar
David Friedrich* from
'Pictures of Magazines',
2011
Digital C-print
231.1 × 180.3 cm /
91 × 71 in.

Increasingly in figurative practice there is an openness, a pleasure even, in being
seen to embrace and connect to the millennia-old tradition of artists turning
to the figure for subject and inspiration. Artists such as Ged Quinn and Ryan
Mosley investigate Picasso's legacy, and the history of painting the figure in the
20th century seems to preoccupy many of the artists in this chapter. (There are
more than a few echoes of the work of Edward Hopper, Alex Katz and Andy
Warhol across the book as a whole.) The rigorous questioning of the image – both
photographic and painted – by Gerhard Richter, Sigmar Polke, Cady Noland, Luc
Tuymans and Richard Hamilton has inspired and influenced a whole generation of
artists across the world. You only need to look at the previous chapter to feel their
specific impact.

However, it is the direct referencing of particular works of art from history
that appears as a marked trend in the global contemporary art scene. Tom Hunter
stages photographic tableaux by following the composition of paintings by
Vermeer and Delacroix but using local tradespeople, students and exotic dancers
to stand in for the original models and shifting the context to contemporary
settings: bedsits, parkland, a local snooker hall. Renaissance paintings of Christ
by Piero della Francesca and Caravaggio have been appropriated recently by
Yue Minjun, who superimposed his iconic self-portrait 'laughing man' on these
familiar compositions. What happens when Christ has a rictus grin? Or is
Chinese? By appropriating Western masterpieces, accessible across the world
largely thanks to the internet, the iconography of the original painting is
transferred to the grinning man. Yue becomes Christ; his followers, the nearby
onlookers. Vik Muniz's recent series of historically inspired prints at first glance
appear to be faithful reproductions of masterpieces: *The Floorscrapers* by Gustave
Caillebotte (1875); Caspar David Friedrich's *Wanderer Above a Sea of Fog* (1818).
But look more closely and the images break down. Muniz collages hundreds
of photographic scraps to recreate these paintings, using fragments torn from
magazines and newspapers, and in doing so comments on the proliferation

81

of images available in the 21st century, and the cheapness and fickleness of reproducibility.

Both Yue and Muniz – from China and Brazil respectively – respond to the Western canon of art history, subverting it to their own ends. American artist Lisa Ruyter also responds to well-known historic images in her sleek, brightly coloured prints. For a recent series she used the Farm Security Administration archive as a starting point, taking Walker Evans's grainy black-and white images of dirt-poor farmers from the 1930s and reworking them in hot pinks and vivid greens. The subjects are transformed: pathos disappears and pin-ups are born. Despite maintaining fidelity to the line, the form, of each photograph, the addition of a new colour register significantly alters the reading of each image.

American artists Mickalene Thomas and Kerry James Marshall also use the Western canon as their starting point. Marshall considers the absence of black subjects (and artists) in art historical genres such as the nude, while Thomas replaces the white women in well-known paintings such as Manet's *Le déjeuner sur l'herbe* (1863) and Goya's *Clothed Maja* (1800–5) with black models. She questions the canon as a place of record (where women are largely white and naked) and rethinks history. In a similar vein to Thomas, although with less glitter and rhinestones, Kehinde Wiley also lifts iconic poses from the vaults of art history, asking his models to assume positions formerly created for nude women or martyred saints. In so doing he recasts the Three Graces, for example, as young north-African men. What does this translation say about our expectations, our understanding of art and its role in society? With a lighter touch, Nicole Eisenman pokes fun at gendered stereotypes in the art world – the nude as female; the artist as man; phallic totemic sculpture. Kara Walker chooses to subvert the 18th century aristocratic fashion for silhouettes, and instead uses the technique to stage unfiltered scenes from history: racial violence, exploitation and retribution. Working on a large scale – often over entire walls and galleries – her graphic figures confront all of us with a reminder of our ancestors' decisions and misguided beliefs.

Other artists take general inspiration from art history, rather than quoting individual compositions. Ged Quinn smashes together aesthetic tropes and motifs – a romantic sweep of a wooded bank; a sublime waterfall; a 19th-century Pre-Raphaelite champion; faceted Cubist planes that confront perception and time. Wolfe von Lenkiewicz also throws fragments of paintings and illustrations together in a frenzy, blending his ambitious range of references using a meticulous graphic style. Ryan Mosley's range is equally broad, but even less direct. Is that soft red ground meant to remind us of a Mark Rothko? Does that thick black band really reference Paul Gauguin's *Vision After the Sermon* (1888)? And is that the spirit of Picasso's harlequin I can see? Ali Banisadr's near-abstract canvases are infused with the spirit of Western art, from Brueghel to Titian, his licks of paint teeming over the surface in response to epic battles and religious triptychs, to Michelangelo's Sistine Chapel ceiling (1508–12) and *Last Judgement* (1536–41). They allude to the colours and sensations of old-master paintings without focusing on individual works.

Wolfe von Lenkiewicz
Oath, 2011
Pencil on Japanese
restoration paper
73 × 56 cm / 28¾ × 22 in.

Yun-Fei Ji takes the spirit of traditional Chinese landscape painting and injects it with recent history to contemporize it. His scrolls and paintings look as if they continue the long tradition of Chinese landscape painting as a place of escape, but as you start to read his works you realize they are full of displaced peoples, violent acts of nature, immigrants and the dispossessed. Mark Alexander, by contrast, creates slow and laborious copies of specific Western paintings – Caravaggio's *Narcissus* (1597–99), Millet's *Sower* (1850) – but leaches all the colour from their work. Using a range of encrusted brushstrokes, his recent paintings look as if they have been exhumed from the bog of art history rather than its walls. Commenting on the archaeological continuum of art making, Alexander's paintings look as old as time itself.

Tom Hunter

Hunter has used the subjects of old-master paintings as his springboard for the last twenty years, photographing painterly tableaux with all the precision of a Pre-Raphaelite. In *Hide and Seek* (2010) we see his response to Ingres's *Roger Freeing Angelica* (1819); in *Death of Coltelli* (2009) a young woman re-enacts the pose of a prone nude in Delacroix's *The Death of Sardanapalus* (1827). But while Ingres and Delacroix created fictitious surroundings for their naked women, Hunter uses his local environment of Hackney, East London, where he lives and works. Hackney is like many inner-city areas – both decaying and regenerating. It is always in flux, its buildings and parklands defined by the people who use them, who pass through arguing or kissing, dying or arriving. He brings a longevity to the lives

of Hackney locals, presenting them in large-scale photographs infused with the light of Vermeer. In 2011 Hunter worked with the Royal Shakespeare Company to retell *A Midsummer Night's Dream* in photographic tableaux and he drew his stars from a cast of Hackney pole dancers, musicians and pearly kings and queens. In *There sleeps Titania something of the night* (2011) it is a samba dancer, not a fairie queen, who reclines in her green bower, the play's verdant woodland replaced by the balding baize of a local snooker hall.

'While my subject has always been Hackney the influences behind my art practice are found in the work of Johannes Vermeer, the Pre-Raphaelites and latterly a whole raft of art historical paintings. While looking for a radical approach to my art I found revolutionary artists in the most traditional of art forms.'

— Hunter

LEFT
The Entombment, 2010
Oil on canvas
380 × 300 cm /
149⅝ × 118⅛ in.

OPPOSITE
The Baptism of Christ, 2010
Oil on canvas
450 × 300 cm /
177⅛ × 118⅛ in.

'I believe that there's a question of power for artists. They should have the right to paint themselves.'

– Yue

Yue Minjun

A laughing man has appeared repeatedly throughout Yue's work since the early 1990s, when he emerged as one of China's leading 'cynical realist' painters. Yue has always rejected artistic labels and refuses to be drawn on politics, but many of his large-scale paintings refer to the rapid changes China is undergoing, and its increasingly capitalist outlook. His 'laughing man' is a stylized self-portrait: eyes tightly shut, mouth wide open in a rictus grin. The man always appears to be laughing uncontrollably, despite being painted into narratives both dire and absurd: abandoned on a rocky outcrop with doppelgängers or facing a firing squad. Yue often draws on Western art history, rifling through its image banks and appropriating scenes. In *The Entombment* (2010) six pastel-coloured men re-enact Christ's removal from the cross as depicted by Caravaggio in 1603–4: Mary Magdalene's sorrow becomes a joke; even the dead Christ is in on it and laughs uncontrollably. Similarly, *The Baptism of Christ* (2010) is based on Piero della Francesca's tranquil and spiritual scene from 1448–50. Now it looks like a holiday snap from a stag weekend, the groom pushing his hands into a quick prayer position for the camera as a friend strips off ready to go for a swim in the lake behind. Culture, this suggests, is overwritten by capitalism; tourism and gloss replace spirituality and depth. But at what price?

'There isn't really a better way to know an artwork from
the past than trying to reproduce it yourself.'

– Muniz

Vik Muniz

All is not what it seems in the work of
Muniz. His prints are the photographic
endgame of carefully constructed collages
and arrangements, their subject matter often
appropriated from the work of other artists,
his materials scavenged from rubbish dumps
or junk stores. Muniz has used a wide range
of media to create his compositions, including
chocolate, dust, industrial waste, thread and
diamonds. For his recent series 'Pictures of
Magazines 2' he returned to making collages
of famous paintings from images torn out
of magazines. He meticulously remakes each
composition by collaging fragments from
advertisements and features and then enlarging
each collage photographically. Iconic paintings

such as Caspar David Friedrich's *Wanderer
Above the Sea of Fog* (1818; page 80) and Gustave
Caillebotte's *The Floor Scrapers* (1875) have
been transformed in this way into a chaotic
explosion of faces, material goods, textures
and words – the original scene decomposing
into a melange of ephemera as you draw near.
Muniz brings a degenerative modern twist to
collage, his material accumulations purposefully
transformed into slick digital prints – infinitely
reproducible yet lacking depth and substance,
a fitting metaphor for our internet age.

Lisa Ruyter

For a recent body of work, American artist Ruyter consulted the Farm Security Administration archive. The archive, established in 1937, employed photographers such as Walker Evans and Dorothea Lange to document the lives of struggling farmers during the Great Depression. The black-and-white photographs of individual sharecroppers such as Floyd Burroughs became icons of poverty. Ruyter's interest in these images stems from this initial fracturing of subject (Floyd Burroughs) and the material photograph. She is interested in how photographs live on, independent of their subject and their author. She has worked from fashion plates and found photographs in the past, but by taking iconic or well-known images such as those in the FSA archive she more clearly articulates her ongoing investigation into the relationship between moments in history, archival storage and the image as

representation. Working in a range of crisp, flat colours, from pastels to fluorescents, she explores how colour changes our reading of photographic images, even images that are lodged in our collective consciousness, such as Floyd Burroughs. In her painting *Walker Evans 'Floyd Burroughs, cotton sharecropper. Hale County, Alabama'* (2011) the man's weather-beaten face becomes pin-up smooth, his ripped shirt now freshly laundered in vivid pea green, matching his eyes and dungarees. These paintings explore the so-called 'authenticity' of image-making, transforming photographs through an aesthetic manipulation of colour. There is a linear indexicality between her acrylic paintings and source photographs, but the bright consumer colours she works with sap each photograph of its pathos, its gravitas, eviscerating dirt and poverty.

'There are traces of colour in history, but for the most part colour tends to escape, leaving only whatever it had been temporarily tied to.'

– Ruyter

LEFT
Dorothea Lange 'Destitute pea pickers in California. Mother of seven children. Age thirty-two. Nipomo, California', 2014
Relief print
113.8 × 84 cm / 44¾ × 33⅛ in.

OPPOSITE
Walker Evans 'Floyd Burroughs, cotton sharecropper. Hale County, Alabama', 2011
Acrylic on canvas
120 × 100 cm / 47¼ × 39⅜ in.

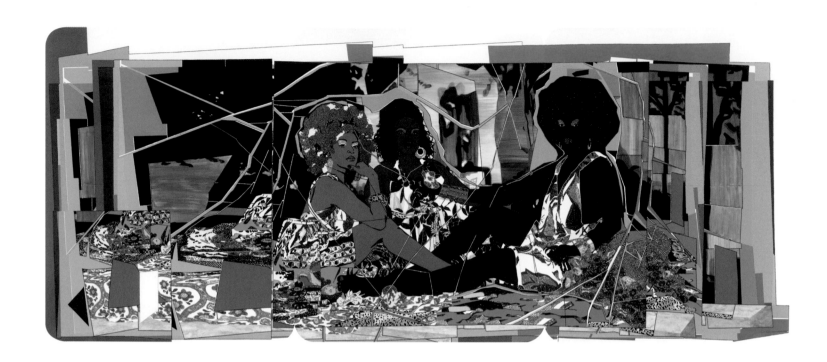

Mickalene Thomas

Thomas's paintings are overwhelming – large-scale multi-coloured rhinestone-encrusted reworkings of masterpieces such as Manet's *Le déjeuner sur l'herbe* (1863) and Courbet's *Origin of the World* (1866). Thomas's selection of historic source paintings is far from arbitrary – both Courbet and Manet's works were viewed as sexually provocative when first painted. Thomas appropriates the women in these paintings, recasting them using black models and transporting them to her own canvases, where fractals of vegetation, fabric patterns and crystals also vie for attention. These women, consequently, have to work. In *Le déjeuner sur l'herbe: Les Trois Femmes Noires* (2010) three clothed, life-size women look out, confronting the viewer's gaze. In *Portrait of*

Madame Mama Bush #1 (2010) Thomas borrows from Goya, taking inspiration from both his clothed and naked *Maja* (1797–1807). Thomas draws on art history to ask questions of female identity, sexuality and what or whom is or was considered beautiful. Recent works have included portraits of heavily made-up faces and glittering line drawings of braided hairstyles, an extension of how beauty is represented in advertising and the media's obsession with female 'perfection'.

ABOVE
Le déjeuner sur l'herbe: Les Trois Femmes Noires, 2010
Rhinestones, acrylic and enamel on wood panel
304.8 × 731.5 cm / 120 × 288 in.

OPPOSITE
Portrait of Madame Mama Bush #1, 2010
Rhinestones, acrylic and enamel on wood panel
213.4 × 274.3 cm / 84 × 108 in.

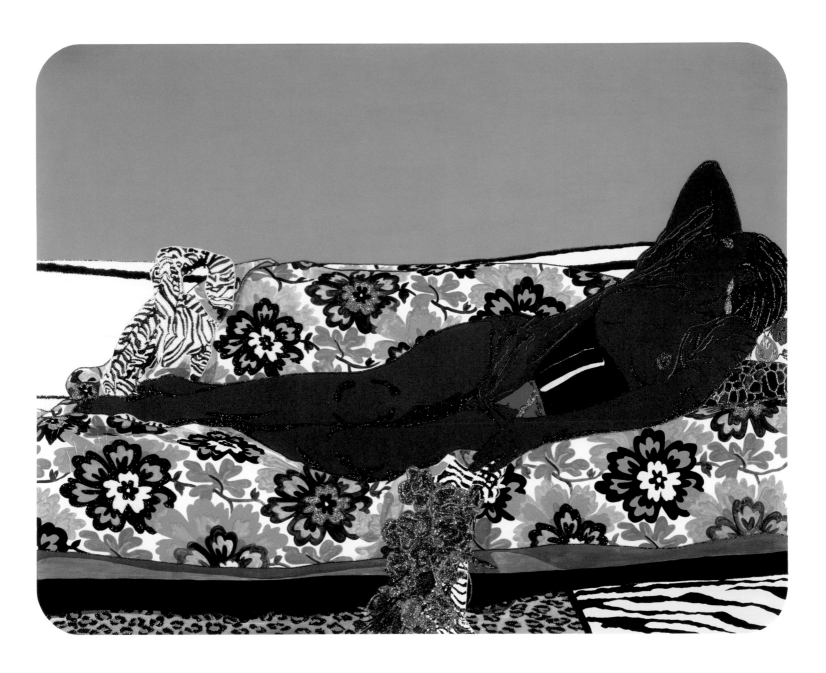

'Black women, for hundreds of years, have had to confront the idea of "beauty" and "what it means to be beautiful".'
— Thomas

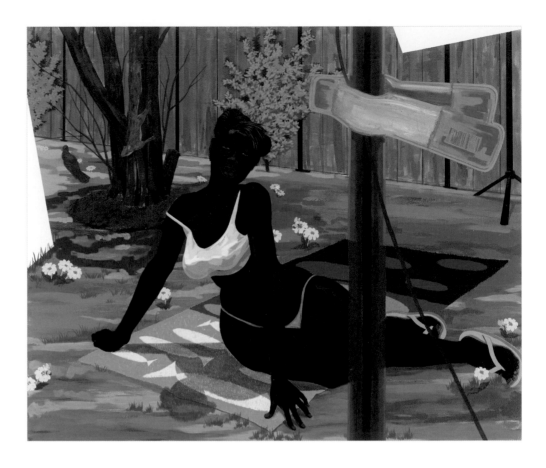

'It's virtually impossible not to be completely mesmerized by the art history that already exists: Leonardo, everyone. It's spectacular; you want to be in that club. But when you recognize your absence [as a black artist] in the pantheon you start to question what's the price of the ticket? Why are certain artists in and others not?'

– Marshall

Kerry James Marshall

Marshall's canvases are about what it means to paint, to be a painter, and in particular to be a black painter today. While he is concerned with looking and perception, nodding here to Vermeer and there to Manet, he is most interested in drawing our attention to the absence of black artists and subjects throughout art history. Marshall wants us to consider how history is written, constructed and painted by the dominant authority of the day, and he is keen to position black men and women as valid subjects for museum-quality paintings, giving them leading roles and increased visibility, rather than the more traditional role of marginalized or exotic black servant. In *Untitled (Pink Towel)* (2014) we see a lustrous pearl drop, similar to that in Vermeer's *Girl with a Pearl Earring* (1665), transplanted to a black woman's ear. She holds a pale towel against her bare skin as if to emphasize the contrast. In *Untitled (Beach Towel)* (2014) the motif of the reclining female nude that Manet commented upon in *Le déjeuner sur l'herbe* (1863) is updated once more. A black woman in G-string and bra poses on a beach towel like a centrefold, asserting her position as a viable subject. Marshall never loses sight of painting as a construct in itself, and each of his paintings has a visual device to create tension between the scene he paints and the canvas as a flat object. In *Untitled (Beach Towel)* (2014), for example, two white architectural facets protrude unexpectedly from the edges of the picture plane, their flatness and whiteness in marked contrast to the fleshy curves of the reclining woman. Marshall may have a point to prove, these seem to suggest, but his is a position like everyone else's, and painting is both real and unreal, just like the people and situations he paints.

Kehinde Wiley

ABOVE
The Three Graces, 2012
Oil on canvas
213.4 × 281.9 cm /
84 × 111 in.

OPPOSITE
Saint Paul, 2014
22K gold leaf and
oil on wood panel
101.6 × 61 × 5.1 cm /
40 × 24 × 2 in.

Wiley's decorative paintings of young men all look familiar. It is not the models we recognize – Sebastian, Eric, Toufiq – but the poses: the arm raised in a blessing, the open palm, the quizzically tilted head. Wiley derives all the poses for his paintings from art history, appropriating the coded gestures of saints, goddesses and emperors and reusing them. In *The Three Graces* (2012) Wiley asked North African men to assume the poses originally adopted by the naked women in Raphael's *Three Graces* (*c.* 1505). This Western ode to beauty and the female form has been transformed into a meeting of contemporary men, their loose jeans and T-shirts replacing the translucent wisps of faux-modesty, a wristwatch and friendship bracelets the stand-in for the women's coral jewelry. The pastoral landscape of the original has been replaced with a repeating floral pattern, tendrils of which extend over the surface, across the torsos of the men. In Wiley's version, the coded gestures of Western portraiture appear stilted, artificial, outmoded. As with *Saint Paul* (2014), *The Three Graces* enfranchises the young men in one sense, elevating them to the gallery wall, their larger-than-life painted portraits giving them a voice, a presence. And yet they have had to re-enact the poses of (white) Western saints and beauties. Who has the upper hand? Who is in control?

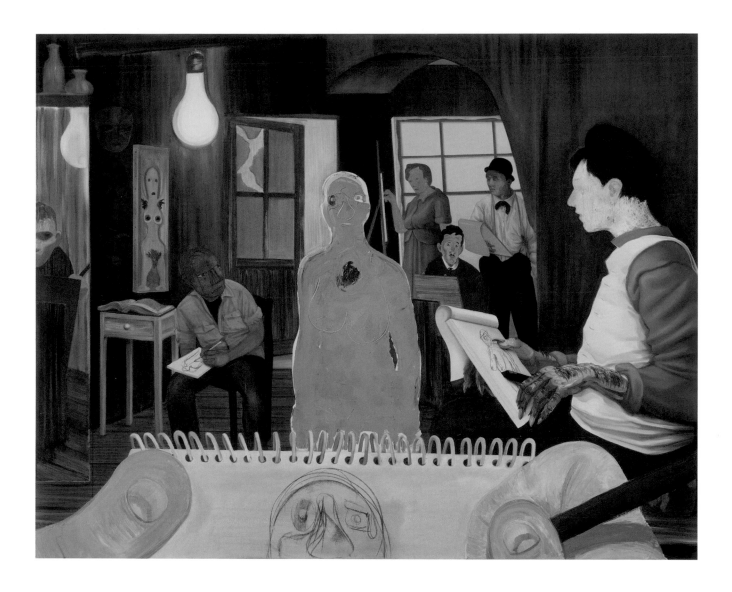

ABOVE
The Drawing Class, 2011
Oil and charcoal on canvas
165.1 × 208.2 cm / 65 × 82 in.

OPPOSITE
Guy Artist, 2011
Oil and collage on canvas
193 × 152.4 cm / 76 × 60 in.

Nicole Eisenman

A midnight séance, a glass of wine with a skeleton, life drawing in the round – Eisenman's expressive paintings are part diaristic, part art historic. They are as much about her life as an artist, one might say a female artist, as they are about what it is to make a painting. The figure at the centre of *The Drawing Class* (2011) is the colour of a Tom Wesselmann peach-melba nude, but the body appears lumpen and almost featureless. Eisenman draws on a wide range of art historical sources to bolster her scenes – Munch, the German expressionists, modernist sculpture and their African source material. In *The Drawing Class* various parodies of male artists like *Guy Artist* (2011) try to get to grips with the female form before them. This painting asks us to question the presentation of the nude

– the painting of the hirsute naked figure on the wall and the masks leering out like extras from Ensor's studio suggest we shouldn't judge people (or paintings) by their idealized covers.

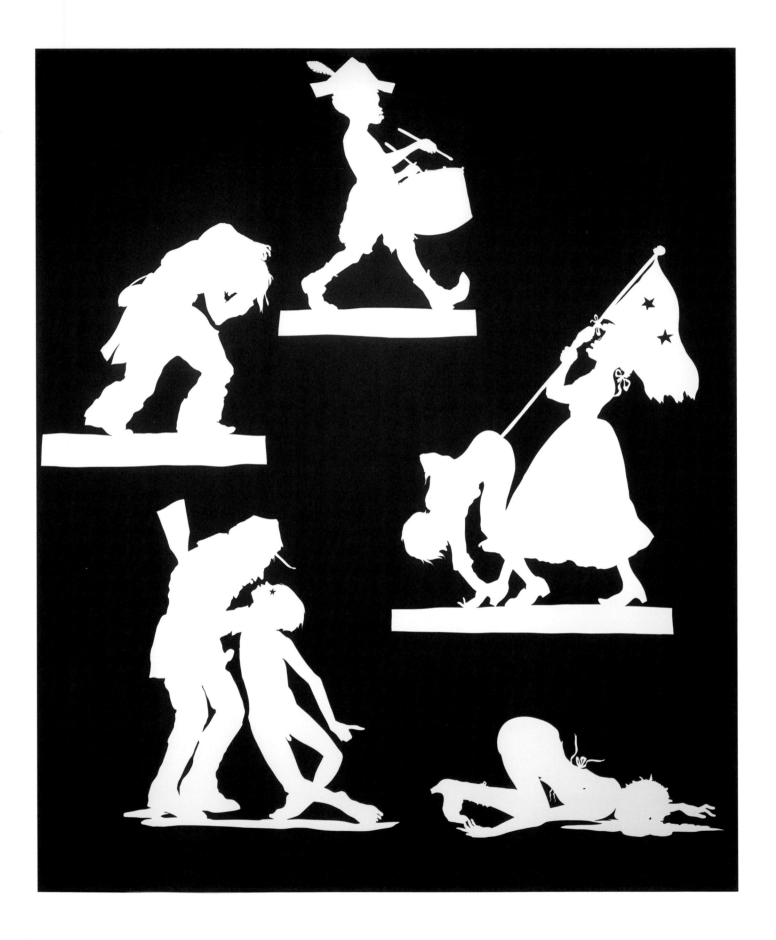

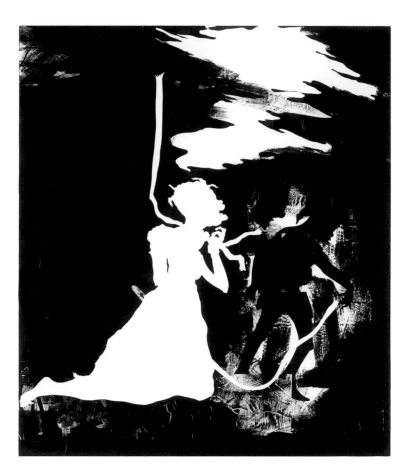

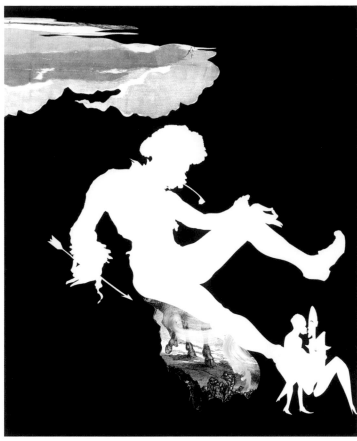

ABOVE LEFT
*10 Year Massacre
(and its Retelling) #3*, 2009
Mixed media, cut paper and
acrylic on gessoed panel
213.4 × 182.9 cm / 84 × 72 in.

ABOVE RIGHT
Untitled, 2009
Cut paper and collage on paper
97.8 × 78.7 cm / 38½ × 31 in.

OPPOSITE
Wall Sampler 1, 2013
Cut paper on latex paint on wall
Installation dimensions variable,
c. 427 × 358 cm / 168 × 141 in.

Kara Walker

Intricate black card cutouts covered the walls
of Walker's 2013 exhibition at the Camden
Arts Centre in London. The cutouts are her
signature style, large-scale 'wall samplers'
based on the 18th-century fashion for society
silhouettes. Her samplers also reflect society, but
the darker side of America's past: slavery, sexual
exploitation and ongoing violence meted out
on black Americans. Using the nomenclature
of folksy American cross-stitch embroideries,
the 'samplers' include caricatures of black
women and children from history, and depict
sexual violence and warfare. In all her work –
her cutouts, drawings, films and installations –
she explores the racial history of America, from
the exploitation of slaves on Caribbean sugar
plantations (as in her site-specific installation
in Brooklyn, *A Subtlety*, 2014) to Barack Obama.

She doesn't want people to feel comfortable
looking at her art, but rather wants them to feel
'queasy' as they confront their past. Often she
seduces viewers through the media she employs
– the filigree details of the silhouettes for
example – and it is only when you draw close do
you slowly realize what you are looking at: a US
flagpole rammed into a supine form; a caricature
of a black drummer boy; a lynching. The 18th-
century style is categorically black and white –
Walker's art makes us see the repercussions
of our shared historic colour-biased society.

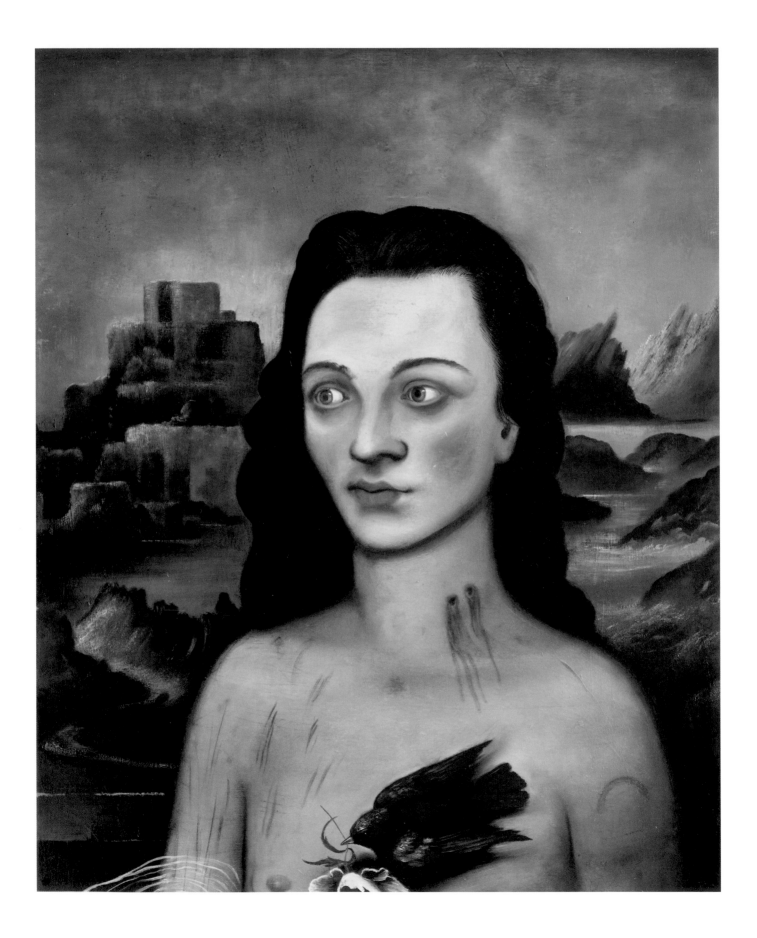

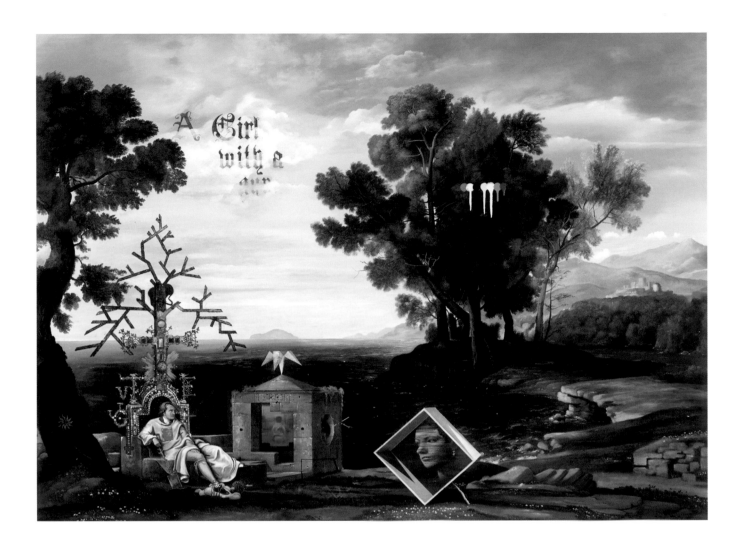

ABOVE
*To Burn The Fleece
of a Grazing Cloud*, 2013
Oil on linen
200 × 274 cm / 78¾ × 107⅞ in.

OPPOSITE
The Time of Distinctions, 2011
Oil on linen
61.5 × 49.5 × 3.5 cm /
24 × 19½ × ⅜ in.

Ged Quinn

Leonardo, Picasso, Poussin, Claude – no artist's work is off limits to Quinn. He relentlessly samples from history, splicing together Dutch landscapes with 19th-century portraits and abstract colour bars, turning Hitler into an 18th-century boy in a dress and mashing together Renaissance backdrops with bullet-ridden nudes. As if despairing of the modernist journey towards abstraction and tiring of the postmodern fragmentation of the recent past, Quinn takes inspiration from earlier centuries for his scenes. His is an exercise in looking – journeying to the sfumato mountains of Leonardo's *Mona Lisa* (1503–6) in *The Time of Distinctions* (2011), hiking into Friedrich's bleak pine forests in *Falling and Being Thrown* (2011), taking a serpentine path through the picturesque in *To Burn The Fleece of a Grazing Cloud* (2013). He explores how these artists constructed their windows on the world, how they turned the earth into landscape, people into portraits. He then populates such places with figures from history – John Ruskin and Friedrich in *Falling and Being Thrown*, Goethe enthroned in *To Burn The Fleece of a Grazing Cloud*. With further references to Martin Luther King, Andrei Tarkovsky, Jean-Luc Godard and Dutch still life colliding in recent paintings, Quinn's cacophony of references offer a 21st-century overload of art history's perspectival tricks and obsessions.

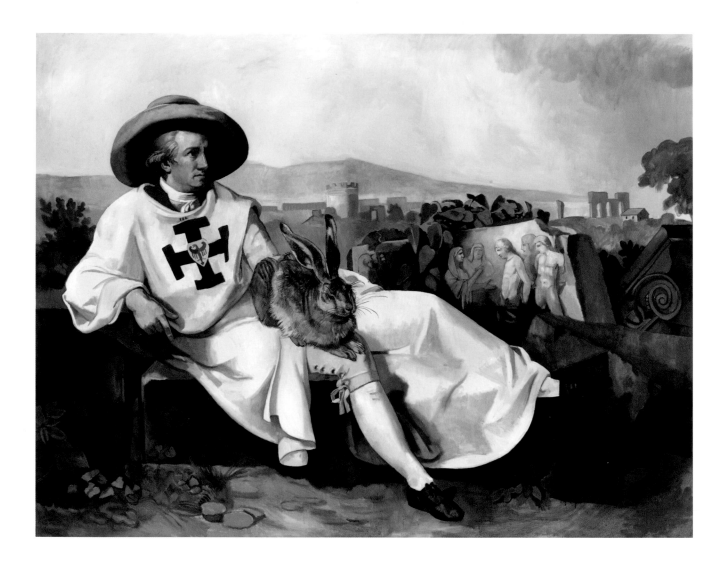

Wolfe von Lenkiewicz

What is originality in art? Where are the
boundaries between art and illustration? Are
there any? Should there be any? These are just
some of the questions that Von Lenkiewicz
addresses in his wide-ranging oeuvre. He splices
together characters and motifs from books,
paintings and prints and sees what happens.
So Lewis Carroll's Alice may find herself talking
to the drug-addled caterpillar while sitting
in Francis Bacon's Pope throne or Albrecht
Dürer's hare might perch on the lap of Johann
Tischbein's Goethe as history unravels behind
them, as in *Beast and Sovereign* (2011). In *Oath*
(2011; page 83), Carroll's white rabbit asks
the Horatii brothers to swear their allegiance
to Rome (it is their father who demands they
take the oath in Jacques-Louis David's version
of the tale). Carroll's Alice is a source of
fascination for Von Lenkiewicz; her mercurial

and dreamlike existence giving her a visual
freedom that he uses to full effect: in *Drink Me*
(2011), for example, the potion transforms her
into a Cubist Alice. As the son and grandson
of professional artists, Von Lenkiewicz never
questioned whether or not he would become an
artist. But through his paintings and drawings
he continues to explore what it is to be an
original artist in the 21st century, drawing
on the work of his predecessors to do so.

ABOVE
Goethe, 2011
Oil on canvas
182 × 232 cm / 71⅝ × 91⅜ in.

OPPOSITE
Drink Me, 2011
Oil on canvas
210 × 160 cm / 82⅝ × 63 in.

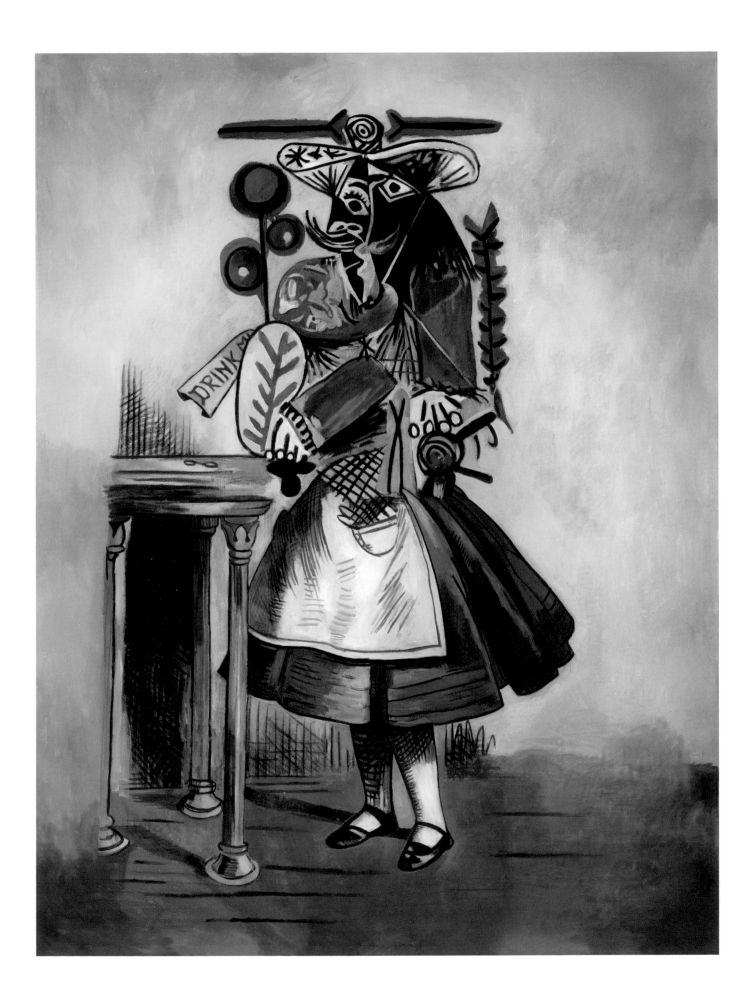

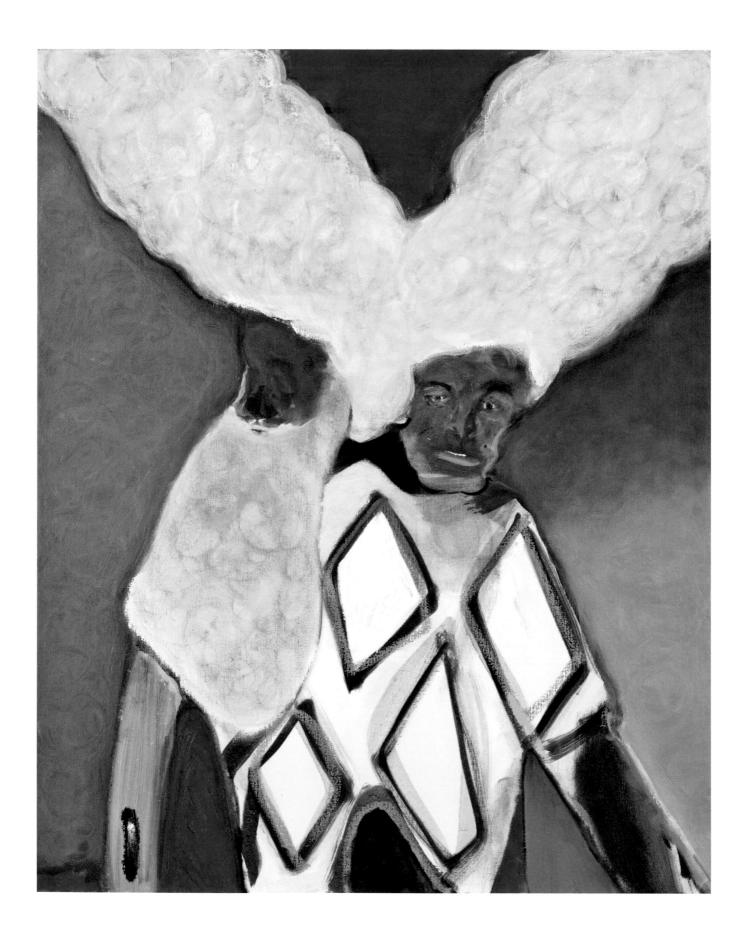

ABOVE LEFT
Smoking Pilgrimage, 2014
Oil on canvas backed with sailcloth
215 × 145 cm / 84⅝ × 57 in.

ABOVE RIGHT
Insinuation, 2014
Oil on canvas
65 × 55 cm / 25⅝ × 21⅝ in.

OPPOSITE
Headswill, 2014
Oil on linen
100 × 80 cm / 39⅜ × 31½ in.

Ryan Mosley

Mosley's characters come to life as he paints; fictitious worlds developing around them, contributing to their presence, their pathos, yet refusing to offer a clear narrative structure. While Picasso is often cited in reference to Mosley's work – the recurring harlequin motif a clear nod – his recent work shows the depth of feeling and knowledge Mosley draws from a wide range of modern art. In *Insinuation* (2014) the blue-green flare of gaslight illuminates the central character, the flat outlines of the faces a purposeful rethinking of Henri Toulouse-Lautrec's cabaret posters. In *Smoking Pilgrimage* (2014), Courbet's self-portrait from *The Meeting* (1854) has taken leave of his patron and hiked into Mosley's cloisonné riff on Gauguin's *Vision*

After the Sermon (1888). Far from detracting from his own ability as a painter, Mosley's deep knowledge of artists' styles and subjects from Courbet to Picasso – as well as Mark Rothko and Kenneth Noland in works such as *Headswill* (2014) – show his commitment to painting and his exploration of what contemporary painting can and should be.

Ali Banisadr

Born in Tehran, Banisadr spent his early years witnessing the Iran–Iraq war first-hand. His family was forced to flee to America, from where he now paints large-format responses to his childhood memories. But Banisadr's paintings are far from a literal depiction of living in a war zone. Rather, they epitomize the heightened senses experienced when the body has to decide to fight or take flight. In his paintings, which hover between figuration and abstraction, we feel the noise, confusion, excitement and terror of battle. From afar, Banisadr's paintings hint at figurative subject matter, reminiscent of Renaissance masterpieces or Futurist statements. In *Parsifal* (2012) it is as if we are witnessing a cloud of frenzied beings

migrate from Bosch's *Garden of Earthly Delights* (1503–4), and in *The Devil* (2012) there's more than a hint of a bacchanalian set-to by Poussin or Titian in those accents of red and blue, the fleshy pink licks. These hints never coalesce into subject matter; they remain marks that dart and fly over his brightly coloured surfaces. The paint refuses to keep still, whipped into energetic vortices of colour, sound almost, as if we can hear the paint enacting battles both modern and ancient. War, it seems to say, is an inevitable part of the human condition.

OPPOSITE
Parsifal, 2012
Oil on linen
152.4 × 182.9 cm / 60 × 72 in.

BELOW LEFT
All the Hemispheres, 2013
Oil on linen
122 × 122 cm / 48 × 48 in.

BELOW RIGHT
The Devil, 2012
Oil on linen
40.6 × 40.6 cm / 16 × 16 in.

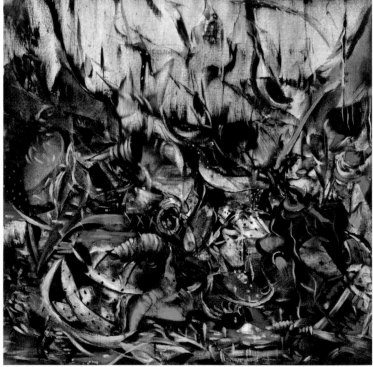

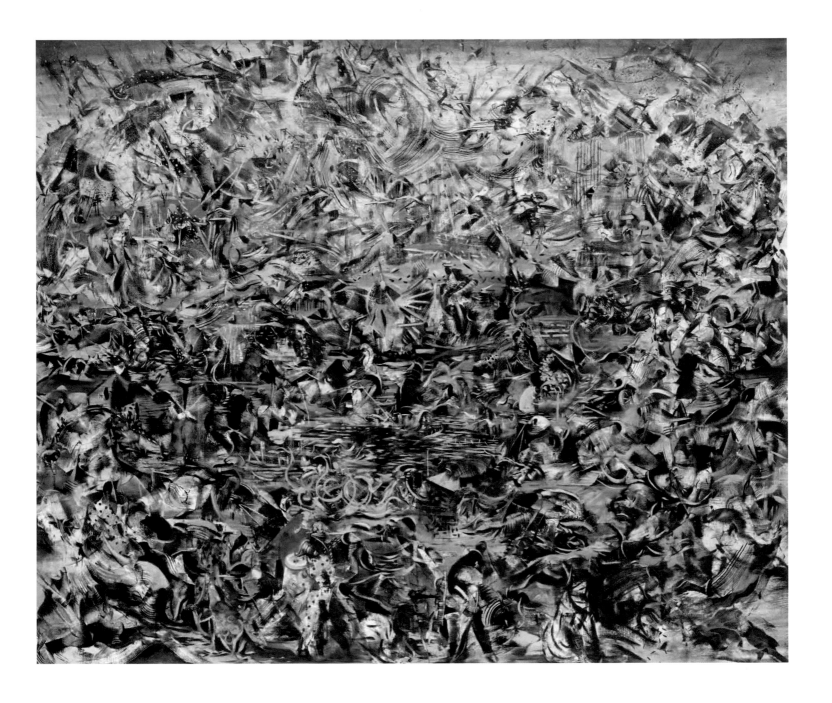

'*When you are looking up to artists like Goya, Michelangelo, Velázquez and Bosch, for example, you realize that you have a long way to go and may never even reach close to what these artists reached in their time. Painting is a slow process; it takes time to get there, you learn little by little and always want the next painting to be better than the last.*'

– Banisadr

'I start my work with many small drawings in pencil. I have them all on the studio wall, hundreds of them; I live with them. I start to work on my painting when I really want to see something in paint.'

– Ji

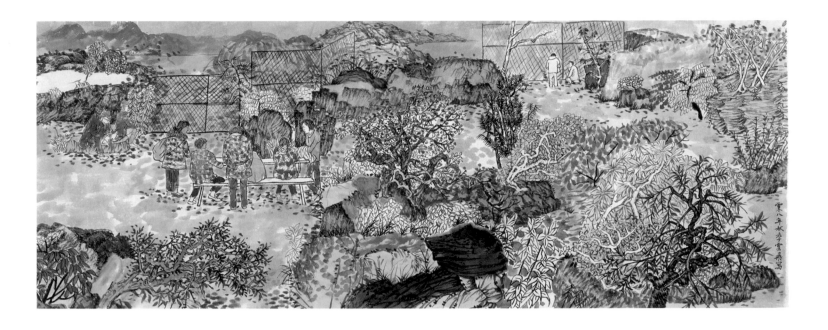

Yun-Fei Ji

Ji paints landscapes in the time-honoured tradition of Chinese scroll painting. However, there is nothing traditional about his drawings, prints and paintings. Born in China but living in America, he responds to both manmade and natural disasters and draws his subject matter from the inability of governments to cope with human displacement and anguish. His artist's book *The Three Gorges Dam Migration* (2009) was based on visits to the area surrounding China's vast hydroelectrical project and witnessing the abandoned towns and forced migration of its inhabitants for himself. The resulting scroll, commissioned by the Museum of Modern Art in New York and printed in China using 500 individual woodblocks,

tells the story of those migrants. Other works have captured the devastation caused by Hurricane Katrina, and he has also retold aspects of the 1900 Boxer Rebellion. Ji chose to work in this style to lull people into a particular sense of expectation in his work. He notes that traditionally Chinese people gazed at landscape paintings to escape their everyday life and consider their place in the world; they were places of visual refuge. Now, in his paintings and prints, they depict refugees fleeing natural disasters and the follies of man's capitalist ambitions.

ABOVE
All Watched Over By Machines Of Infinite Loving Grace, 2011
Oil on canvas
Central part: 110 × 100 cm / 43¼ × 39⅜ in.; left and right parts: 110 × 45.2 cm / 43¼ × 17¾ in.

OPPOSITE
Sower, 2012
Oil on canvas
81.4 × 65.2 cm / 32 × 25⅝ in.

Mark Alexander

Alexander is ambitious. He wants his paintings to speak of man's place in the universe, and of the cycles of the earth. In a recent series, 'Ground and Unground', he drew on ancient rituals, millennia-old corpses and historical masterpieces to highlight this continuum. In *Sower* (2012), *Narcissus* (2012) and *Hands* (2012) he appropriated paintings by Millet, Caravaggio and Dürer. Alexander reinterpreted Millet's familiar peasant in *Sower* so that the entire work looks as if it has been pulled from a peat bog, an organic layer of earthy tones encrusting the surface. Alexander used to hunt for iron-age tools as a boy, and has long been interested in the naturally preserved ancient bodies pulled from bogs in the 20th century, such as the 2,000-year-old Lindow Man. In *Sower*

it is as if the painting itself has been extracted, commenting perhaps on the contribution artists have made in refracting the human condition since the Stone Age. Alexander takes months to complete each canvas, slowing painting down until it becomes connected to the earth's cycles. In other works, based on Bosch's *Garden of Earthly Delights* (1503–4) and Van Gogh's *Dr Gachet* (1890), we see a similar fascination with the body's fleshiness and its ability to die and decay, dust to dust.

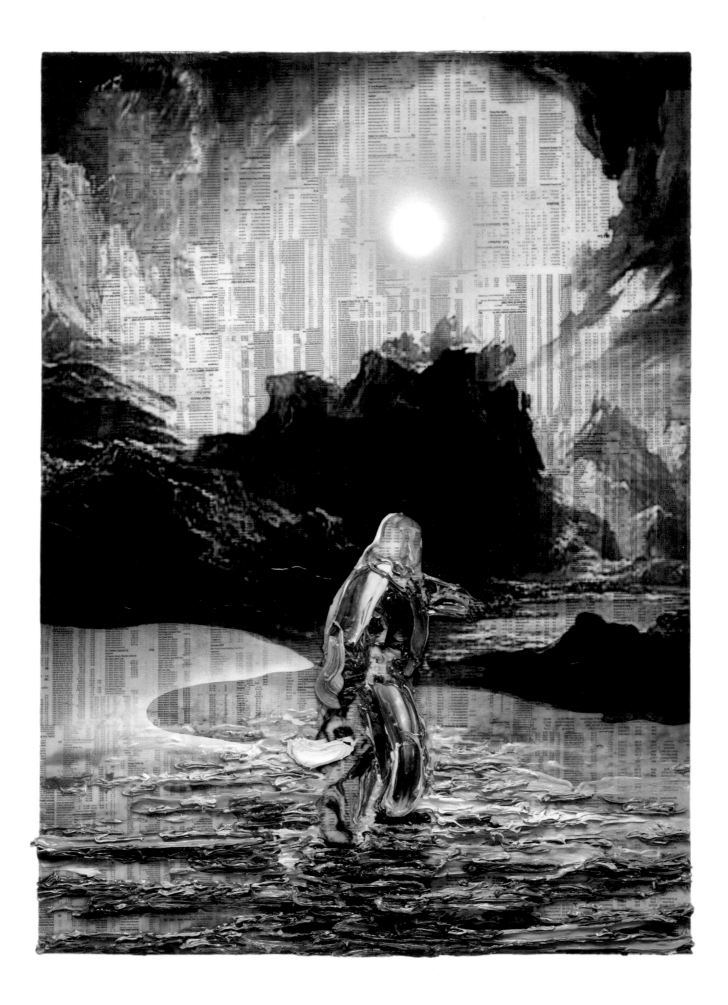

4.

The role of the figure in the creation of parallel universes and impossible situations.

Parallel Worlds

Gordon Cheung
Wanderer, 2014
Newspaper stock listings,
archival inkjet and acrylic on sailcloth
77 × 55 cm / 30⅜ × 21⅝ in.

Superstring theory has been around in theoretical physics for decades, and slowly filtered into the wider public consciousness as the millennium loomed. The theory suggests that there are eleven dimensions in the universe, not the standard three, and that in all probability there are other versions of earth and the human race out there, perhaps not more than a millimetre from us right now. If that blows your mind, some of the works in this chapter may do the same, for all the artists in it supplant the real with the fictive, creating imaginary environments or dreamscapes, parallel worlds for their figures to exist in.

For the last decade Charles Avery has been recording the lives of his 'Islanders', who inhabit their own fictitious island. Most recently Avery staged an exhibition at the island's Museum of Art, 'filling' the white-walled galleries with iconic pieces of Western art selected by curator Tom Morton. Avery's drawings were then exhibited in a gallery in London in 2013, and explored questions of being and reality. Real artworks – by Bridget Riley, Jeff Koons, Barbara Hepworth, Marina Abramović and others – became part of Avery's own exhibition, drawn as being viewed by fictitious people on an island that doesn't exist. Does our observation of the drawings legitimize the exhibition, and make it real?

While Avery is fond of depicting his Islanders gutting vast buckets of eels or propping up bars, he also ensures they have access to culture, transportation, food. Theirs is a strange world, but not a dystopic one. Jia Aili's vast canvases of destroyed forests or crumbling cities, on the other hand, appear to offer a far bleaker vision of humanity. And yet, just as they begin to sap us of all hope, we notice a lone figure climbing over the rubble. Jia calls these figures 'seekers', and sends them out across his landscapes, seeking out a future (resurrection?) in the ruins of the recent past. In Nigel Cooke's paintings, all hope does indeed seem lost. High-school dropouts and stoners are attacked by the paint itself, which has been whipped up into energetic vortices of destruction. Grey-black tornadoes fuel electric storms; bathers are swallowed by jungle vegetation; huge skulls leer down at inconsequential mankind.

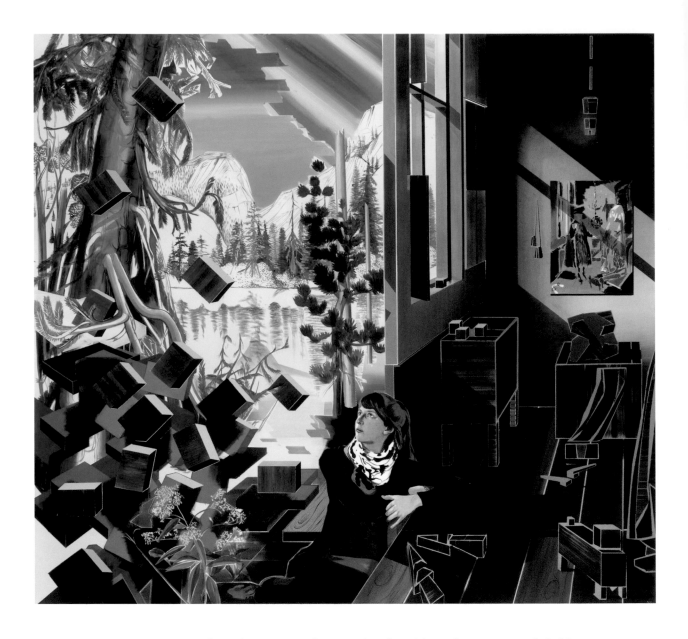

Gordon Cheung's cowboys and rodeo riders also appear to inhabit a dystopic world: buildings melt in heat hazes, stocks and shares fall like rain under a psychedelic aurora borealis. Cheung calls his style 'techno-sublime', and apocalyptic skies certainly threaten to overwhelm his riders, who glow with thermo-nuclear intensity. In the past, Stephen Bush has similarly loaded his canvases with saturated colour, his wooden hermit shacks overcome by arcs of acid yellow, tartrazine orange, candy-floss pink. But increasingly he uses a monochrome palette, and a hallucinogenic violet now delineates clouds, buildings, costumed figures, vehicles. Bush often features modernist buildings in his compositions, as does Marius Bercea. The buildings become a metaphor for a failed utopia, the futility of linear progress. In Bercea's paintings they appear as focal points for people who gather around them as skies grow yellow and the paint begins to erode the landscape, to eat into the figures.

OPPOSITE
Susanne Kühn
Green – the Arnolfinis, 2011
Acrylic on canvas
220 × 240 cm / 86⅝ × 94¼ in.

The melancholy landscapes of Nik Christensen share affinities with Bush's reduced palette and the drama of Jia's cinematic vistas. Working solely in black ink on white paper, Christensen records lone shamen in bat-infested forests and cultish gatherings of unknown tribes. Are we catching sight of a lunar sect, perhaps, or a closed order? Each drawing is as if a flashbulb has just exploded – enough to illuminate figures, mountains, palm fronds and water for a moment but not enough for us to work out what is happening, or to identify those we have glimpsed momentarily.

Masks, strange symbols, ley lines, auras – all make repeated appearances in this chapter. In Christopher Orr's paintings figures appropriated from old magazines are subjected to laser divination and soothsaying, while Paul Johnson tries to communicate the aura of creativity in his painstaking paper cutouts. Carla Busutill hides the identity of her brightly coloured figures, cloaking them in ermine, adding wigs or rudimentary masks, creating scenarios whereby they have to fight to survive in a world that is driven by ritual and tribal affiliation.

Other artists in this chapter take us into dream worlds. Dreams are our own personal parallel universes that blur lived experiences and memories with fantastical scenarios and strong emotions such as fear or love. Tilo Baumgärtel's street scenes give off a green glow of radiation, while dolphins jump in moonlit pools and kitchen lights illuminate the penumbra of academia. Ruprecht von Kaufmann's figures also occupy the shadowy world of R.E.M., their faces indistinct, eyes and mouths scratched out or mutilated. Lowering skies, mists and fog, walls of water – nature works against them, leaching Von Kaufmann's scenes of colour, of clarity. Baumgärtel and Von Kaufmann's settings are eerie and creepy, not places to linger. Simone Haack's twilit scenes are similarly disturbing, with doppelgängers staring out from isolated clearings or abandoned paths and twins playing 'hot potato' with a burning firework. By contrast, Annelies Štrba's scenes are romantic, melancholic, multi-layered landscapes of female reverie. The women and girls in Štrba's photographs appear to inhabit closed dreamscapes, layers of natural imagery – leaves, trees – overlaid on their sleeping or reclining forms.

Susanne Kühn also paints images of women alone in the forest as they attempt to commune with eagles and wildlife. But urban weeds sprout under the women's feet and threaten the rural idyll. Kühn also moves her female protagonists inside, painting them into constructions of interiors that wouldn't stand unaided, challenging the viewer to make sense of all the different facets and picture planes, to question what is real. While Kühn samples from the real world to create her complex splicings of architecture, nature and the figure, Kaoru Usukubo's pared-down world seems to be wholly virtual. Alabaster children with improbable hairstyles appear against airbrushed skies, holding origami shapes or adorned with oversized paper flowers. It's a strange world(s).

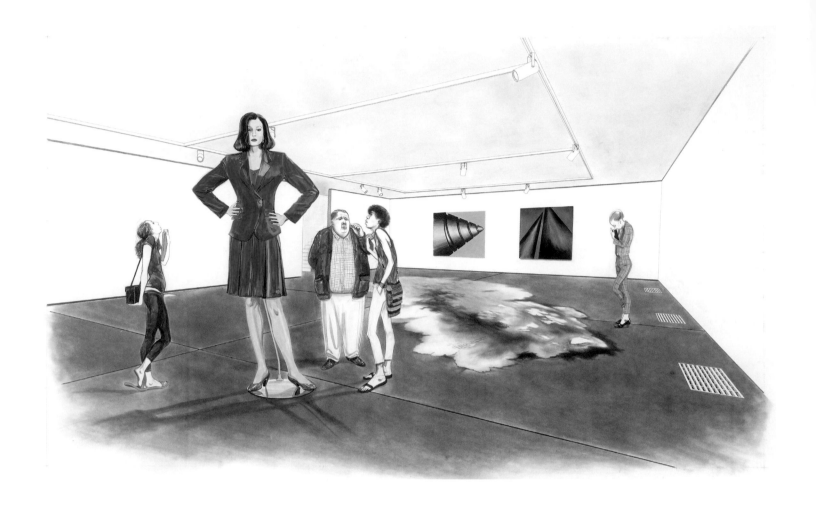

'The land can never reveal its totality, but I can produce a detailed enough survey that will compel others to explore that world on their own terms. Every day my knowledge of the place becomes more detailed, and the better it becomes the more time I spend there. I am sure I will end up retiring there…'

– Avery

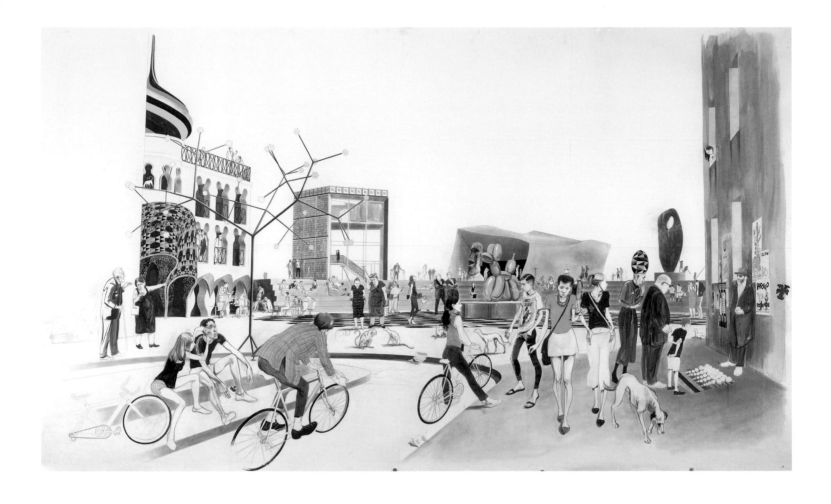

ABOVE
Untitled (View of the MoAO from the direction of Place de la Revolution with Hammons, Hepworth, Koons, Unknown Easter Island Artist), 2012
Pencil, ink, acrylic and gouache on paper
Framed: 260 × 420 × 10.2 cm / 102⅜ × 165⅜ × 4 in.

OPPOSITE
Untitled (It Means It Means; Hiorns, Lozano, Ray), 2013
Pencil, ink, acrylic and gouache on paper
Framed: 122 × 189 × 8 cm / 48 × 74⅜ × 3⅛ in.

Charles Avery

For the last ten years Avery has drawn, sketched and painted an imaginary island. From the capital city of Onomatopoeia, with its own art gallery and market square, to the Eternal Forest and the Causeway of Effect, Avery creates a habitable world for his Islanders, who go about daily tasks such as slitting open eels or viewing the best Western art in their fictional gallery. In a recent installment of the project Avery worked with writer Tom Morton to 'curate' an exhibition in the fictitious gallery. Morton proposed an eclectic series of works of art for display and Avery drew his inhabitants looking at them on the white walls and floors of Onomatopoeia's Museum of Art. But what really exists of the project? The artworks of course never moved from the public institutions that house them in our world, and the people observing Bridget Riley's op art, Jeff Koons's balloon dog or Charles Ray's giant woman are not really there. But the documentation of the exhibition is real, exhibited at Pilar Corrias gallery in London in 2013 as 'It Means It Means!'. Like an Escher drawing, it folds in on itself – an artwork of artworks and looking, a work to be viewed in a manner that replicates the figures who populate it.

Jia Aili

Jia's vast landscapes have an otherworldly feel to them. Grisaille twilight diffuses desolate plains; derelict buildings and felled trees stretch for miles. They are landscapes of past greatness but present neglect, bleak and sparsely populated. And yet solitary figures often appear among the ruins, stepping between broken window frames or squatting in clearings, as if looking for something or someone. *Untitled* (2012) was part of Jia's exhibition 'Seeker of Hope' at the Singapore Art Museum, and 'seekers' crop up repeatedly in his large-scale works. *Untitled* (2010–12) is more intimate in scale and subject, a view of three children in school uniform at a table. The girls are turned towards each other, one wearing what looks like

an old-fashioned underwater breathing aid as she clutches a toadstool. The boy by comparison seems isolated, self-reflective, surrounded by a phantasmic glow in this subaqueous dreamscape. Jia asserts that all his work is autobiographical, representing his take on contemporary China and the societal problems he has witnessed. Perhaps the solitary boy – representative of China's one-child policy and Jia himself? – grows up into one of his 'seekers', searching out hope while all around him he witnesses destruction and decay as China casts off its traditions and is captivated by the false aura of the new.

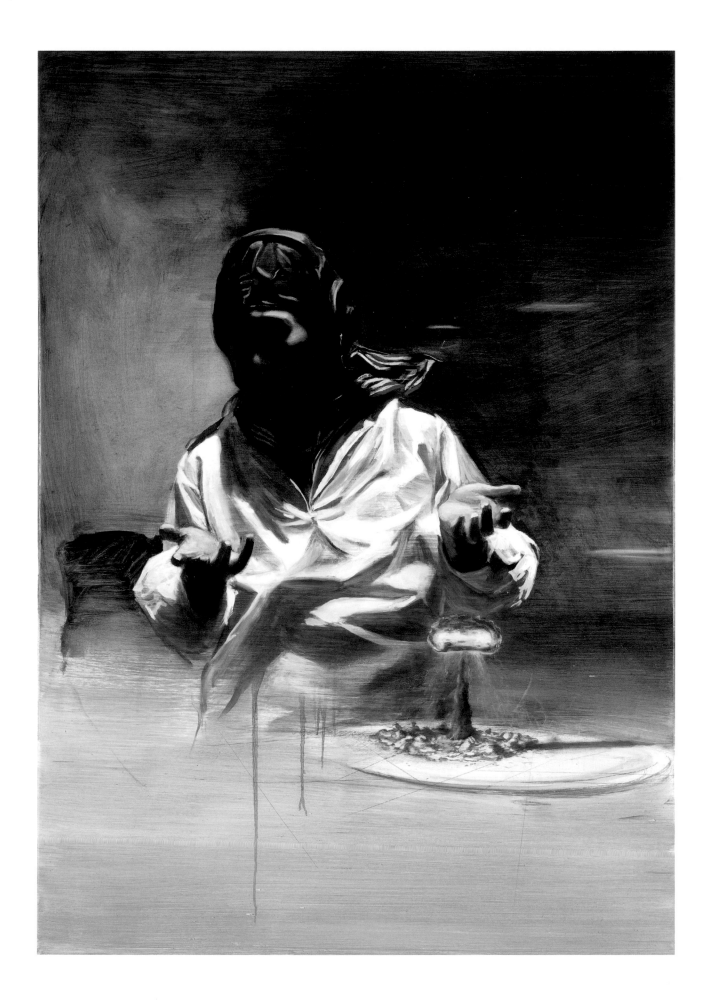

'My paintings have to be a bit nasty colour-wise to have any bite at all, and I've come to accept that anxiety is the only appropriate feeling for a contemporary figure painting. But it's also because I'm more attracted to bad or desperate images — they communicate more ambivalence and doubt and conflict than very polished pictures.'

– Cooke

Nigel Cooke

Cooke's paintings are surreal and disturbing, fantastical forays into a parallel world where flash cars, disembodied heads, waterfall skulls and vortexes of energy compete for our attention. In *Interference* (2011) two aging rockers drink and stagger next to their jacked-up monster truck, a miserable portrait of mediocre lives, their ride covered in graffiti, grey clouds swirling, the view desolate. These recurring characters have now been 'retired', and Cooke's fascination with the human experience of landscape has taken centre stage. Typhoons of paint swirl across his canvases, engulfing certain figures while providing refuge for others. Female faces appear in flower-heads or partially buried in the dirt floor, while androgynous nudes search for unknowable things. Paintings appear tacked to bare trunks of silver birch, as if Cooke's scenes were mere explorations of what it is to paint, to observe the tensions between the abstract qualities of paint and its figurative power when coerced into a narrative. *Spring* (2012), for example, is an orgy of technique, the acid yellow gestural abstraction of the jungle overwhelming the tiny figures who appear to bathe in the waterfall. Even the car has had an aesthetic paint job and, despite Cooke's technical proficiency at solidifying its expensive curves, the linear starbursts of paint in front and above insist the canvas is a flat reflection of, and not a window on, a strange new world.

Gordon Cheung

ABOVE
Supercell, 2012
Newspaper stock listings,
archival inkjet and acrylic on
canvas and polycarbonate
150 × 200 cm / 59 × 78¾ in.

OPPOSITE
Fallen, 2009
Newspaper stock listings,
archival inkjet and acrylic on
sailcloth and canvas
218 × 153 cm / 85⅞ × 60¼ in.

Cheung's world is one in which stocks and shares are constantly tumbling. Using the *Financial Times*'s pink-paper market data as his ground in every painting, Cheung conjures lone horsemen and rodeo stars to ride across it against a backdrop of psychedelic mountain ranges and luminous coronas of light. His surfaces are layered with photographic prints, spray-paint, pastel and pencil, oil straight from the tube; his colours are hallucinatory, artificial, all hot neon flares and cool sfumato seas. Office blocks melt and crumble in the heat haze; men become spectres; animals glow with heat-seeking intensity. There's something of the sublime to his paintings, as if John Martin had migrated from 19th-century America to a post-apocalyptic 23rd-century hell. In *Wanderer* (2014; page 114) Friedrich's classic *Rückenfigur*

now stumbles across rutted ground, attempting to reach vertiginous mountains as a scalding white sun burns the sky. In *Supercell* (2012) a rodeo rider appears displaced, the bull's hind leg slipping in the oily lake that has flooded the plain. Only a shack and a stone ruin remain under the nebula of pink and blue smoke (from some nuclear explosion?) that threatens to engulf the rider. Cheung, long interested in what he calls the 'techno-sublime', confronts us with our future as we try to wrestle mankind back from the brink of environmental disaster and technological overload.

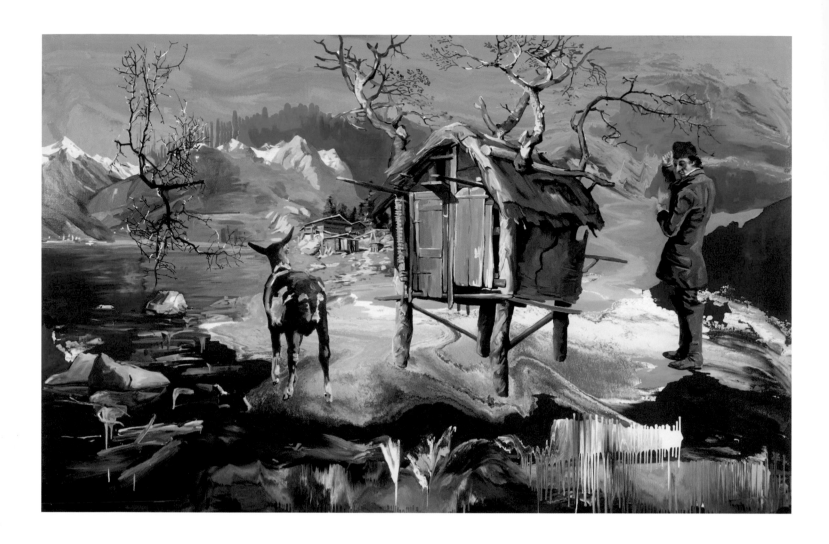

Stephen Bush

Bush oscillates between high-colour psychedelia and cool monochrome, working in each style until – like a pendulum – he swings back the other way. Perhaps he sees himself as a frontiersman, exploring the limits of narrative painting. Recently the oily slicks of poured enamel that formed the ground in *Delivering Pinus Mugo* (2010) have receded; *Lady Campbell Weed: Black Halligan* (2014) is painted in lilac, mauve and violet; a purple monochrome. His fragmentary subject matter remains similar throughout: isolated dwellings, singular figures confronting mountainous landscapes, dreamlike configurations of disparate objects, and the odd modernist building thrown in for good measure, perhaps symbolizing a lost utopia. The single

figure, often viewed from behind or obliquely, is surely a stand-in for the artist, a way of isolating himself, a way of escaping. But, as if to point to the artifice of his escape, none of the figures seem rooted to the lurid ground they stand on, and his paintings repeatedly reveal themselves to be flat surfaces, dreams not reality.

ABOVE
Delivering Pinus Mugo, 2010
Oil and enamel on linen
200 × 310 cm / 78¾ × 122 in.

OPPOSITE
Lady Campbell Weed:
Black Halligan, 2014
Oil on linen
183 × 183 cm / 72 × 72 in.

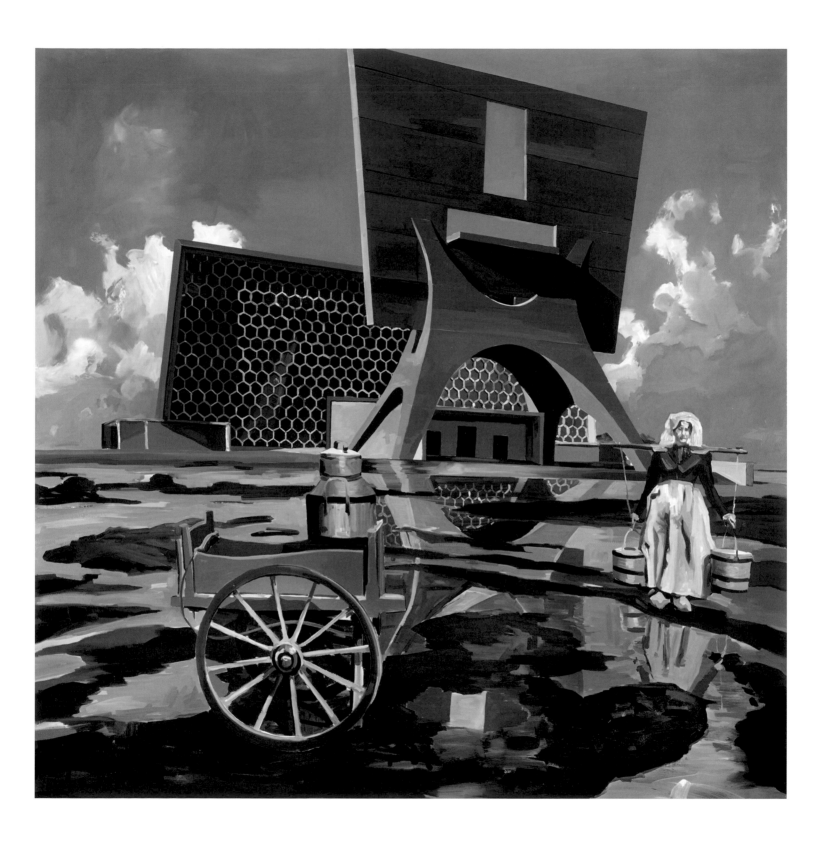

Marius Bercea

One of the leading artists working in Cluj in Romania, Bercea's recent paintings fuse the Transylvanian landscape of his childhood with the high-octane colour of Los Angeles. And yet his paintings are far from literal explorations of new or old topographies. Works such as *Sunset of Joy* (2012) juxtapose modernist edifices with apocalyptic sunsets and palimpsests of paint to create vivid otherworldly scenes. By splicing together elements from different environments he creates liminal spaces where modernist architecture gives way to palm trees and pot plants, and unidentifiable people sunbathe amid the ruins. Perhaps Bercea's paintings can be read as a visual manifestation of Romania's psyche as experienced by people of his generation, who lived out their childhoods under communism and now experience modernization and the transition of Romania into a democratic country that faces West, not East. By fusing memories and fragments of different environments – scrubbing off and reapplying paint like layers of history – Bercea seems to be reflecting something nebulous and intangible and yet also felt: a presence; a development; a sensation. Windowless concrete edifices rise in the forests, modernist temples back on to swimming pools, statues and campers rub shoulders on Transylvanian hillsides. Past and present, nature and culture, approximations of life and life itself come together in Bercea's complex world.

ABOVE
Sunset of Joy, 2012
Oil on canvas
150 × 200 cm / 59 × 78¾ in.

OPPOSITE
The Hierarchy of Democracy, 2011
Oil on canvas
280 × 400 cm / 110¼ × 157½ in.

*'The architecture I use, let's call it modernist, is
schizophrenic; mixing styles and traditions.... I try
to turn my audience into an unwilling accomplice, as
I create a landscape that may or may not be populated;
a landscape that is suspended in space and time.'*

– Bercea

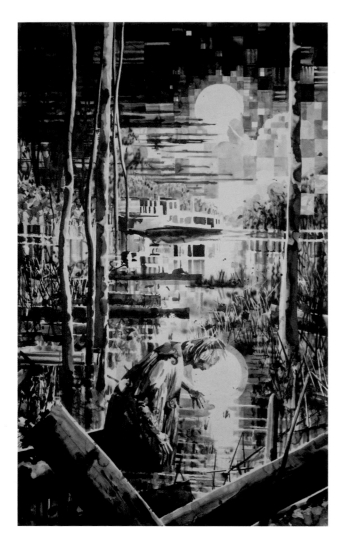

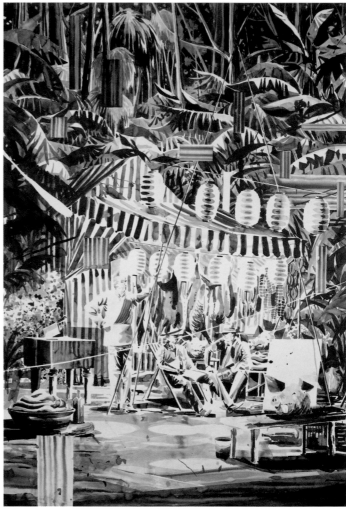

Nik Christensen

In *Tomorrow Right Now* (2014) a long procession advances, coming from the sharp snowy peaks in the distance. The leading group carries a makeshift platform on top of which sits a guitar-playing high priest, sheltering under a parasol. This work exemplifies Christensen's practice, an ongoing pursuit of possible future worlds after society has imploded following a digital disintegration of real and unreal. Drawing in black suma ink on paper, he conjures his worlds with cinematic tension: who is the man with the guitar? Where is the procession heading? The conflation of perspective and flatness – the snake of people seeming to puncture the tessellated landscape that hangs like a theatrical backdrop above and around them – further challenges a straightforward narrative reading. What, exactly, are we looking at? Figures begin to fragment as if some digital disaster has led to mankind itself breaking down and glitches ulcerate across the surface. Often nature seems to overwhelm Christensen's tribe, as if mankind's future actions have precipitated a rapid return to jungle survival. Dense palms soar overhead in *Wash Your Hands* (2014), as if Christensen is recreating the oversized fecundity of J. G. Ballard's *The Drowned World* (1962). In *Hunters Moon* (2013) a figure is mired in swamp water, the moon's reflection a symbolic corona around his head. Is he a member of a lunar cult? Is he the man from the platform? Should we fear him or help him?

ABOVE LEFT
Hunters Moon, 2013
Sumi ink on paper
243 × 150 cm / 95⅝ × 59 in.

ABOVE RIGHT
Wash Your Hands, 2014
Sumi ink on paper
225 × 149 cm / 88⅝ × 58⅝ in.

OPPOSITE
Tomorrow Right Now, 2014
Sumi ink on paper
223 × 149 cm / 87¾ × 58⅝ in.

 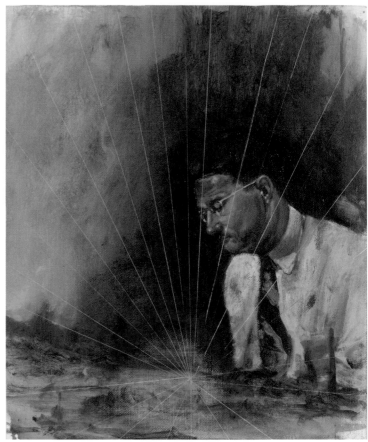

Christopher Orr

Orr's paintings all hint at something unknown, beyond reason, an uncanny element that sends a shiver of the supernatural down your spine. In *Together We Sing* (2013) a group of people of different ages and genders sit close together on a patch of earth as if admiring the view. The sky is a dirty yellow, as if belonging to an uncleaned landscape painting *c.* 1700. Yet across this aged sky, like laser ley lines, two blue marks stretch to a point. In *The Beneficent Lights Dim* (2012) a man – a giant this time – looks down on a sepia landscape, his wild tie rumpling on the hillside as he bends towards the focal point of dozens of thin white lines that score the surface. In both works the figures look dated, from a different historical era to our own. Orr sources them from old books and magazines, faithfully

retaining the scale of each original image. He then inserts them into landscapes drawn from art history's image banks – Leonardo's sfumato, Friedrich's trees, Turner's atmospheres – and adds a dose of pagan mysticism through the addition of ley lines.

ABOVE LEFT
The Beguiled Eye, 2014
Oil on linen
36 × 30.5 cm / 14⅛ × 12 in.

ABOVE RIGHT
The Beneficent Lights Dim, 2012
Oil on linen
27.2 × 22.6 cm / 10¾ × 8⅞ in.

OPPOSITE
Together We Sing, 2013
Oil on linen
25.4 × 20.4 × 2.2 cm / 10 × 8 × ⅞ in.

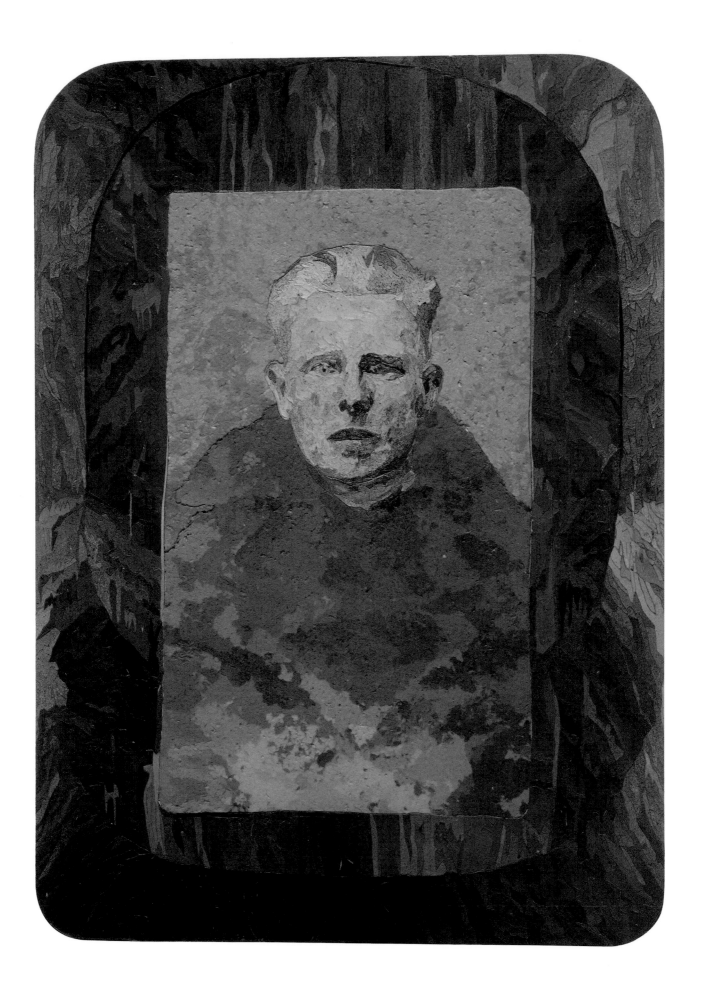

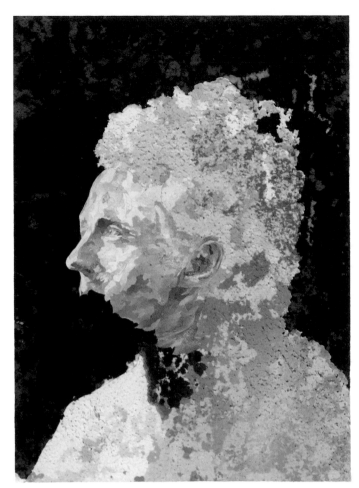

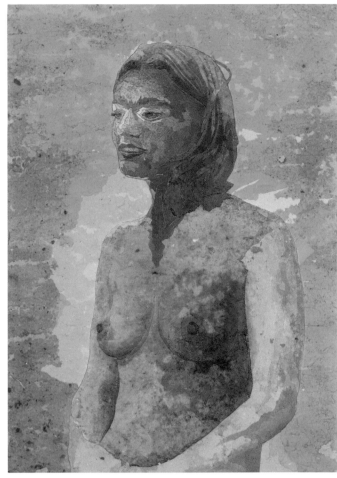

ABOVE LEFT
Neptune...Neptune...Neptune, 2013
Hand-coloured paper on board
53 × 48 cm / 20⅞ × 18⅞ in.

ABOVE RIGHT
*Let My Soul be Healed like the
Stars in Heaven*, 2011
Hand-coloured paper on board
45 × 33 cm / 18¾ × 13 in.

OPPOSITE
Partner, 2013
Hand-coloured paper on board
40 × 33 cm / 15¾ × 13 in.

Paul Johnson

In Johnson's collage *Partner* (2013) a pale man with turquoise eyes and flame-coloured hair stares out, his collar turned up against the cold, his cheeks mottled. There is no landscape or detailing to help us work out who he is or why he stands and stares; the background is dense blue-green, turning brown in places as if decaying. The frame, part of the picture itself but looking like oiled hardwood, resembles one reserved for a photograph of a favourite uncle lost in the war or a dead grandparent. Johnson made *Partner* to hang alongside a small potent portrait of A. G. Webster (1881) by George Clausen that he discovered in the Usher Museum in Lincoln, England, in 2013. Together they speak of the memorial associations of portraiture, and of the enigmatic qualities that remain when identity is lost. Johnson builds time into his collages, each of which take months to complete. He hand-colours individual paper shards, cutting and splicing them like a

marquetry craftsman, his portraits comprising hundreds of individual facets in each face. This gives each image a density, a sense of time built into the surface, and supports Johnson's interest in the journeys and mysteries that exist between past, present and future. In his earlier practice he was drawn to rituals and beliefs, bringing to life fictional futures where visible auras encircled heads and military uniforms sported symbols of the sun and stars. More recently it is the face itself that he scrutinizes, the sense of a portrait existing after death, in another dimension, gradually conjoining with the environment as in *Neptune...Neptune...Neptune* (2013) or becoming otherworldly as in *Let My Soul be Healed like the Stars in Heaven* (2011).

Carla Busuttil

Despite being drawn to photographs of war, violence, corrupt power and colonial exploitation, Busuttil insists she is more interested in creating a strong image that functions well as a painting rather than making any particular statement about world affairs. She takes her inspiration from media reportage – national leaders, royalty, soldiers – often splicing together figures from different times and contexts on each canvas. Her expressive, faux-naive style then takes over, and the results are powerful and disturbing canvases that she describes as 'tragicomic'. An ermine-clad soldier wields a sabre but his face is covered by a donkey mask; in *The Manifold Men* (2014) four gentlemen line up as if waiting for a bus, their canes and tailoring suggesting they are from another time. We cannot see who they are as

their faces are covered by rudimentary masks that offer only basic features – eyes, mouths – as if crayoned at kindergarten. Despite drawing on historic source material, Busuttil's paintings seem to speak of a timeless dystopia, where all have resorted to mask-wearing to survive, cloaking their true personalities or beliefs, bending to superstition and ritual. In *Swagger & Pomp* (2013), attendees at a ball wear mask upon mask in their struggle to keep up with fashionable expectations; in other paintings child soldiers in comical disguises wield guns and wear strips of ammunition like scarves. Busuttil's world is lawless and degenerative, a place in which one must survive, not thrive.

ABOVE
The Manifold Men, 2014
Oil on canvas
200 × 260 cm / 78¾ × 102⅜ in.

OPPOSITE
Swagger & Pomp, 2013
Oil on canvas
180 × 150 cm / 71 × 59 in.

Tilo Baumgärtel

ABOVE
The Green-Gray Day, 2014
Oil on paper
280 × 395 cm / 110¼ × 155½ in.

OPPOSITE
The Black Man, 2009
Oil on canvas
40 × 30 cm / 15¾ × 11¾ in.

Lowering clouds skirt the treeline as a solitary man walks two small black dogs down a country path in *The Green-Gray Day* (2014). To the man's left, a brutalist campus building, tiered like a wedding cake, appears unoccupied despite the flare of fluorescent light leeching out of the lower windows. The man walks on, entering a shaft of light that illuminates a large black toad traversing his path. Hang on – this all sounds a little fantastical. And I haven't even mentioned the two bodies camouflaged in the undergrowth….Baumgärtel is a Leipzig artist who refuses to be drawn on any narrative meaning that could be lurking in his paintings. Often set at night-time, his cinematic scenes initially suggest coherence and a potential plot but they soon break down into contradictions

or anomalies. Dolphins jump to a conductor's baton as Jane Austen looks on from the bleachers in *Brod* (2012); a man emerges from a cardboard box outside (or inside?) a low-rent home in *The Black Man* (2009). Sitting, standing, lying down – Baumgärtel's cast of characters wait for imminent events to unfold, but Baumgärtel refuses to give the viewer an inkling of what these might be.

'There's no resource material; all these scenes are made up, they happen in my head. I find it liberating to invent everything I do because you can tweak everything to fit the composition and the mood you want to set.'
— Von Kaufmann

Ruprecht von Kaufmann

In *The Pawning* (2010) a man is marooned on a low post in an estuary, his life jacket and umbrella little compensation for his abandonment. An oarsman rows away, a large pig taking the marooned man's place in the boat. The colour has been leached out of the scene, leaving a maritime mist that makes it hard to see. The distant shore has become a grey smudge, the water a dirty white impasto. The painting raises question after question, with no hope of resolution. Who are these men? Why the pig? Where are they? And why is the abandoned man sitting on his suitcase on a post? Von Kaufmann describes his work as narrative painting, and takes inspiration from classical myths and literary fables. But he's careful not to make his paintings illustrative, installing strange segues and changes in tempo into each canvas to create ambiguity as in *The Prisoners* (2011) where masked prisoners feel their way around the outside of a guarded windowless block. The reduced palette transforms each scene into something half-glimpsed and never fully experienced. Each provokes a physical reaction in the viewer, something first felt rather than seen, whether it's the fear instilled by a small rowing boat heroically attempting to scale a black wall of a wave or the eeriness of an illuminated figure gliding through a first-floor window into the uncertain night like Peter Pan.

Simone Haack

Haack's figures seem to step right out of family albums: Bonfire Night, a walk in the woods, school photographs. And yet there's something not quite right about them, something downright creepy. In *Attrappen* (2013) two boys in matching clothes pose on a path in the park, hair slicked down and shoes polished. Haack's palette is near monochromatic, a nod towards the black-and-white photograph this scene was most probably inspired by. Their feet meet the ground solidly, but further up their bodies start to fade, the pale icy landscape showing through their chests, their faces. Like ghosts with saucer eyes and hunched shoulders they stand still, staring at us, never blinking. In *Feuer* (2011) another pair of young children stand in the twilight in front of a bonfire. But the fire

is raging out of control as one girl turns, hand outstretched to her twin, a lit firework burning brightly within it. Like stills from David Lynch or Stanley Kubrick films there is a palpable tension in all her paintings, a sense of quietened horror in each protagonist's paleness, their clothes, their awkward poses, their gaze. All of Haack's work presents disturbed atmospheres, feelings of unease. Darkness crowds in, twilight descends, dreams turn to nightmares. We look behind ourselves and switch the light on.

ABOVE
Feuer, 2011
Oil on canvas
140 × 190 cm / 55⅛ × 74¾ in.

OPPOSITE
Attrappen, 2013
Oil on canvas
160 × 150 cm / 63 × 59 in.

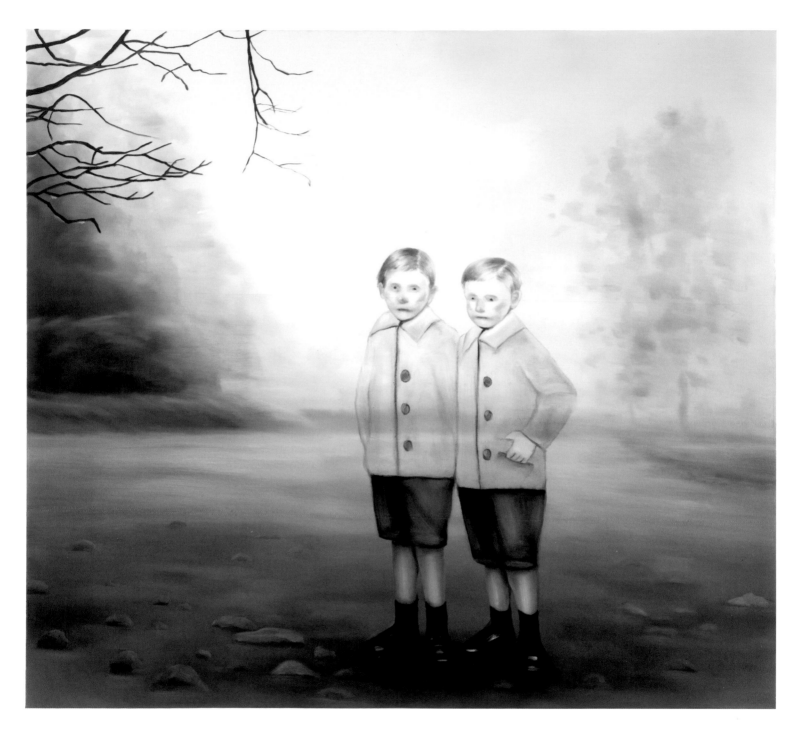

*'I give the eerie exactly as much scope as
I give absurdity, irony, and humour.'*
— Haack

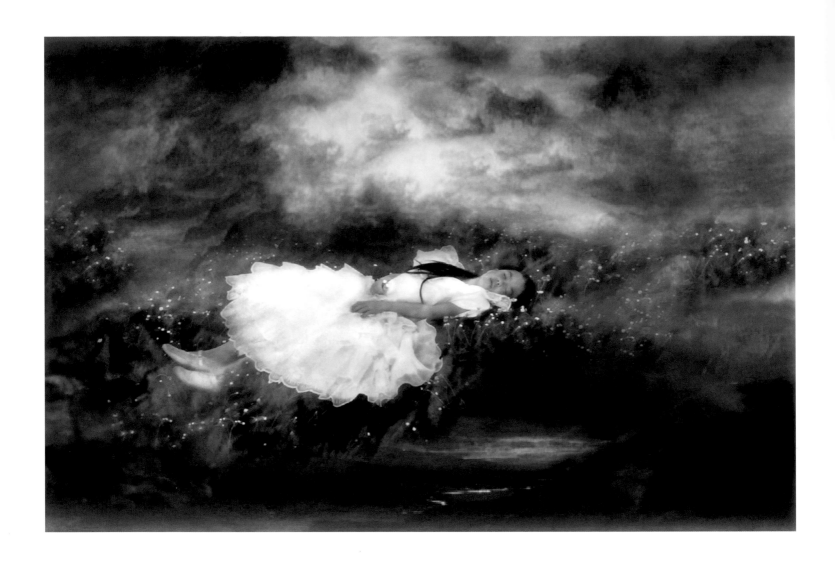

'*My inspirations are memories, dreams, stories, my fantasies and also my daughters and granddaughter, who are my most [frequently used] motifs. I would like to express something with my pictures, [something] you cannot say with words, things you can only feel and then see.*'

– Štrba

Annelies Štrba

Washes of colour and patches of light swirl over the sleeping girls and women in Štrba's 'Nyima' series (Nyima means 'sun' in Tibetan). A woman's face and arms are solarized grey, her dress a photographic negative, the light burning above and around the figure. The same woman, in the same pose, appears again in a royal blue dress, her skin pale and hair fanned out on the patterned rug beneath her, a hallucinatory scene of slender trees against the sky emanating from her still form. In *Nyima 456* (2011) a girl appears half-buried in a field of fluorescent poppies, their petals reflecting the burning sunset, while in *Nyima 438* (2010) a girl in a confirmation dress appears to hover over a swirling meadow. Štrba's granddaughter is the model for these works, just as Štrba used her own daughters for decades, photographing them as they grew up and became mothers themselves. Hers is a closed female world, a place of intoxicating dreams, the figure dissolving into nature, modern-day Ophelias drowning in light, colour, private thoughts. Created using video stills reworked and layered on a computer, Štrba prints her final images onto canvas, connecting to the painterly traditions of artists she admires: Monet, Klimt, Turner. In the ongoing series the girl's closed eyes allow us to penetrate her world, enter her thoughts, and by so doing we unlock our own mind and drift and float in the timeless landscapes of Štrba's own making.

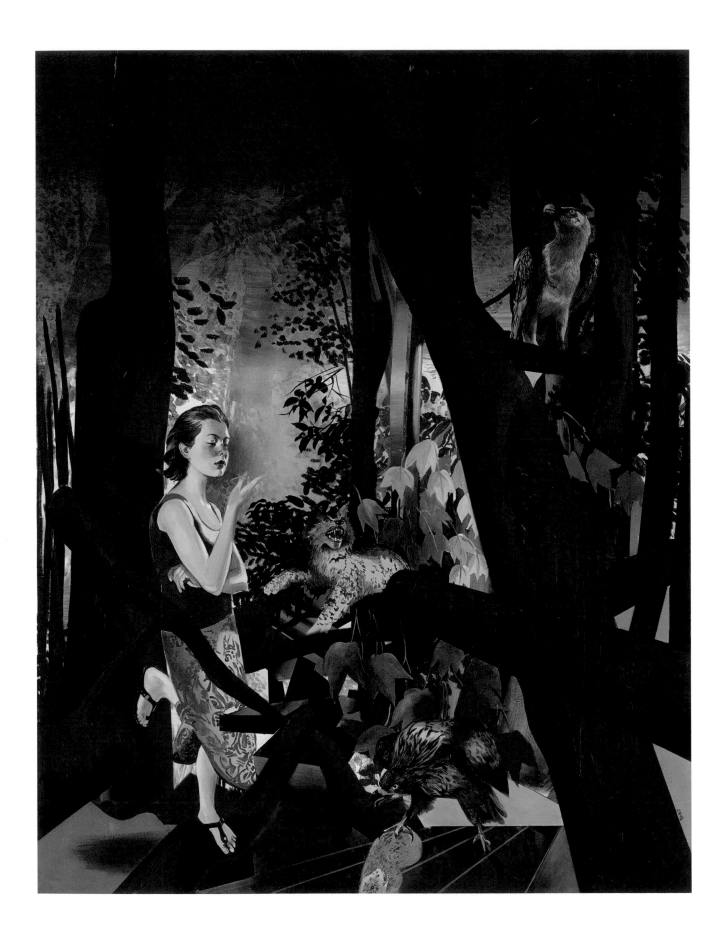

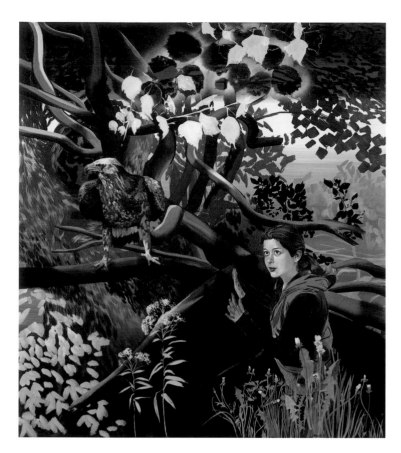

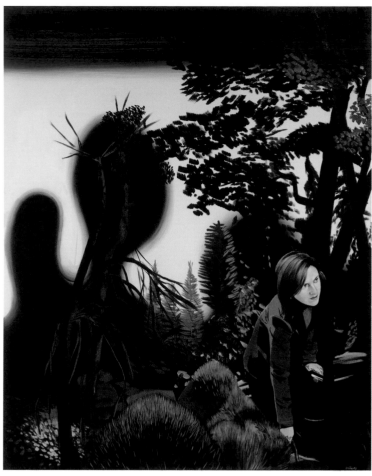

ABOVE LEFT
Curiosity, 2013
Acrylics on canvas
170 × 150 cm / 66⅞ × 59 in.

ABOVE RIGHT
Forest, 2013
Acrylics on canvas
190 × 150 cm / 74¾ × 59 in.

OPPOSITE
Girl in the Forest, 2014
Acrylics on canvas
230 × 180 cm / 90½ × 70⅞ in.

Susanne Kühn

Kühn's paintings are a complex fusion of art historical sources, contemporary styles and eclectic subjects. Eagles, Ming vases, mushrooms, pine trees, modernist architecture, Afghan hounds and camp fires are brought together in settings that variously bring to mind Friedrich's isolated forests or Vermeer's Dutch domestic interiors. Kühn is interested in boundaries, as in *Curiosity* (2013), where a girl stands expectantly behind a screen of urban weeds, slowly approaching an eagle perched on a branch. Kühn has conflated two different landscapes – city and wilderness – into a complex pattern of branches, leaf silhouettes and dandelions. In *Girl in the Forest* (2014) two further eagles and a wild cat are at odds with the polished pink tones of a girl in sun top and sandals, leg bent and resting on a tree

trunk. Kühn also paints thresholds between outside and inside, as in *Green – The Arnolfinis* (2011; page 116), the highly controlled interior contrasting with the vivid pine landscape. Kühn is fascinated in bringing together art historical sources and strands, and her work openly samples from the past, particularly the German romantic tradition (she was born in Leipzig) and Van Eyck's *The Arnolfini Wedding* (1434), which appears pinned to the wall in *Green – The Arnolfinis*.

Kaoru Usukubo

In *The proof of prophecy, The First Sentence* (2013) Usukubo transports a young girl to an unfamiliar world, placing her down in front of an unforgiving rocky landscape. Her purple sleeveless dress is caught by the wind, and her simple paper garlands suggest she has come from a party. But why is she wearing a paper chain? And whose sculptures stand behind her on the barren rocks? The girl's eyes are closed; she offers us no clues. Usukubo's disquieting works often juxtapose smooth-skinned Japanese children with strange accessories (crystal tears, purple hair, oversized garlands), placing them in incongruous landscapes or stripping away the background so they exist out of time. Growing up in Japan in the 1980s and 1990s Usukubo was of the generation for whom reality was intercut with video games and CGI. In her paintings she questions what reality is today; her hyperreal children have hair with a mind of its own in *Sprout* (2009) or wear wigs in *Part and the whole, Encounters and Beyond* (2009). They all seem pensive, passive and rather sad, aware of their construction as paintings perhaps; aware that – in reality – they too don't exist.

OPPOSITE
*Part and the whole,
Encounters and Beyond*, 2009
Oil on panel
194 × 194 cm / 76⅜ × 76⅜ in.

BELOW LEFT
Sprout, 2009
Oil on panel
90.1 × 90.1 cm / 35½ × 35½ in.

BELOW RIGHT
*The proof of prophecy,
The First Sentence*, 2013
Oil on canvas
194 × 194 cm / 76⅜ × 76⅜ in.

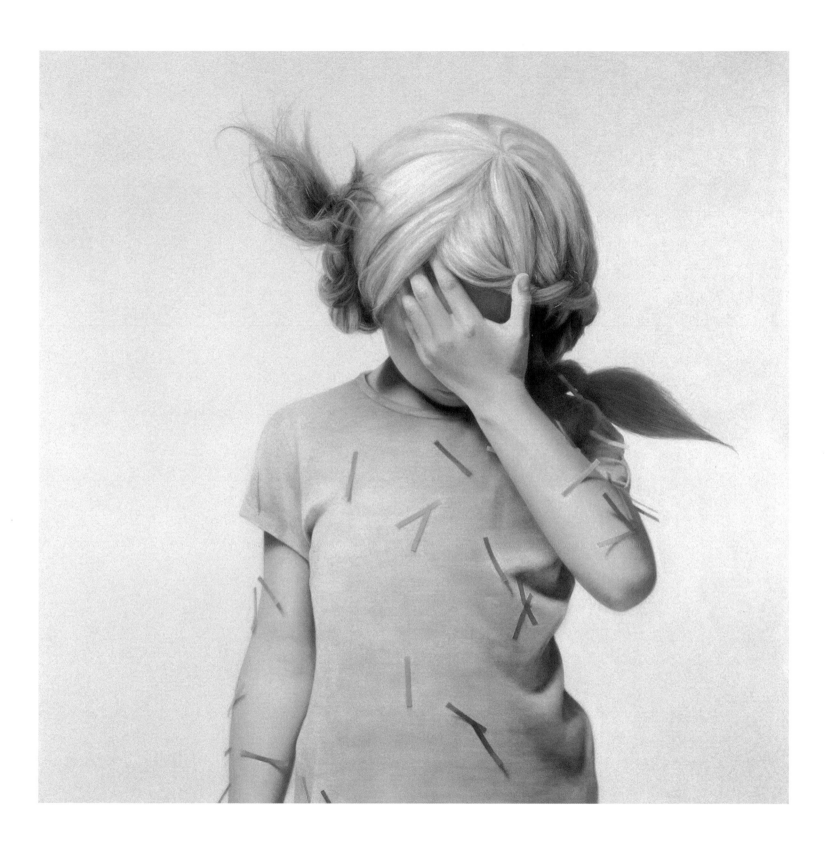

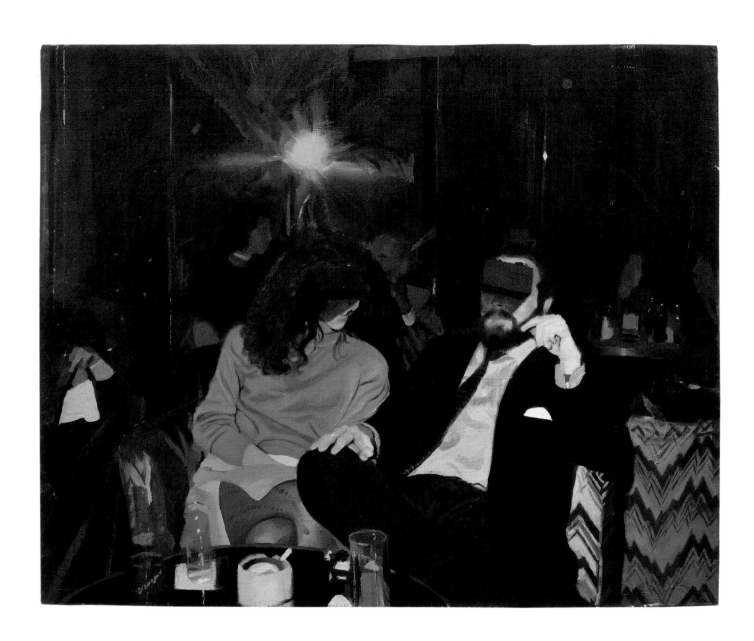

5.

Depictions of contemporary life through images of the public, unknowns, celebrities and the self.

Observer / Observed

Pere Llobera
Untitled, 2014
Oil on canvas
55 × 65 cm / 21⅝ × 25⅝ in.

What is it to look at another person and record what you see? Do you need their permission, and how does the viewing change if you observe them secretly? What if you turn that intensive scrutiny on yourself? This chapter features artists who closely observe others or themselves. The artists featured are not portrait artists, but artists who paint, draw or photograph the figure to reveal collective truths, to grapple with what it is to be human in the 21st century.

Jessica Craig-Martin and Katherine Bernhardt use the rich and famous as their canvas. Craig-Martin looks for cracks in the armature of the international jet set. False smiles, wrinkles that have been nipped and tucked, too tight dresses and too small shoes, jewelry like armour – she photographs it all. Often heads are cropped out of the frame, her brutal observations pointing to the avarice and superficiality of capitalism, not to any individual's particular fashion faux pas. Money can't buy you an identity, a lasting presence, she suggests; no matter how much you have, someone will always have more. Bernhardt, on the other hand, idolizes celebrities, particularly fashion models and pop stars. But through her obsessive way of working she transforms their perfect skin and size zero bodies into exuberant, fleshy, drippy explosions of juicy paint. Her fast and loose canvases are as over-the-top as the garish and brittle world of fashion itself.

Grayson Perry, in his ambitious tapestry series 'The Vanity of Small Differences' (2012), wriggled under the skin of tribal Britain in a hunt for contemporary identity. He visited corner shops and football stadia, chintzy semis and council estates, picking up details as to what makes the British so class-riven as a society. A pictorial narrative unfolds over six tapestries and makes clear that money cannot buy happiness (although it can buy a Ferrari). Liu Xiaodong and Jitish Kallat also observe everyday life, depicting work places and societal trends, not in middle England but in Chinese jade mines and the rapidly expanding city of Mumbai. Liu relocates for each series he paints, getting to know the local population, asking them to pose for him once he has earned their trust, whether in the heartland of the 2008 Sichuan earthquake, the jade mines of Xinjiang or

around the Three Gorges Dam project. Kallat paints the people of Mumbai, particularly the disenfranchised poor, and the complex and contradictory elements of his home city. Nermine Hammam confronts past perceptions of Egypt, her home nation, relocating soldiers from the 2011 revolution to Alpine meadows or splicing them into 19th-century paintings of camel trains and Orientalist scenes.

The figures Tala Madani paints are office workers and middle-aged men, fabricated in her imagination rather than observed from life. What she has carefully observed, though, are the rituals and ceremonies of patriarchal society. These she inflicts on her balding, overweight subjects, who sit in their underpants or stand naked on a chair as they are taught how to hang themselves. Society can be humiliating; only the fittest survive.

Pere Llobera and Imran Qureshi reference their own bodies in their work. Llobera paints what look like snapshots from a family album (his album), an awkwardness pervading each painting as he swings on a door or watches TV, while Qureshi paints himself at work as an artist in Pakistan. This use of the artist's own body as subject is taken further by Lorna Simpson, Cindy Sherman and Gillian Wearing. They do not create self-portraits in the traditional sense, but rather use their own image to challenge perceptions of women both today and historically, as well as in the media and in works of art. In a recent series Sherman posed in various vintage outfits against incongruous backdrops of rugged terrain. These works are fabrications of identity, reminiscent of 19th-century *cartes de visite* or cabinet cards, taken in photographic studios on both sides of the Atlantic. The studio lighting visible on her characters' costumes jars with the natural light of the landscapes (shot on location in Iceland and Italy), further emphasizing the construction of each image.

In one body of work Wearing chose to become the photographers who had influenced her. To this end she moulded latex masks over her own face to transform herself into Robert Mapplethorpe, August Sander, Claude Cahun and others. What does it mean when one artist assumes the face of another? In each one she aped their photographic style but intentionally didn't perfect her disguise. Simultaneously these bring to mind the photographers they portray while revealing the construction and artifice of their fabrication. In a recent series, Simpson similarly transformed herself into another person. She recreated poses from a 1957 photo album, asking the viewer to reconsider the framing of photographs, the expectations of the person in the image and to what extent they could control the reading of the final image both when it was made and today.

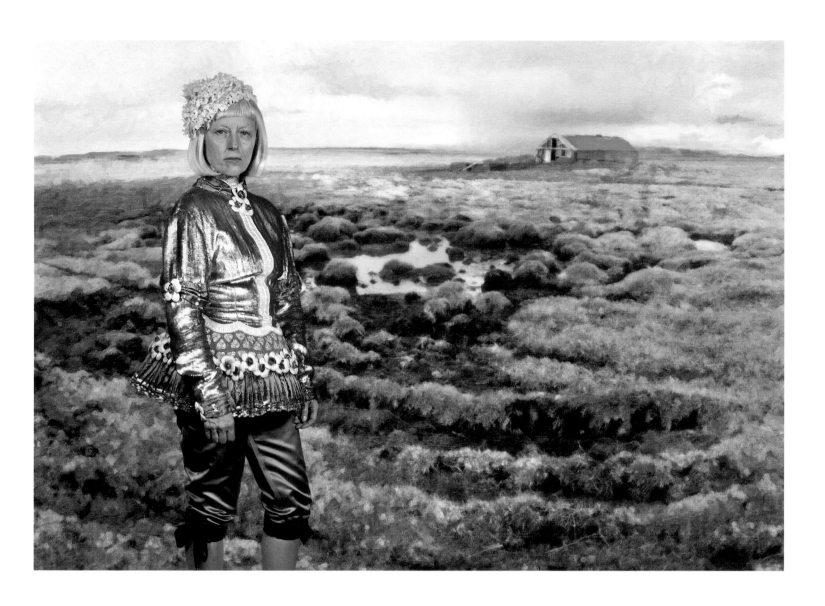

Cindy Sherman
Untitled #513, 2010–11
C-print
172.7 × 244.8 cm / 68 × 96⅜ in.

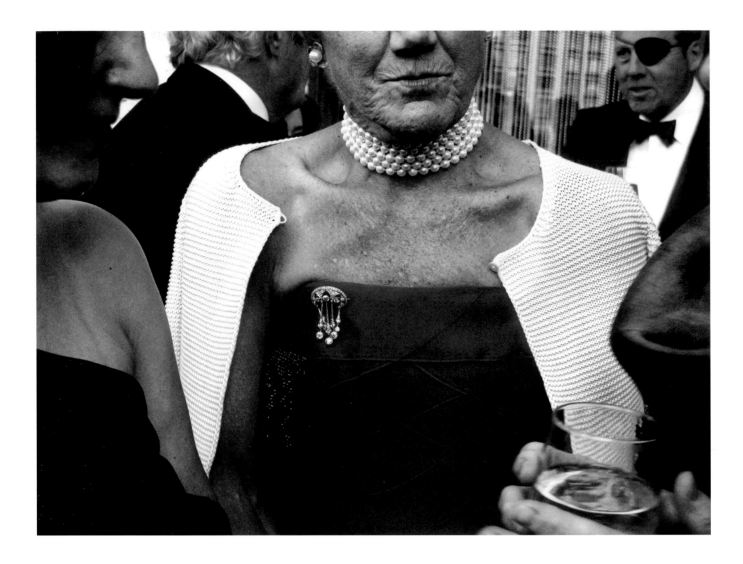

Jessica Craig-Martin

Craig-Martin travels the world, photographing the rich and famous at Cannes, the Venice Biennale, New York benefit balls. But she is no society photographer – she cuts heads out of the frame, focusing instead on baroque opulence: waterfall diamonds, low-cut satin dresses, endless canapés, acres of aging skin. She picks up on fake gestures, deference and ridicule, costume clashes and jewelry worn like armour, almost always keeping her camera at lip level or below. By taking away the eyes, the personality, we concentrate on the clothes, the pearls and gold, the lipstick. It all seems so artificial, so devoid of purpose. The women in *Midnight at the Oasis* (2012) all look the same; *An Embarrassment of Riches* (2014) offers a garish

colour-clash and an ambiguous gesture – is that hand pushing, guiding or embracing? Craig-Martin's perspicacious works reveal the artifice and transience of money and fame; while the tight-lipped woman in *The General* (2014) may still feel in control, the arrival and departure of the two beautiful women in *Coming and Going* (2014) show that no-one stays at the centre of attention for long.

The General, 2014
C-print
68 × 91 cm / 26¾ × 35¾ in.

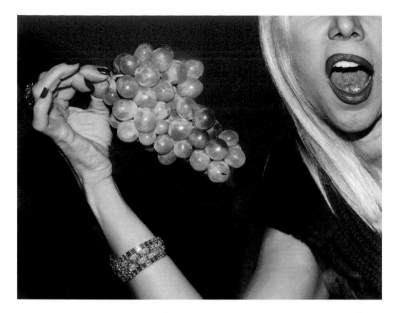

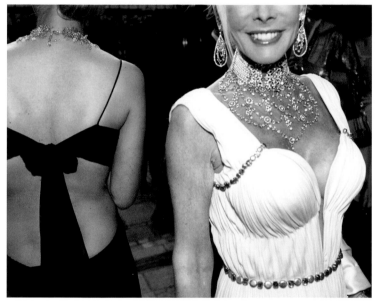

'I see them [her photographs] as abstract studies of sequins, evicted molluscs, and air-conditioned mink. My camera wants to eradicate the personal.'

– Craig-Martin

TOP
Grapes in Gstaad, 2008
C-print
91.4 x 66 cm / 36 x 26 in.

ABOVE
Coming and Going, 2014
C-print
72 × 91 cm / 28½ × 35¾ in.

ABOVE RIGHT
An Embarrassment of Riches, 2014
C-print
101 × 131.4 cm / 39¾ × 51¾ in.

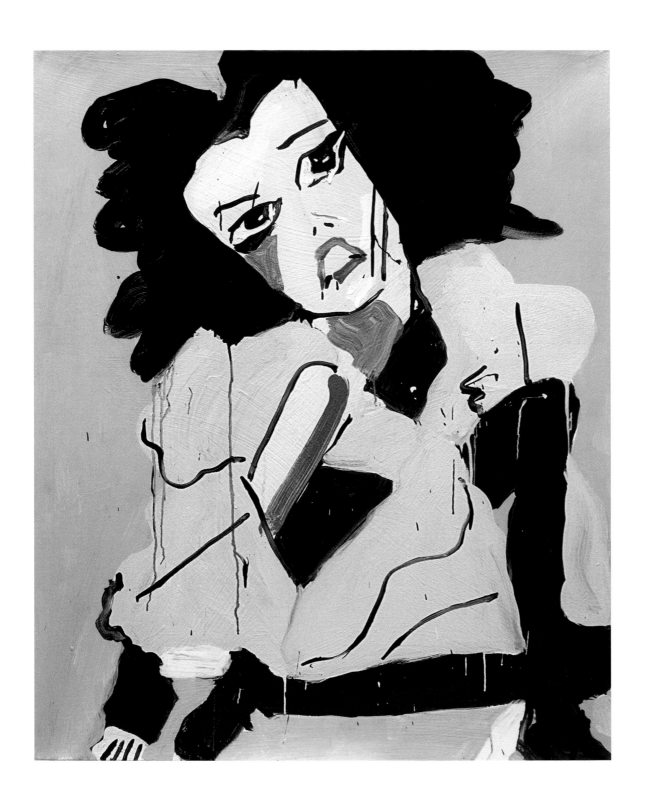

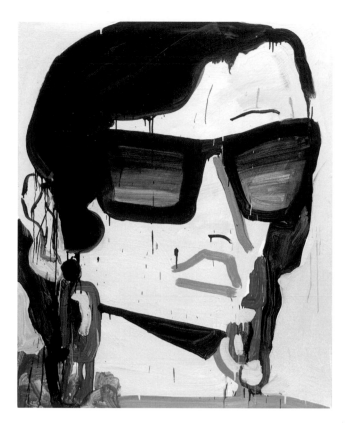

Katherine Bernhardt

Exuberant, messy, colourful, extreme: Bernhardt's portraits of celebrities and models are explosions of fast and loose colour. Naomi Campbell, Nicki Minaj, Agyness Deyn and Beyoncé all appear as repeated motifs – for example *Naomi* (2011) – as do anonymous fashion models, who twist their long limbs into awkward poses, as in *Fendi* (2011). Bernhardt has been fascinated by fashion magazines and models from a young age, and one suspects she is obsessive in her interests – she rips out fashion shoots from magazines, follows models on the street, repeatedly watches the same pop videos on YouTube. She immerses herself in her subject, painting rapidly, black acrylic dripping down the canvas like weeping mascara, brown and pink paint delineating cheekbones, jawlines, emaciated chests. There's no depth to her paintings, no background or content beyond each woman's face, and her work could be seen to satirize the fickle and brittle fashion world that she claims to be in love with. The complicated position of the woman's limbs in *Fendi* is uncomfortable to look at; the reflection in the sunglasses in *Prada Occhiali* (2011) is the only hint of life beyond the surface gloss of the image. And yet, in the fluorescent pink, yellow and green brushstrokes, the rapid squiggles of hair, the black-rimmed eyes, there's an exuberance, a passion, that gives these characters a new life of their own while commenting on the artificial 'perfection' of their former existence.

Grayson Perry

Throughout the 1990s Perry inscribed giant pots with uncompromising scenes of contemporary urban life, winning Britain's prestigious Turner Prize in 2003 and continuing to develop his ascerbic narratives, as in *Jane Austen in E17* (2009). But in 2012 he completed a series of six tapestries that took his work to a new scale. Collectively known as 'The Vanity of Small Differences', the tapestries followed Hogarth's theme of *A Rake's Progress* (1732–33) and restaged it in 21st-century Britain. The bounder Tom Rakewell became Tim Rakewell, computer programmer, who made enough money to drag himself up from his working-class roots, across the shifting sands of liberal middle-class existence and into the lofty faux-posh territory of the nouveau riche. Rakewell meets a sticky end in tapestry six, his Ferrari wrapped around a lamp post,

his body near-naked and bleeding like Christ in Van der Weyden's *Lamentation* (*c.* 1441). All of Perry's tapestries are based on individual works by old masters – the *Lamentation*; Thomas Gainsborough's *Mr and Mrs Andrews* (*c.* 1750) – as if to link the worries of today's society to those of our ancestors and suggest *plus ça change*. The carefully observed details in Perry's tapestries – the changing brands; the smug in-jokes of the middle classes; the ubiquity of commodities – are supplemented with a written narrative that weaves across all six works as the sun sets on Rakewell's rise and fall.

ABOVE
Expulsion from Number 8 Eden Close, from 'The Vanity of Small Differences', 2012
Wool, cotton, acrylic, polyester and silk tapestry
200 × 400 cm / 78¾ × 157½ in.

OPPOSITE
Jane Austen in E17, 2009
Glazed ceramic
100 × 51.5 cm / 39⅜ × 20¼ in.

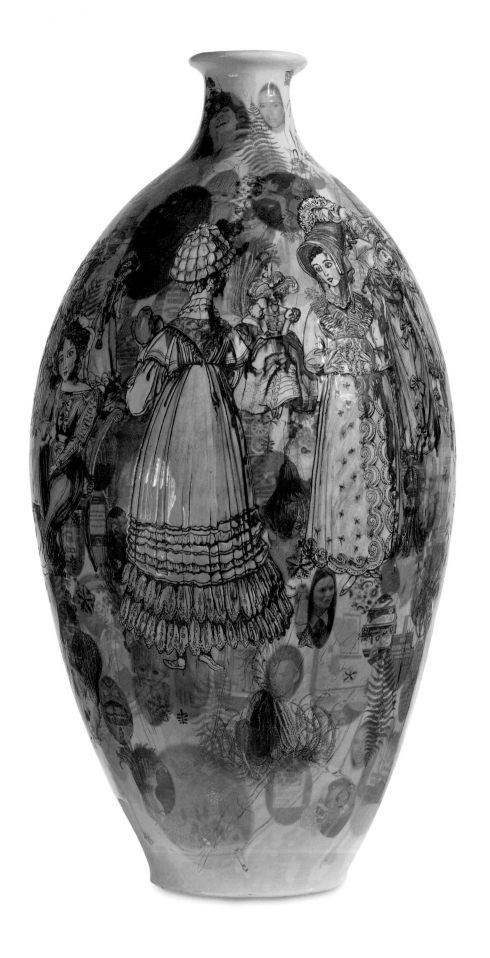

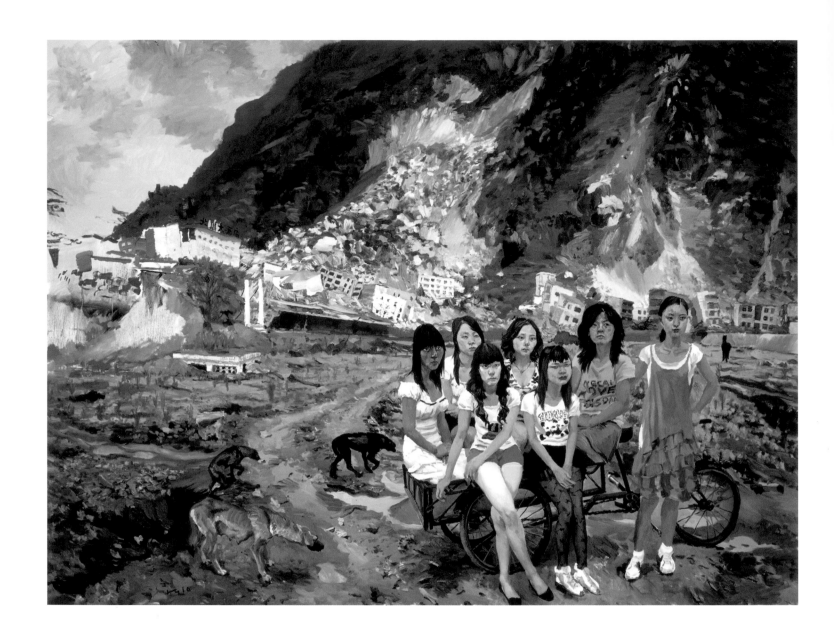

'I used to pursue perfection, integrity, and uniqueness. But later on, as my understanding of society grew, I realized it was the scene that was irreplaceable. Under these conditions, paintings are born from all kinds of factors, which are unimaginable in the studio. Ideas come from nowhere and this gives the work the trace of thought and practice.'

– Liu

ABOVE
East, 2012
Oil on canvas
250 × 300 cm / 98⅜ × 118⅛ in.

OPPOSITE
Out of Beichuan, 2010
Oil on canvas
300 × 400 cm / 118⅛ × 157½ in.

Liu Xiaodong

There's something of Lucian Freud's ethos in the paintings of Liu Xiaodong. He wants to paint people as they really are, and to this end he has worked directly from the model for the last ten years. Liu doesn't work in a studio, however, but rather paints each man, woman and child in the environment in which they live or work. In 2003, for example, he travelled to the site of China's Three Gorges Dam project and recorded the population displacement he found there. More recently he spent two months in Xinjiang, a Western province of China, getting to know local jade miners. While he is interested in the complex histories of each area in which he paints, he wants to convey this through the people he meets. To this end he paints them in groups, surrounded by the local landscape: the jade mine in *East* (2012); a town shattered by the Sichuan earthquake

of 2010 in *Out of Beichuan* (2010). He works on an epic scale, each canvas the size of a 19th-century European Salon painting. His focus is always local: a boy stands alongside his older compatriots in *East*; young women crowd on to a three-wheeled delivery bicycle to pose in *Out of Beichuan*. He always works in a similar way, moving into the local area and getting to know the people who live and work there. Resilience and existence connect each series; the strength of people to adapt and survive.

'The city street is my university. One finds all the themes
of life and art – pain, happiness, anger, violence and
compassion – played out here in full volume.'

– Kallat

Baggage Claim

ABOVE
Baggage Claim, 2010
Acrylic on canvas, bronze
Triptych overall 244 × 518 cm /
96 × 204 in.

OPPOSITE
Untitled (Stations of a Pause),
2010–11
Acrylic on canvas, bronze
Each panel 175 × 175 cm /
69 × 69 in.

Jitish Kallat

Kallat chronicles life in his native city of Mumbai, and his large-scale canvases, photographs and sculptures all reference the rapidly modernizing metropolis. His paintings often feature groups of men waiting around, as in *Untitled (Stations Of a Pause)* (2010–11) and *Baggage Claim* (2010). But as they wait, city life continues in microcosm literally on top of them: every square centimetre of their scalps teem with cars, people and animals, squashed into the space of a hairstyle. Kallat throws together contemporary references to city life, particularly the life of those who have been dispossessed by recent city planning, as suggested by the blacked-out speech bubbles – a population silenced. The men in *Baggage Claim* wait expectantly as cars explode and crash in front of them, and bronze waterspouts – based on those at Victoria train station in central Mumbai – appear to disgorge toxic liquids that trickle down the canvases. Further stains and marks turn his paintings into city walls, pockmarked and graffitied, representative of urban life in Mumbai and beyond.

'The interchangeability of victims in media portrayals, their second death, lay at the root of this project....My constant interaction with such micro-violations of truth and event for the sake of narrative led me to this reflection on the fabrication, manipulation and implications of political myths.'

– Hammam

Nermine Hammam

ABOVE
An Algerian in Kantara from
'Wétiko…Cowboys and Indigenes',
2014
Hand-tinted photograph
56 × 80 cm / 22 × 31½ in.

OPPOSITE
Digital Dementia from 'Upekkha',
2011
Collage
60 × 90 cm / 23⅝ × 35⅜ in.

Hammam was born in Cairo, where she continues to live and work. She witnessed the Arab Spring first hand; she watched buildings burn and protestors die. What struck her was the disparity between what she saw on the streets and what was reported on Egyptian news channels. She then witnessed a 'restaging' of particular revolutionary events for a Western photojournalist who went on to circulate the photographs as 'live' images. Photography, particularly news reportage, has been fabricated and manipulated since the Crimean war, and Hammam became fascinated with the relationship between her recent experiences of staged war photographs that appeared authentic, and earlier painted representations of non-Western populations showing similar stagings of history. In her latest series, 'Wétiko…Cowboys and Indigenes' (2014), she turned to late 19th- and early 20th-century paintings of the 'Wild West' and 'Orientalism', inspired by the Native American term *wétiko*, a word for an evil spirit that rules by power and consumes others. She first selected paintings

that typified the prejudices and assumptions about Native American and Middle Eastern cultures in the West at this time – the cowboy as lawmaker and sheriff, chasing Native American trouble-makers; the Arab man as passive and lethargic, lazing on temple steps or lolling on camels. Then she chose photographs of the Arab Spring from internet news feeds: soldiers in camouflage displaying the American flag; children looting electrical goods; freedom fighters on the run, their ammunition flaunted like ostentatious jewelry. She spliced together these two representations of society, both contemporary and historic, creating seamless new photographic tableaux of Arabs being frisked by American troops as their camel train passes and of Marilyn Monroe entertaining the troops sixty years before the film star flew to Korea to do just that. History, and image-making, is a construct, she suggests – make sure you know who is responsible for its compilation…

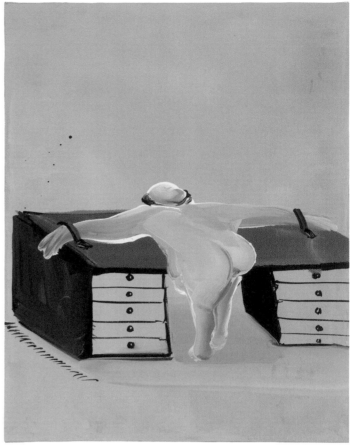

ABOVE LEFT
Yellowed Pants, 2013
Oil on linen
41 × 35.5 cm / 16⅛ × 14 in.

ABOVE RIGHT
Fundament, 2013
Oil on linen
35.5 × 28 cm / 14 × 11 in.

OPPOSITE
Popular Toys, 2013
Oil on linen
97 × 62 cm / 38¼ × 24⅜ in.

Tala Madani

In Madani's paintings and animations middle-aged men are humiliated again and again. As if enacting complex initiation ceremonies into closed male orders, they stand in their pants and vest or bend supine over office desks as in *Fundament* (2013). In other works men stand around and encroach on the vulnerable figure, as in *Yellowed Pants* (2013), where a grey-haired man in spectacles opens the fly of his slacks and appears to angle a torch inside. Although the men often appear in a classroom environment, they never learn – one is taught to hang himself while another displays his bulging belly on the wall behind him using an overhead projector. Often described as darkly humorous, Madani's paintings also hint at retaliation, at the dominance of men and male groups in Iran, where she was born (she now lives and works in America.) But they also speak of other male environments, from the workplace to working men's clubs, where rituals and tribal networks must be observed. In *Popular Toys* (2013) we see yet another classroom reference, this time to children's traditional reading primers. In this painting, one of a series, the girl has her hand inside a blonde glove puppet while a boy in a red polo-neck plays with a cartoonish naked man who had an air pump inserted into his rectum. The boy has fun squeezing the pump; the girl and boy already seem coated in the fluid the 'toy' has ejaculated. It's a long way from *Janet and John*, as if the children (and the artist herself) are finally getting their own back on the patriarchy.

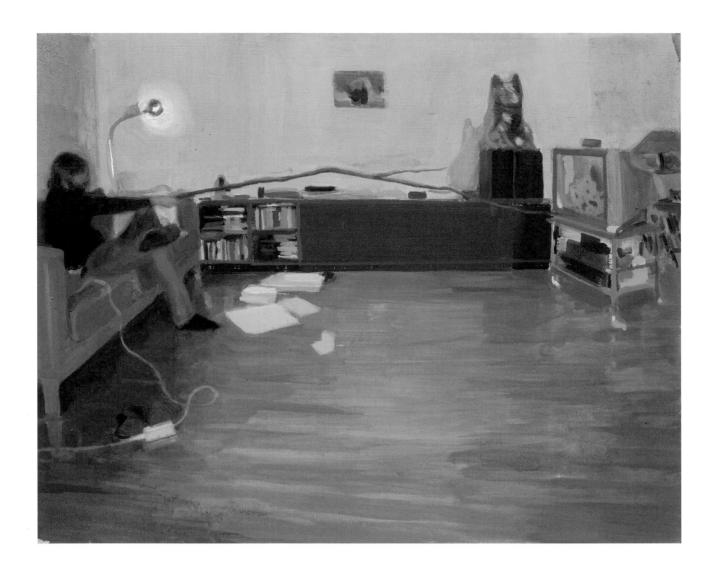

Pere Llobera

Llobera's paintings appear drawn from the everyday: cramped dinner parties, TV suppers, nights out, homework. They are derived from personal experiences, of his past as a child, man and artist, the men in his paintings usually self-portraits. And yet visual disturbances challenge any familial reading. In *Involució, ja! (Involution, right now!)* (2011) a bearded man (the artist) sits on a low-slung sofa, watching TV across the living room. A giant 'fortune cat' ornament appears on the sideboard, dwarfing the small canvas on the wall behind. As we consider these objects we notice that the man is changing channels by using a long, bent branch rather than a remote control. Why on earth is he doing that? In *Walk as a Giant* (2012) another man holds up what looks like a large piece of masonry above his head; in *Untitled* (2010)

a man (again the artist) swings on the handles of an apartment door, two pink balloons bobbing at his feet (a nod to Martin Kippenberger's self-portraits from 1988). Llobera's classical training and love of Goya is supplemented by his admiration for Kippenberger's rigorous questioning of what it meant to paint and be an artist in a postmodern world.

OPPOSITE
Involució, ja! (Involution, right now!), 2011
Oil on canvas
40 × 50 cm / 15¾ × 19⅝ in.

RIGHT
Untitled, 2010
Oil on canvas
33.5 × 43 cm / 13¼ × 16⅞ in.

RIGHT BELOW
Caminar com un gegant (Walk as a Giant), 2012
Oil on canvas
33 × 41 cm / 13 × 16⅛ in.

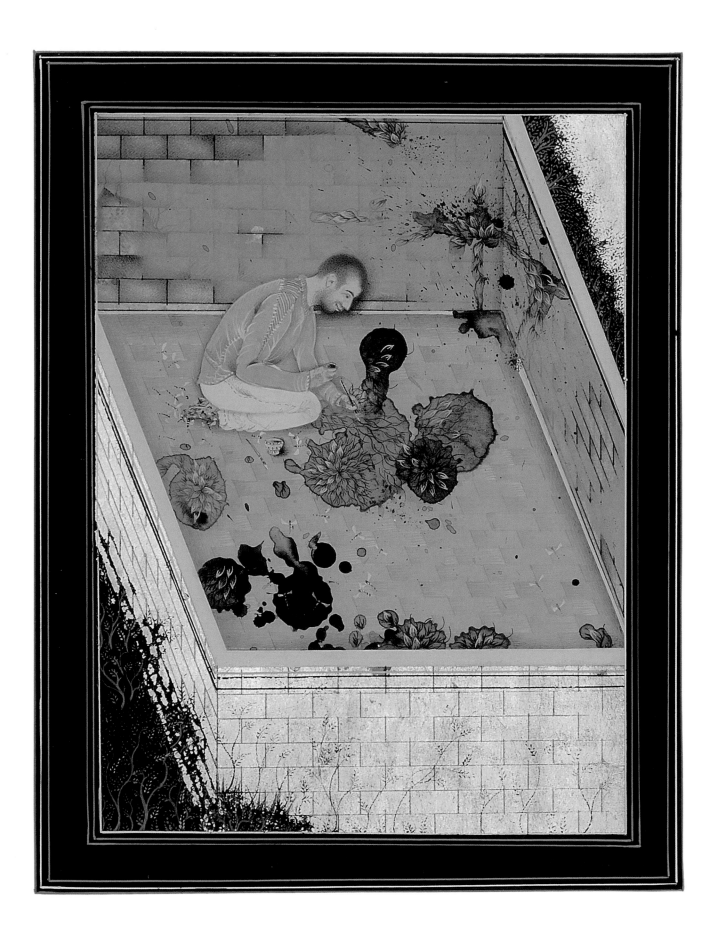

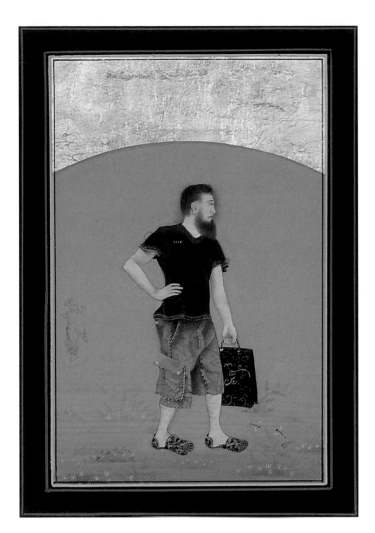

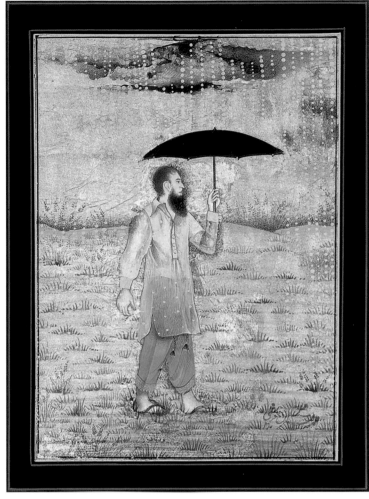

Imran Qureshi

Qureshi was trained in miniature painting in Lahore in the early 1990s, and continues to use this traditional style to express contemporary concerns. Increasingly he has moved towards installation, throwing red ink around courtyards as if each were the scene of a terrible bloodbath, yet one from which tender shoots of foliage have started to bloom. However, alongside these powerful evocations of war, *vanitas* and natural cycles are a series of figurative works. 'Moderate Enlightenment' (2007–9) shows religious men enjoying everyday activities: working out, reading, shopping, walking in the rain. While working in the miniature tradition, Western elements purposefully creep in – a branded carrier bag, an umbrella, combat shorts – challenging modern preconceptions of such men. In 2013 he completed a self-portrait

entitled *Opening Word of This New Scripture*. In it we see the artist at work on one of his courtyard installations, patiently drawing red flowers from the splattered ink. Qureshi uses the traditions of Mughal miniature painting – the luminous brushwork, gold leaf, multiple perspectives – to comment on his own experiences in India and Pakistan. In this painting he appears in a blue shirt and white trousers, unshaven, holding his brush in his left hand, a pot of ink in his right. This courtyard is small, and there is no visible way out. Despite the violence implied by the 'action painting' of the bloody ink it is as if Qureshi can forget it all while he paints his fantastical blooms.

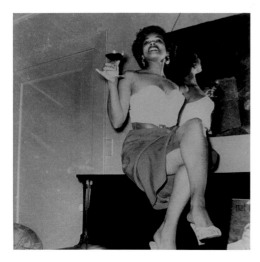

'The posing, the creating of these archetypes – really nothing is learned about her as a person. The insertion of myself, of being a doppelgänger for her – you don't get a sense of who I am, you don't get a sense of who she is, but there's this desire for creating a persona, creating scenarios.'

– Simpson

Lorna Simpson

OPPOSITE AND ABOVE
Summer '57/Summer '09, 2009
Silver gelatin prints
Each print 12.7 × 12.7 cm /
5 × 5 in.

In 2009 Simpson did something unusual in her practice – she inserted herself into her work. She had bought a photograph album on eBay, which was full of small black-and-white images of an unknown African-American woman in Los Angeles from the summer of 1957. Looking at these images, Simpson decided to mimic the woman's poses, and her work *Summer '57/ Summer '09* began. Studying the woman's tight clothes and glamour poses – she answers the telephone in a baby doll nightie; pouts in the garden in micro shorts; is coquettish on the sofa in a pencil skirt – Simpson realized the woman had created a portfolio of poses. Nothing of herself, her personality, had been included; these were carefully orchestrated scenes to show her slim figure and attractive face from all angles, in all lights, staged in a domestic setting akin to those found in Doris Day movies but featuring

a black leading lady. Did this unknown woman have aspirations to be an actress? A model? Her photographs were performances for the camera, for a male viewer, at a time – Simpson has noted – when segregation was still widespread in America. What were realistic aspirations for a single black woman in California in the 1950s? By inserting herself into the work, recreating the poses and settings of the originals, Simpson asks what has changed in the ensuing fifty-two years for women, and in particular for black women. Simpson takes the woman's private archive of staged scenes and makes them public, giving her the stage she so actively desired, but all the while raising questions concerning the male gaze and the voyeurism of looking at images of women in art, in photographs and in society.

Cindy Sherman

A feathered 'bride' stands on a mossy outcrop, a ravine cutting through the landscape behind her, moorland stretching into the distance. But this modern-day Cathy does not seem about to run across the hills. Instead she stands stock still, as if for a studio portrait, at odds with the romantic landscape that appears underfoot. In front of her, in a white suit that nods to both the military and the kitchen, stands a guardian figure, tall and still, hands clasped together. Who are these women? What are they doing? Where are they from? Are they historic or contemporary? Do they even know each other? This photograph, *Untitled #548* (2010–12), is from a recent series by Sherman. For it she photographed desolate landscapes in Italy and Iceland and raided the couture archive of Chanel, posing in a selection of borrowed outfits in front of a green screen in her studio. She

assumed a number of characters, inspired by Chanel's collections, and then retreated to her computer to knit everything together. Sherman has been using herself as model, stylist, director and photographer for over thirty years, and in her latest photographs she still continues to question the role of women and the guises they adopt throughout history. From her 1970s *Untitled (Film Stills)* series to her clowns, centrefolds and historic women, she continues to morph and change in front of our eyes, asking us to consider the complexity of identity and its internal and external contributing factors.

ABOVE
Untitled #548, 2010–12
C-print
179.1 × 353.1 cm / 70½ × 139 in.

OPPOSITE
Untitled #540, 2010–12
C-print
180.3 × 221.3 cm / 71 × 87⅛ in.

'For the longest time I was trying to lose myself in the work, literally and figuratively, so that I would never be recognized. Not just that it wouldn't look like me but that it wouldn't look like any of the other characters I'd done before. Just a few years ago, relaxing about that and not feeling this pressure to hide kind of freed me up.'

– Sherman

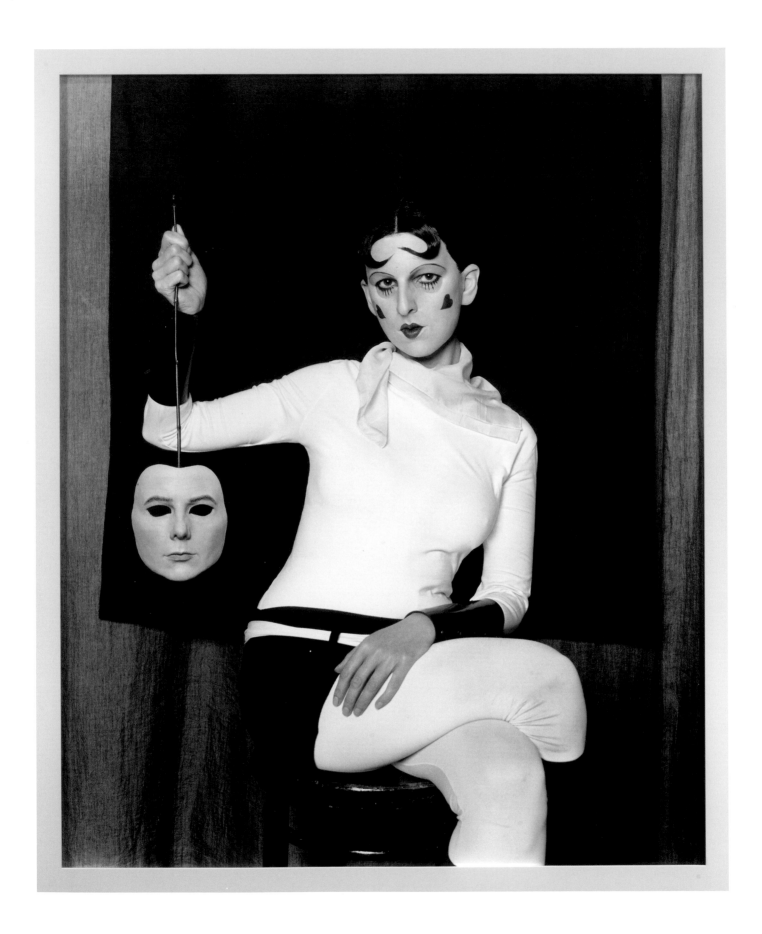

Gillian Wearing

Wearing's early work explored the boundary between private thought and public image in the construction of identity, both collective and personal. More recently she has focused on her own transformation, using prosthetics and photography to manipulate her self-image, turning into her mother, her father, her younger self, and herself in 2011 (as in *Self Portrait of Me Now in Mask*, 2011). In an ongoing series Wearing has also transformed herself into various photographers who have influenced her, and who themselves pushed at the boundaries of identity, such as Robert Mapplethorpe in *Me as Mapplethorpe* (2009) and Andy Warhol in *Me as Warhol in Drag with Scar* (2010, page 7). In 2012 she posed as Claude Cahun in *Me as Cahun Holding a Mask of My Face*. Cahun, a French surrealist photographer, challenged concepts of gender and used photography to her own

ends, exploiting its seemingly documentary status to transform herself repeatedly, from a kiss-curled Pierrot (*Don't kiss me…*, 1927–29) to a shaven-headed conjoined twin (*What Do You Want From Me?*, 1928). In the photograph *Me as Cahun…* Wearing acknowledges Cahun's role in photographic history while adding a further layer of complexity: Wearing becomes Cahun while holding a life cast of Wearing's own face in her hand.

Artists' Biographies

NJIDEKA AKUNYILI CROSBY / 26

Born 1983, Enugu, Nigeria
Lives in Brooklyn, USA
MFA Yale University School of Art, New Haven CT, USA, 2011
Post-Baccalaureate Certificate Pennsylvania Academy of Fine Arts, Philadelphia PA, USA, 2006
BA Swarthmore College, Swarthmore PA, USA, 2004

Select solo and two-person shows
2013 Franklin Art Works, Minneapolis
Tiwani Contemporary, London
Sensei Exchange, New York
Gallery Zidoun, Luxembourg

Selected group exhibitions
2014 'Meeting in Brooklyn', Landcommandery of Alden-Biesen, Bilzen
'Shakti', Brand New Gallery, Milan
2013 'Jump Cut', Marianne Boesky Gallery, New York
'Bronx Calling: The Second Bronx Biennial', Bronx Museum New York
'Cinematic Visions: Paintings at the Edge of Reality', Victoria Miro, London

Further reading
Ong, A., 'Showcase: Njideka Akunyili', *Elephant*, Issue 17, winter 2013/14
Scheffler, D., 'Brooklyn Inspires African Artists', *The New York Times*, 14 Oct 2014
Wyatt, D., 'Things Fall Into Two Parts: Artist Njideka Akunyili Tells a New Nigerian Story', *The Independent*, 17 Oct 2013

Contact
njidekaakunyili.com

MARK ALEXANDER / 112

Born 1966, Horsham, England
Lives and works in London, England
BFA Ruskin School of Drawing and Fine Art, Oxford, England, 1996

Select solo shows
2014 Mannheim Paintings, Galerie Bastian, Berlin
2013 American Bog, Broadway 1602 Gallery, New York
2012 Ground and Unground, Wilkinson Gallery, London

Select group shows
2013 'Green Flower Street, curated by Ariel Roger-Paris', Tatiana Kourochkina

Galleria D'Art, Istanbul
2012 'power FLOWER: Blüten Zauber in der Zeitgenössischen Kunst', Galerie ABTART, Stuttgart
2011 'Ars Apocalipsis, Kunst und Kollaps', Kunstverein Kreis, Veerhoffhaus, Gütersloh

Further reading
'Andrew Graham-Dixon in Berlin with Mark Alexander (Pt 1)', www.youtube.com, 21 Oct 2009
Searle, A., 'Mark Alexander', *The Guardian*, 30 Mar 2005
'Lives of the Artist: Interview', *Areté*, vol. 17, spring/summer 2005

Contact
www.markalexanderart.com
www.wilkinsongallery.com

CHARLES AVERY / 118

Born 1973, Oban, Scotland
Lives and works in London, England and Mull, Scotland
Self-taught

Select solo shows
2015 Gemeente Museum, The Hague
2014 Galleria S.A.L.E.S, Rome
2013 Pilar Corrias, London

Select group shows
2014 'Feels like Heaven', Sommer Contemporary Art, Tel Aviv
'The Great Acceleration: Art in the Anthropocene', Taipei Biennial, Taipei
2013 'Revealed2: CollectorSpace', Anne and Gordon Samstag Museum of Art, University of South Australia, Adelaide
'The World is Almost Six Thousand Years Old', Collection and Usher Gallery, Lincoln
2012 'Galicia: Topographies of Myth', SOKOL, Nowy S cz

Further reading
Fite-Wassilak, C., 'Charles Avery: Parasol Unit', *Frieze*, Nov/Dec 2008
Spira, A., 'Charles Avery', *MAP*, issue 16, winter 2008/9
Zechlin, R. ed., *Charles Avery: Onomatopoeia. The Port*, Walther Konig, 2010

Contact
www.pilarcorrias.com

ALI BANISADR / 108

Born 1976 Tehran, Iran
Lives and works in Brooklyn, USA

MFA New York Academy of Art, USA, 2007
BFA School of Visual Arts, New York, USA, 2005

Select solo shows
2015 Blain|Southern, London
2014 Sperone Westwater, New York
2012 Galerie Thaddaeus Ropac, Salzburg
2011 Leslie Tonkonow Artworks + Projects, New York

Select group shows
2014 'Eurasia: A view on Painting', Galerie Thaddaeus Ropac, Pantin
'Between Worlds', Galerie Isa, Mumbai
2013 'Love Me, Love Me Not: Contemporary Art from Azerbaijan and its Neighbours, 55th Venice Biennale, Venice
'Expanded Painting', Prague Biennial 6, Prague
'Cinematic Visions: Painting at the Edge of Reality', Victoria Miro Gallery, London
2012 'The Sound of Painting', Palazzo Saluzzo Paesana, Turin
2011 'East Ex East', Brand New Gallery, Milan

Further reading
Cohen, D., 'Brueghel meets Mughal: Ali Banisdadr at Sperone Westwater', *ArtCritical*, Apr 2014
Denson, G. R., 'Going Forward in Reverse: The present Tense(ion) of History Painting', www.huffingtonpost.com, 7 Sep 2012
Wei, L., 'Ali Banisadr: Interview', *Studio International*, June 2014

Contact
www.alibanisadr.com
www.blainsouthern.com

TILO BAUMGÄRTEL / 138

Born 1972, Leipzig, Germany
Lives and works in Leipzig, Germany
Hochschule für Grafik und Buchkunst, Leipzig, Germany, 1991–2000

Select solo shows
2014 GOGO, Māksla XO, Riga
2012 Patron, Christian Ehrentraut, Berlin
2011 Galerie Kleindienst, Leipzig

Select group shows
2013 'Beautiful Landscape, Threatening Nature: Old Masters in Dialogue with Contemporary Art', Kunsthalle Osnabrück

2012 'Painting of Uncertain Places', Frankfurter Kunstverein, Frankfurt

Further reading
Lublow, A., 'The New Leipzig School', *The New York Times*, 8 Jan 2006
Sumpter, H., 'Tilo Baumgärtel', *Time Out*, Sep 2009

Contact
www.wilkinsongallery.com

MARIUS BERCEA / 128

Born Cluj-Napoca, Romania
Lives and works in Cluj-Napoca, Romania
MA University of Art and Design, Cluj-Napoca, Romania, 2005
BA University of Art and Design, Cluj-Napoca, Romania, 2003

Select solo shows
2014 Blain|Southern, London
2012 François Ghebaly Gallery, Los Angeles
2011 Blain|Southern, London

Select group shows
2014 'The Art School of Cluj', Województwo Małopolskie, Kraków
'Between Worlds', Galerie ISA, Mumbai
2013 'Hotspot Cluj – New Romanian Art', Arken Museum of Modern Art, Copenhagen

Further reading
Schwabsky, B., 'Scenes form the mirage' in *Marius Bercea*, exh. cat., Blain Southern, 2014
Waters, L., 'Review: Marius Bercea at Blain/Southern', *Apollo*, 8 Apr 2014
Hotspot Cluj – New Romanian Art, exh. cat., ARKEN Museum of Modern Art, DK, 2013

Contact
www.blainsouthern.com

KATHERINE BERNHARDT / 156

Born 1975, St Louis MO, USA
Lives and works in New York, USA
MFA School of Visual Arts, New York, USA, 2000
BFA School of the Art Institute of Chicago, USA, 1998

Select solo shows
2014 China Art Objects Galleries, Los Angeles
Canada NY, New York
2013 Roberto Paradise, San Juan
2012 Loyal Gallery, Malmo

Select group shows
2014 'Live and Let Die', Stuart Shave/
 Modern Art, London
'Don't Look Now', Zach Feuer Gallery,
 New York
2013 'The Triumph of Human Painting',
 Bull and Ram, New York
2012 'The State, Domination Hegemony
 and the Panopticon', Traffic, Dubai

Further reading
Bollen, C., 'Katherine Bernhardt',
 Interview, Dec/Jan 2009
Church, A., 'Katherine Bernhardt',
 Flash Art, Nov/Dec 2010
Smith, R., 'Katherine Bernhardt: Stupid,
 Crazy, Ridiculous, Funny Patterns',
 The New York Times, 20 Feb 2014

Contact
www.canadanewyork.com

STEPHEN BUSH / 126

Born 1958, Colac, Australia
Lives in Melbourne, Australia
Graduate Diploma of Fine Arts, Royal
 Melbourne Institute of Technology,
 Australia, 1979
BFA Royal Melbourne Institute of
 Technology, Australia, 1976–78

Select solo shows
2012 Sutton Gallery, Melbourne
Volta art Fair, New York
2010 Melbourne Art Fair, Melbourne
Sutton Gallery, Melbourne

Select group shows
2013 'Mix Tape 1980s: Appropriation,
 Subculture, Critical Style', The Ian
 Potter Centre: National Gallery
 Victoria, Melbourne
2012 'Negotiating This World:
 Contemporary Australian Art',
 National Gallery Victoria, Melbourne
2011 'Marie Celeste', Artspace,
 New Haven CT

Further reading
Coates, R., 'Stephen Bush: Toxic Utopias',
 Art World, Oct/Nov 2008
Statton, L., 'Stephen Bush: Unconditional
 Reinvention' in *Stephen Bush: Steenhuf-*
 fel, exh. cat., The Ian Potter Museum of
 Art/University of Melbourne, 2014

Contact
www.stephenjbush.com
www.suttongallery.com.au

CARLA BUSUTTIL / 136

Born 1982, Johannesburg, South Africa
Lives and works in Oxford, England
Postgraduate Diploma Fine Art, Royal
 Academy Schools, London,
 England, 2008

BA (Hons) (Fine Art) University of
 Witwatersrand, Johannesburg, South
 Africa, 2004

Select solo shows
2013 Josh Lilley Gallery, London
2012 Goodman Gallery, Johannesburg
2011 Josh Lilley Gallery, London

Select group shows
2013 'Post-National Bliss', Goodman
 Gallery, Cape Town
2012 'Creative London, Space_K',
 touring Seoul, Gwangju, Gwacheon
2011 'British Art Now: Saatchi in
 Adelaide', Adelaide

Further reading
Beers, K. (ed.), *100 Painters Of Tomorrow*,
 Thames & Hudson, 2014
Lass, A., 'Anne Lass in conversation with
 Carla Busuttil', *Platinum Love*, 22
 Apr 2014
Leiman, L., 'Exit Mode',
 www.mahala.co.uk, 11 Apr 2012

Contact
carlabusuttil.com
www.joshlilleygallery.com

GORDON CHEUNG / 124

Born 1975, London, England
Lives and works in London, England
MFA Royal College of Art, London,
 England, 1999–2001
BFA Central Saint Martins College of Art
 and Design, London, England 1995–98

Select solo shows
2015 Edel Assanti Gallery, London,
2012 Touchstones Rochdale
2011 Alan Cristea Gallery, London

Select group shows
2014 'How to Explain Pictures to a Dead
 Hare', Pristine Gallery, Monterrey
2014 'Look at Me: Portraiture from
 Manet to the Present', Leila Heller
 Gallery, New York
2012 'Wild New Territories', Camley
 Park, London touring to Vancouver
 and Berlin

Further reading
Carey, P., 'Interview with Gordon
 Cheung', *Art World*, Feb/Mar 2009
Hobson, P. 'Hacking into the present' in
 Four Horsemen of the Apocalypse, exh.
 cat., New Art Gallery Walsall, 2009

Contact
www.gordoncheung.com
www.edelassanti.com

NIK CHRISTENSEN / 130

Born 1973, Bromley, England
Lives and works in Amsterdam,
 the Netherlands
Rietveld Academie, Amsterdam,
 the Netherlands, 1996–2000

Select solo shows
2014 Galerie Gabriel Rolt, Amsterdam
2011 Galerie Gabriel Rolt, Amsterdam
2010 Gallery Conradi, Hamburg
De Brakke Grond, Amsterdam

Select group shows
2014 'Natuurkracht', Coda Museum,
 Apeldoorn
2013 'BUE-AMS', Schlifka/Molina
 Gallery, Buenos Aires
2012 'Met Andere Ogen', Teylers
 Museum, Haarlem

Further reading
Alessi, A., 'Nik Christensen: The Lower
 Depths', www.artslant.com, Oct 2011
Siddall, L., 'Nik Christensen',
 www.itsnicethat.com, 2 Nov 2011

Contact
www.nikchristensen.com
www.gabrielrolt.com

NIGEL COOKE / 122

Born 1973, Manchester, England
Lives and works in London, England
PhD (Fine Arts) Goldsmiths University
 of London, England, 1999–2004
MA (Painting) Royal College of Art,
 London, England, 1995–97
BA (Hons) (Fine Art) Nottingham Trent
 University, England, 1991–94

Select solo shows
2013 Modern Art, London
Douglas Hyde Gallery, Trinity College,
 Dublin
2012 Andrea Rosen Gallery, New York
2011 Goss Michael Foundation, Dallas
Blum & Poe, Los Angeles

Select group shows
2012 'Hidden Stories', KAI 10, Düsseldorf
2010 'Skin Fruit: Selections from the Dakis
 Joannou Collection', New Museum,
 New York

Further reading
Conner, J., 'Nigel Cooke
 Confronts Painted Reality',
 www.interviewmagazine.com, 2012
Wood, E., 'Nigel Cooke: Blum & Poe,
 LA', *Flash Art*, Mar/Apr 2011
Wullschlager, J., 'Lars Elling',
 Financial Times, 27 Mar 2011

Contact
nigelcooke.net
www.pacegallery.com

JESSICA CRAIG-MARTIN / 154

Born 1963, Hanover NH, USA
Lives and works in New York, USA
International Center of Photography,
 New York, USA, 1996–97
Parsons The New School for Design,
 New York, USA, 1995–96
New York University, New York,
 USA, 1982–84

Select solo shows
2014 Winston Wächter Fine Art, Seattle
2012 Galerie Andres Thalmann, Zürich
2009 Galerie 64bis, Paris

Select group shows
2013 'Best Dressed/Undressed',
 Winston Wächter Fine Art, Seattle
2011 'Being American', Visual Arts
 Gallery, School of Visual Arts,
 New York
'Exhibition A', Colette, Paris
2010 'Secrets', Space 15 Twenty,
 Los Angeles

Further reading
Kennedy, M. H. and Fang, H. (eds),
 New York: A Photographer's City,
 Rizzoli, 2011
Upchurch, M., 'Twisted takes on summer
 wear at Winston Wächter', *The Seattle*
 Times, 26 July 2014
Being American, exh. cat., Visual Arts
 Gallery, New York, 2011

Contact
seattle.winstonwachter.com

NICOLE EISENMAN / 98

Born 1965, Verdun, France
Lives and works in New York, USA
BFA Rhode Island School of Design,
 Providence, USA, 1987

Select solo shows
2015 The Jewish Museum, New York
Museum of Contemporary Art San Diego
2014 Van Horn, Düsseldorf
Institute of Contemporary Art,
 Philadelphia
2013 Berkeley Art Museum

Select group shows
2014 'Manifesta 10', Hermitage
 Museum, St Petersburg
'New Dawn', Silberkupper, Berlin
2013 'Carnegie International', Carnegie
 Museum of Art, Pittsburgh
2012 'Whitney Biennial', Whitney
 Museum of American Art, New York

Further reading
Jones, S., 'Painting and Power Tools
 with Nicole Eisenman',
 www.yaledailynews.com, 31 Oct 2014
Sillman, A., 'Nicole Eisenman',
 Artforum, May 2013

Simmons, W. J., 'Taxi Ride to Gauguin:
 An Interview with Amy Sillman and
 Nicole Eisenman' *Haunt Journal
 of Art*, 2014

Contact
www.vielmetter.com

JUDITH EISLER / 40

Born 1962, Newark NJ, USA
Lives and works in New York, USA
 and Vienna, Austria
BFA Cornell University, Ithaca,
 New York, USA 1984

Select solo shows
2012 Krobath, Vienna
2009 Krobath, Vienna

Select group shows
2011 'Vanishing Point: Paint and
 Paintings from the Collection of Debra
 and Dennis Scholl', Bass Museum
 of Art, Miami
2009 'Infinitesimal Eternity', Yale
 University, New Haven
 'The Female Gaze', Cheim and Read,
 New York
2007 'Painting of Modern Life',
 Hayward Gallery, London

Further reading
Bollen, C., 'Judith Eisler', *Interview*,
 Oct 2008
Strohner, I., 'Judith Eisler: Rodeo Season',
 Haupstadt, May 2009
Wiener, E., 'I Don't Believe It, I Won't
 Let it Happen', *Artforum*, Oct 2008

Contact
www.juditheisler.com
www.gavlakgallery.com

LARS ELLING / 66

Born 1966, Trondheim, Norway
Lives and works in Oslo, Norway
MA Bergen National Academy of the
 Arts, Norway, 1993
BA Bergen National Academy of the
 Arts, Norway, 1988–92

Select solo shows
2014 Haugesund Museum of Fine Art,
 Haugesund
2013 Galleri Brandstrup, Oslo
 Kunstverket Galleri, Oslo
2012 Galleri Norske Grafikere, Oslo
2010 Thomas Williams, London

Select group shows
2014 'Reinhard Haverkamp, Lars Elling',
 Vedholmen Galleri, Lepsøy
2013 'Meshes of the Afternoon',
 Sean Kelly, New York
2010 'Portraits', Galleri Ismene,
 Trondheim

Further reading
Domitran, R., 'Lars Elling:
 Simultaneously and Close',
 www.artworldnow.com, 12 Mar 2013
Werner, A.-L., 'Interview with Lars
 Elling', www.artfridge.de,
 25 Mar 2011

Contact
www.larselling.no
brandstrup.no

ADRIAN GHENIE / 32

Born 1977, Baia Mare, Romania
Lives and works in Cluj, Romania
 and Berlin, Germany
University of Art and Design,
 Cluj, Romania, 2001

Select solo shows
2015 MAC Belfast
2014 CAC Málaga
 Pace London
 Galerie Judin, Berlin
 Tim Van Laere Gallery, Antwerp
2013 Museum of Contemporary Art,
 Denver

Select group shows
2014 Centre Pompidou, Paris
 'Love Story', Winter Palace and 21er
 Haus, Belvedere, Vienna
2013 'Nightfall', Galerie Rudolfinum,
 Prague
2012 'Castle in the air: A séance of
 imagination', Centre of Culture
 ZAMEK, Poznan
 'Six Lines of Flight', SF MOMA,
 San Francisco

Further reading
Gartenfeld, A., 'Adrian Ghenie',
 Interview, Dec 2011
Wolff, R., 'Adrian Ghenie: The Past is
 Present', *Art + Auction*, Mar 2013

Contact
www.timvanlaeregallery.com
www.pacegallery.com

SIMONE HAACK / 142

Born 1978, Rotenburg an der
 Wümme, Germany
Lives and works in Berlin and
 Bremen, Germany
École Nationale Supérieure des Beaux-Arts
 Paris, France, 2004–5
Unitec School of Art and Design in
 Auckland, New Zealand, 2000–1
University of the Arts Bremen,
 Germany, 1997–2004

Select solo shows
2014 Galerie Obrist, Essen
 Galerie Anke Zeisler, Berlin
 Kunstverein Heinsberg

 Artdocks Bremen
2012 Galerie Beim Steinernen
 Kreuz, Bremen

Select group shows
2014 'Species', Kunstverein Gera
2013 'Mutterbild', Galerie Schmalfuss,
 Marburg
 'Small World', Galerie im Park, Bremen
 'Sometimes it takes hours to disappear',
 Kreuzberg Pavillon, Berlin

Further reading
Nierhoff, B., 'Between imagination and
 reality: the imagery of Simone Haack',
 www.artnews.org, 2006
Tannert, C., 'Alla Prima Painting made
 of Realism, Terror, and the Everyday'
 in *Simone Haack: The Others*, exh. cat.,
 Kerber, 2012

Contact
www.simone-haack.de
www.galerie-obrist.de

SUSIE HAMILTON / 22

Born 1950, London, England
Lives and works in London, England
Diploma (Fine Art) Byam Shaw School
 of Art, London, England 1989–92
BA, PhD London University, England
 1981–89
Dip AD (Fine Art) Central Saint Martins
 School of Art, London, England
 1968–72

Select solo shows
2015 The House of St Barnabas, London
2011 St Giles Cripplegate, London
2009 Paul Stolper, London
 Galleri Hugo Opdal, Flo

Select group shows
2015 'Promised Lands', Sarah O'Kane
 Contemporary Fine Art, St Anne's
 Galleries, Lewes
2014 'John Moores Painting Prize',
 The Walker Art Gallery, Liverpool
 'Reinvention', The Green Gallery,
 Nashville, Tennessee

Further reading
Dyer, R. and Mullins, C., *Riddled with
 Light*, exh. cat., Paul Stolper, 2006
McNay, A., 'Vacant Lots', *Art-Corpus*,
 Oct 2012
Spencer, C., 'Spying on Zombies',
 Garageland, Oct 2012

Contact
www.susiehamilton.co.uk
www.paulstolper.com

NERMINE HAMMAM / 164

Born 1967, Cairo, Egypt
Lives and works in Cairo, Egypt

 Tisch School of the Arts, New York
 University, USA, 1989

Select solo shows
2014 Rose Issa Projects, London
2012 The Mosaic Rooms in association
 with Rose Issa Projects, London
2010 Safarkhan Gallery, Cairo
 The Townhouse Gallery, Cairo

Select group shows
2014 'The King's Peace: Realism and
 War', Stills: Scotland's Centre for
 Photography, Edinburgh
 'Confluence: Contemporary Photography
 and Video Installation from the Arab
 World', VCU Qatar, Doha,
 'View from Inside', Houston
 Fotofest, Texas
2012 'Light of the Middle East'
 V&A, London

Further reading
Esposti, E. D., 'Nermine Hammam:
 A whisper in a war', www.arabreview.
 org, 2012
Golia, M., *Exposures, Photography and
 Egypt*, Reaktion, 2010
Gresh, K., 'She Who Tells a Story:
 Women *Photographers from Iran and the
 Arab World'*, MFA Publications, 2014

Contact
www.nerminehammam.com
www.roseissa.com

KARIN HANSSEN / 60

Born 1960, Antwerp, Belgium
Lives and works in Antwerp, Belgium
National Higher Institute of Fine Arts,
 Antwerp, Belgium, 1993
Royal Academy of Fine Arts (Painting),
 Antwerp, Belgium, 1990

Select solo shows
2014 Roberto Polo Gallery, Brussels
2012 Canberra Contemporary Art Space
2010 Kunstverein Ahlen

Select group shows
2014 'Re: Painted', S.M.A.K., Ghent
 'Punctum', Salzburger Kunstverein
2013 'Happy Birthday Dear Academie',
 MAS, Antwerp
2012 'Fat Birds Don't Fly', Netwerk, Aalst

Further reading
Mullins, C., *Karin Hanssen: The Borrowed
 Gaze*, Lannoo, 2014
Vanhoutte, K., *The Borrowed Gaze/
 Variations GTB*, MER Paper
 Kunsthalle, 2012
Verbiest, C., 'A women's season', *Flanders
 Today*, 22 Oct 2014

Contact
www.karin-hanssen.be
www.robertopologallery.com

TOM HUNTER / 84

Born 1965, Dorset, England
Lives and works in London, England
BA London College of Printing,
England, 1994
MA (Photography) Royal College of Art,
London, England, 1997

Select solo shows
2013 Birmingham Central Library
(England)
Mission Gallery, Swansea
Print House Gallery, London
RSC, The Roundhouse, London
2012 V&A Museum of Childhood, London

Select group shows
2013 'Making It Up: Photographic
Fictions', V&A Museum, London
2012 'Seduced by Art; Photography
Past & Present', National Gallery,
London
2011 'Another Story', Modern Museet,
Stockholm

Further reading
Hunter, T., *The Way Home*, Hatje Cantz,
2012
Slyce, J., 'All art is local' in *Tom Hunter,
Unheralded Stories*, exh. cat., Purdy
Hicks Gallery, 2010

Contact
www.tomhunter.org
www.purdyhicks.com

YUN-FEI JI / 110

Born 1963, Beijing, China
Lives and works in New York, USA
and Beijing, China
MFA University of Arkansas, Fayetteville
AR, USA, 1989
BFA Central Academy of Fine Arts,
Beijing, China, 1982

Select solo shows
2015 University Museum of
Contemporary Art, Amherst, MA
2013 Krannert Art Museum, Champaign,
IL
2012 Ullens Center for Contemporary
Art in Beijing
2010 James Cohan Gallery, Shanghai

Select group shows
2014 'Prospect 3: New Orleans Biennial',
New Orleans
2012 'Biennale of Sydney, Australia'
2011 'East Da East', Brand New Gallery,
Milan
2008 'Displacement: the Three Gorges
Dam and Contemporary Chinese Art',

Smart Museum of Art, Chicago
and touring

Further reading
Garcia, C., 'Interview: Yun-Fei Ji', *Modern
Painters*, Apr 2010
Pennington, C., 'Water-work: Yun-Fei Ji',
Time Out (Beijing), 25 June 2012
Spears, D., 'Part Traditionalist, Part Nat-
uralist, Part Dissident', *The New York
Times*, 20 Feb 2010

Contact
www.zeno-x.com
www.jamescohan.com

JIA AILI / 120

Born 1979, Dandong, Liaoning
Province, China
Lives and works in Beijing, China
MA (Painting) Lu Xun Academy of Fine
Arts, Shenyang, China, 2006
BA (Painting) Lu Xun Academy of Fine
Arts Shenyang, China, 2004

Select solo shows
2012 Singapore Art Museum
Platform China, Hong Kong
2010 Platform China, Beijing
Cornell University (Hartell Gallery), Ithaca
Iniva, London

Select group shows
2011 'Fly Through the Troposphere:
Memo of the New Generation Paint-
ing', Iberia Center for Contemporary
Art, Beijing
2010 'Jungle – A Close-Up Focus on
Chinese Contemporary Art Trends',
Platform China, Beijing
2009 '10 Years', Lu Xun Academy of Fine
Arts, Shenyang

Further reading
'Jia Aili: interview', www.iniva.org, 2010
'Seeker of Hope: Works by Jia Aili',
www.youtube.com, 31 July 2012

Contact
www.platformchina.org

PAUL JOHNSON / 136

Born 1972, London, England
Lives and works in London, England
MA Royal Academy Schools, London,
England, 2000–3
BA (Hons) (Fine Art, Painting) Glasgow
School of Art, Scotland 1993–96

Select solo shows
2015 Focal Point Gallery, Southend-
on-Sea
Ancient & Modern, London
2013 Usher Gallery, The Collection
Museum, Lincoln

Select group shows
2013 'Paul Johnson & Madge Gill',
The Nunnery, London
2011 'The Rainbow House', Agency
Gallery, London
2010 'Newspeak: British Art Now',
Saatchi Gallery, London
'Big Minis: Fetishes of Crisis', CAPC
centre d'art contemporain de Bordeaux

Further reading
Paul Johnson, *There's something about you
that I'm unsure about*, exh. cat., Usher
Gallery Lincoln, 2013
'Paul Johnson, Usher Gallery, Lincoln',
www.vimeo.com

Contact
www.ancientandmodern.org

JOHNANNES KAHRS / 88

Born 1965, Bremen, Germany
Lives and works in Berlin, Germany
University of the Arts, Berlin,
Germany, 1994

Select solo shows
2014 Kunsthalle Nürnberg
Zeno X Gallery, Gorgerhout Antwerp
2013 Staatliche Kunstsammlungen,
Dresden
2012 CentrePasquArt, Biel
2011 Luhring Augustine, New York

Select group shows
2014 'Donkere kamers, Over melancholie
en depressie', Museum Dr Guislain,
Ghent
2012 'Fruits de la passion', Centre
Georges Pompidou, Paris
2011 'abc: about painting', Station-Berlin,
Berlin

Further reading
Asfour, N., 'Johannes Kahrs', *Time Out*
(New York), 13–19 Oct 2011
Seifermann, E. and Lohrey, A., *Johannes
Kahrs: Tropical Nights*, Verlag für
moderne Kunst, 2014

Contact
www.zeno-x.com

JITISH KALLAT / 162

Born 1974, Mumbai, India
Lives and works in Mumbai, India
Sir J.J. School of Art, Mumbai, India, 1996

Select solo shows
2012 Ian Potter Museum of Art,
Melbourne
2011 Bhau Daji Lad Museum, Mumbai
2010 Arndt, Berlin
Art Institute of Chicago
Haunch of Venison, London

Select group shows
2012 'India: Art Now' Arken Museum,
Ishoj
'Indian Highway IV', MAXXI, Rome
2010 'The Empire Strikes Back: Indian
Art Today', Saatchi Gallery, London

Further reading
Jepsen, C. J., 'Jitish Kallat: Investigating
the City', www.cocreatenow.org, 2012
Public Notice 3: Jitish Kallat, exh. cat.,
Art Institute Chicago, 2011

Contact
www.arndtberlin.com

Y. Z. KAMI / 36

Born 1956, Tehran, Iran
Lives and works in New York, USA
Conservatoire Libre, du Cinema,
Paris, France, 1982
BA, MA University of Paris-Sorbonne,
Paris, France, 1976–81
University of California, Berkeley CA,
USA, 1974–75
Holy Name College, Oakland CA,
USA, 1973

Select solo shows
2014 Gagosian Gallery, New York
2009 National Museum of Contemporary
Art, EMST, Athens
2008 Parasol Unit, London

Select group shows
2014 'Seeing Through Light',
Guggenheim Abu Dhabi
2012 'Contemporary Iranian Art',
The Metropolitan Museum of Art,
New York
2011 'The Mask and the Mirror', Leila
Heller Gallery, New York, USA

Further reading
Kafetski, A., *Y.Z. Kami: Beyond Silence*, exh.
cat., Athens Museum of Contemporary
Art, 2009
Storr, R., *Y.Z. Kami: Paintings*, exh. cat.,
Gagosian Gallery (New York), 2014

Contact
www.gagosian.com

RUPRECHT VON KAUFMANN / 140

Born 1974, Munich, Germany
Lives and works in Berlin, Germany
BFA Art Center College of Design,
Los Angeles, USA, 1995–97
Art Center College of Design (Europe),
La Tour de Peilz, Switzerland, 1995

Select solo shows
2014 Georg Kolbe Museum, Berlin
Museum Abtei Liesborn, Wadersloh-
Liesborn

2013 Junge Kunst, Wolfsburg and Galerie
 Rupert Pfab, Düsseldorf
2012 Galerie Christian Ehrentraut, Berlin

Select group shows
2014 'The Sea', Kunsthalle Brandts,
 Odense
2013 'Edge and Surface', Leipziger Str.61-
 65, Berlin
'Alles Wasser', Galerie Mikael Andersen,
 Copenhagen
2012 'Between Truth and Fiction: Pictorial
 Narratives', Koplin del Rio Gallery,
 Los Angeles

Further reading
Ehrentraut, C. and Pfab, R. (eds), *Ruprecht
 von Kaufmann 2007–10*, Hirmer
 Publishers, 2012
'Interview with Ruprecht von Kaufmann',
 www.neotericart.com, 30 June 2008

Contact
www.rvonkaufmann.com
www.christianehrentraut.com

MARIA KONTIS / 52

Born 1969, Canberra, Australia
Lives and works in the Blue Mountains,
 Australia
MA Fine Art Chelsea College of Art and
 Design, University of the Arts London,
 London, England, 2005
BFA (Hons) College of Fine Arts,
 The University of New South Wales,
 Sydney, Australia, 1999
BA Australian National University,
 Canberra, Australia, 1991

Select solo shows
2013 Darren Knight Gallery, Sydney
2009 Gitte Weise Galerie, Berlin

Select group shows
2012 'Look Closely Now, Lake Macquarie
 City Gallery, New South Wales
2010 'Beleura National Works on Paper',
 Mornington Peninsula Regional
 Gallery, Mornington, Victoria
2009 'I walk the line: new Australian
 drawing', Museum of Contemporary
 Art, Sydney
'Australian Art For Berlin', Gitte Weise
 Galerie, Berlin

Further reading
Flynn, P., 'Maria Kontis', *Artist Profile*,
 issue 8, 2009, pp. 44–47
I walk the line: New Australian Drawing,
 exh. cat., Museum of Contemporary
 Art (Sydney), 2009

Contact
www.darrenknightgallery.com

SUSANNE KÜHN / 146

Born 1969, Leipzig, Germany
Lives and works in Freiburg, Germany
MFA (Painting and Graphic Art)
 Hochschule für Grafik und Buchkunst,
 Leipzig, Germany, 1995

Select solo shows
2014 Beck&Eggeling, Düsseldorf
2012 Städtische Galerie Offenburg
2011 Haunch of Venison, London
2010 Kunstverein Lippe
Robert Goff Gallery, New York

Select group shows
2013 'Inside', Merkur Art Gallery
 Istanbul
2012 'Contemporary German Painting:
 The Future Lasts Forever', Interalia,
 Seoul
'Malerei der ungewissen Gegenden',
 Kunstverein Frankfurt
2011 'The Big Reveal', Kemper Museum,
 Kansas City

Further reading
Kunitz, D., 'Brush in the Water', *Modern
 Painters*, Apr 2011
Auslander, P., 'Susanne Kühn: Museum of
 Contemporary Art, Denver', *Artforum*,
 Dec 2008, p. 309
Brandenburger-Eisele, G. and Ulmer,
 B., *Susanne Kühn: Works 2006–2012*,
 Städtische Galerie Offenburg, 2012

Contact
www.susannekuehn.com
www.beck-eggeling.de

LAURA LANCASTER / 44

Born 1979, Hartlepool, England
Lives and works in Newcastle upon Tyne,
 England
BA (Hons) (Fine Art) Northumbria
 University, England, 1998–2001

Select solo shows
2015 Musée d'art Moderne de Saint-
 Etienne
2014 Wooson Gallery, Daegu
Workplace London
2013 Workplace Gallery, Gateshead

Select group shows
2014–15 'British Council Touring
 Exhibition', Okayama Prefectural
 Museum of Art, Tokyo Station Gallery,
 Itami City Museum of Art, Osaka and
 Museum of Art, Kochi
2013 'Painting past Present', Laing Art
 Gallery, Newcastle upon Tyne
2012 John Moores Painting Prize, Walker
 Art Gallery, Liverpool

Further reading
'Laura Lancaster reanimates images

through painting', www.huffingtonpost.
 com, 21 Mar 2012
'Interview: Laura Lancaster',
 www.johnjones.co.uk, undated

Contact
www.workplacegallery.co.uk

WOLFE VON LENKIEWICZ / 104

Born 1966, Dartmoor, England
Lives and works in London, England
BA (Philosophy), University of York,
 England, 1989

Select solo shows
2015 Aeroplastics contemporary, Brussels
2014 Riflemaker, London
2013 All Visual Arts, London

Select group shows
2013 'Viewing Room', All Visual Arts,
 London
2012 'Misunderstood', Noga Gallery
 of Contemporary Art, Tel Aviv
2011 'Mémoires du futur', La Maison
 Rouge, Paris

Further reading
Dyer, R., *The Descent of Man*, exh. cat.,
 All Visual Arts, 2009
Mikhilovsky, S. et al, *Victory Over the Sum*,
 exh. cat., Triumph Gallery,
 Moscow, 2010

Contact
www.wolfevonlenkiewicz.com

LI SONGSONG / 70

Born 1973, Beijing, China
Lives and works in Beijing, China
BFA Central Academy of Fine Arts,
 Beijing, China, 1996
Subsidiary School of the Central
 Academy of Fine Arts in Beijing,
 China, 1992

Select solo shows
2013 Pace London
2012 Pace Beijing
2011 The Pace Gallery, New York

Select group shows
2013 '28 Chinese', Contemporary Arts
 Foundation, Miami
2012 'Real Life Stories', Bergen Art
 Museum
2009 'Red Storm', Rijksmuseum,
 Amsterdam

Further reading
Mackenzie, C. et al, *The Chinese Art Book*,
 Phaidon, 2013
Paparoni, D., and Ai Weiwei, *Li Songsong:
 We Have Betrayed the Revolution*, exh.
 cat., Pace London, 2013
Weight of History: The Collectors Show 2013,

exh. cat., Singapore Art Museum, 2013,
 pp. 49–52

Contact
www.pacegallery.com

LIU XIAODONG / 160

Born 1963, Jincheng, Liaoning, China
Lives in Beijing, China
Academy of Fine Arts, University of
 Complutense, Madrid, Spain, 1999
BFA Central Academy of Fine Arts,
 Beijing, China, 1988
MFA Central Academy of Fine Arts,
 Beijing, China, 1995

Select solo shows
2013 Seattle Art Museum, Seattle
Today Art Museum, Beijing
Mary Boone Gallery, New York
2012 Kunsthaus Graz

Select group shows
2013 'Host & Guest', Tel Aviv Museum
 of Art, Tel Aviv
2012 'Face', Minsheng Art Museum,
 Shanghai
2011 'Collecting History: China New Art',
 MOCA, Chengdu
'A New Horizon: Contemporary Chinese
 Art', National Museum of Australia,
 Canberra

Further reading
Martin, B., 'Liu Xiaodong: life as he
 knows it', *Financial Times*, 4 Aug 2013
Pollack, B., 'Keeping It Real', *Art News*,
 Mar 2011, pp. 96–103
Rigdol, T., 'Over the Tanggula Pass:
 Liu Xiaodong's Paintings of Tibet',
 Art Asia Pacific, May 2008, pp. 80–81

Contact
www.maryboonegallery.com

PERE LLOBERA / 168

Born 1970, Barcelona, Spain
Lives and works in Amsterdam,
 the Netherlands
Rijksakademie van Beeldende Kunsten,
 Amsterdam, the Netherlands, 2006–7
University of Valladolid (History and
 Aesthetic of the Cinematography),
 Spain, 1992
Sant Jordi Faculty Barcelona (Fine Arts),
 Spain, 1989–93

Select solo shows
2014 Galería Fúcares, Madrid
Bradwolff Projects, Amsterdam
2013 Fons Welters Gallery, Amsterdam

Select group shows
2014 'I, Chronicle: Narrative, History and
 Subjectivity', Fabra i Coats Contempo-
 rary Art Centre, Barcelona

'Nothing but good life', Park, Platform
for Visual Art, Tilburg
2012 'From a Painter's Perspective',
Arti et Amicitiae, Amsterdam

Further reading
Commandeur, I., 'I am not cool: Pere
Llobera', *Metropolis M*, May 2010
Hontoria, J., 'Pere Llobera', *Artforum*,
July 2013

Contact
www.perellobera.com
www.spruethmagers.com

TALA MADANI / 166

Born 1981, Tehran, Iran
Lives and works in Los Angeles, USA
MFA (Painting) Yale University, New
Haven, USA, 2004–6
BFA (Visual Arts and BFA Political
Science) Oregon State University,
Corvallis, USA, 1999–2004

Select solo shows
2014 Centro Andaluz de Arte Contem-
poráneo, Seville
Nottingham Contemporary, Nottingham
2013 Moderna Museet, Malmö; Moderna
Museet, Stockholm
Utah Museum of Contemporary Art,
Salt Lake City

Select group shows
2014 'The Great Acceleration: Art in the
Anthropocene', Taipei Biennial, Taiwan
'Where are we Now?', 5th Marrakech
Biennale, Marrakech
'In the Near Future', The Museum of
Modern Art, Warsaw
2013 'Made in Space', Gavin Brown
Enterprise, New York
'NO BORDERS: Contemporary art in a
globalised world', Bristol Museum and
Art Gallery, Bristol

Further reading
Amirsadeghi, H., *Different Sames: New
Perspectives in Contemporary Iranian Art*,
Transglobe Publishing, 2009
Masters, H. G. 'Stop(ped) Making Sense',
Art Asia Pacific, issue 81, 2012
Moshayedi, A., 'Men without Women',
Frieze, issue 152, 2013

Contact
www.pilarcorrias.com

KERRY JAMES MARSHALL / 94

Born 1955, Birmingham, Alabama, USA
Lives and works in Chicago, USA
BFA Otis Art Institute, Los Angeles,
USA, 1978

Select solo shows
2014 David Zwirner, London

2013 Contemporary Art Museum,
St Louis MO
National Gallery of Art, Washington DC
Museum van Hedendaagse Kunst,
Antwerp and touring
2012 Arthur M. Sackler museum,
Harvard University, Cambridge MA

Select group shows
2014 'An appetite for painting:
contemporary painting 2000–2014',
The National Museum of Art,
Architecture and Design, Oslo
'When the Stars Begin to Fall:
Imagination and the American South',
The Studio Museum in Harlem,
New York and touring
2013 'Etched in Collective History',
Birmingham Museum of Art, AL
2012 'SuperHUMAN', Central Utah
Arts Center, Ephraim UT

Further reading
De Wachter, E. M., 'What You See:
Visibility, Identity and Black People
on Mars: In conversation with Kerry
James Marshall', *Frieze*, Jan/Feb 2014
Kantor, J., 'Kerry James Marshall',
Artforum, Jan 2011
Kravagna, C., 'Kerry James Marshall:
Secession, Vienna', *Artforum*,
Feb 2013

Contact
www.davidzwirner.com

MARILYN MINTER / 38

Born 1948, Shreveport, Louisiana, USA
Lives and works in New York, USA
MFA (Painting) Syracuse University,
Syracuse, USA, 1972
BFA University of Florida, USA, 1970

Select solo shows
2013 Parkett Space, Zürich
2011 Salon 94 Bowery, New York
Deichtorhallen, Hamburg
Team Gallery, New York

Select group shows
2014 'Killer Heels: The Art of the
High-Heeled Shoe', Brooklyn Museum,
New York
'Gorgeous', SFMOMA at the Asian Art
Museum, San Francisco
'Painting & The Painterly', Louisiana
Museum of Modern Art, Humlebæk
2012 'Riotous Baroque: From Cattelan
to Zurbaran' Kunsthaus Zürich and
Guggenheim Museum, Bilbao

Further reading
Burton, J. et al, *Marilyn Minter*, Gregory
R. Miller & Co., 2010
Curiger, B. (ed.), *Riotous Baroque*, exh. cat.,
Kunsthaus Zürich, 2013

Slenske, M., 'Marilyn Minter's Precious
Metals', *Interview*, 28 Oct 2011

Contact
www.marilynminter.net
www.regenprojects.com

ELEANOR MORETON / 56

Born 1956, London, England
Lives and works in London, England
MA (Painting) Chelsea College of Art,
London, England 1999
MA (Art History) University of Central
England, Birmingham, England, 1996
Post Graduate Diploma (Art History)
University of Central England,
Birmingham, England, 1993
BA (Painting) Exeter College of Art,
England, 1979

Select solo shows
2014 Ceri Hand Gallery, London
2012 Jack Hanley Gallery, New York
2010 Ceri Hand Gallery, Liverpool
Harewood House, Leeds

Select group shows
2013 'A Painter's Craft', Laing Art
Gallery, Newcastle upon Tyne
'Rituals Are Tellers Of Us', Newlyn Art
Gallery, Newlyn
2011 'Make Believe', Galerie Magnus
Karlsson, Stockholm
2010 'Behind the Mask', The New Art
Gallery Walsall

Further reading
Chaundy, B., 'Eleanor Moreton: Tales of
Love and Darkness', www.huffington-
post.co.uk, 17 Mar 2014
Yvette Greslé, 'Eleanor Moreton:
I See the Bones in the River',
www.fadwebsite.com, 24 Nov 2012
'Eleanor Moreton: visiting speaker.
Hull School of Art & Design',
www.youtube.com, 3 Oct 2013

Contact
www.cerihand.co.uk

JUSTIN MORTIMER / 30

Born 1970, London, England
Lives and works in London, England
BFA Slade School of Art, London,
England 1988–92

Select solo shows
2015 Parafin, London
Djanogly Gallery, University of
Nottingham
Future Perfect, Singapore
2012 Haunch of Venison, London
2011 Mihai Nicodim Gallery, Los Angeles

Select group shows
2013 'Are you alright?', MOCCA, Toronto

2012 'The Observer', Haunch of Venison,
London
'Nightfall', MODEM Centre for Modern
and Contemporary Arts, Debrecen
2011 'Some Domestic Incidents', MAC
Birmingham (England)
'Some Domestic Incidents', Prague
Biennale 5, Prague

Further reading
Black, P. 'Beyond Bacon and Freud:
Artist Justin Mortimer Interviewed',
www.artlyst.com, 22 Aug 2013
Cooley, R., 'Justin Mortimer: Contorted
View', www.guernicamag.com,
25 Jan 2013
Herbert, M., 'Unsayable', 2014,
www.justinmortimer.co.uk

Contact
www.justinmortimer.co.uk
www.parafin.co.uk

RYAN MOSLEY / 106

Born 1980, Chesterfield, England
Lives and works in London, England
MA (Painting) Royal College of Art,
London, England, 2005–7
BA (Painting and Drawing) Huddersfield
University, England, 2000–3

Select solo shows
2014 Susanne Vielmetter Los Angeles
Projects, Los Angeles
Alison Jacques Gallery, London
2013 Tierney Gardarin, New York
2012 Eigen + Art, Berlin

Select group shows
2013 'Zero Hours', S1 Artspace, Sheffield
'Re-opening', Eigen + Art, Berlin
2012 'Nightfall', Modem Museum
'Merging Bridges', Museum of Modern
Art, Baku

Further reading
Boucher, B., 'Decoding Images', *Art in
America*, July 2013
Jones, J., 'Ryan Mosley: A Great Artist in
the Making?', www.guardian.com,
2 Feb 2010
Thorpe, H, 'Interview: Ryan Mosley',
Studio International, 7 Mar 2014

Contact
www.alisonjacquesgallery.com

VIK MUNIZ / 88

Born 1961, São Paulo, Brazil
Lives and works in New York, USA
and Rio de Janeiro, Brazil

Select solo shows
2014 Museum of Contemporary
Art, Lima
Tel Aviv Museum of Art, Tel Aviv

Long Museum, Shanghai
Contemporary Art, Tokyo
2013 The Frick Art & Historical Center, Pittsburgh PA

Select group shows
2014 'Mind the Map', Punkt Ø, Moss
2013 'Surveying the Terrain', CAM Raleigh, Raleigh NC
2012–13 'More Real? Art in the Age of Truthiness', Minneapolis Institute of Arts and SITE Santa Fe NM

Further reading
Adams, P., 'The Art of Repetition: Exploitation or Ethics?', *Art Monitor*, no. 3, 2008
Smith, R., 'Vik Muniz: Pictures of Magazines 2', *The New York Times*, 15 Sep 2011
Zagala, M., 'Interview with Vik Muniz', for the exhibition 'Imaginary Prisons', 2007, National Gallery of Victoria, Melbourne, reproduced on www.vikmuniz.net

Contact
www.vikmuniz.net
www.sikkemajenkinsco.com

PAULINA OLOWSKA / 72

Born 1976, Gdansk, Poland
Lives and works in Raba Nizna, Poland
Rijksakademie, Amsterdam, the Netherlands, 2003
MFA Academy of Fine Arts, Gdansk, Poland, 1995–99
BFA School of the Art Institute of Chicago, USA, 1993–95

Select solo shows
2014 Ludwig Forum für Internationale Kunst, Aachen
The Tatra Museum, Zakoplane
Simon Lee Gallery, Hong Kong
2013 Stedelijk Museum, Amsterdam
Kunsthalle Basel, Switzerland

Select group shows
2012 'Olinka, or where the movement was created', Museo Rufino Tamayo, Mexico City
'Ecstatic Alphabets/Heaps of Language', Museum of Modern Art, New York
2011 'The Power of Fantasy: Modern and Contemporary Art from Poland', BOZAR, Palais des Beaux-Arts, Brussels

Further reading
Bishop, C., 'Paulina Olowska: Reactivating Modernism', *Parkett*, May 2013
Fox, D., 'Being Curated', *Frieze*, Apr 2013

O'Neill-Butler, L., 'Reviews: Paulina Olowksa', *Artforum*, XLIX no. 5, Jan 2011

Contact
www.simonleegallery.com

CHRISTOPHER ORR / 132

Born 1967, Helensburgh, Scotland
Lives and works in London, England
MA (Painting) Royal College of Art, London, England, 2001–3
BA (Fine Art) Duncan of Jordanstone College of Art and Design, Dundee, Scotland, 1996–2000

Select solo shows
2014 Talbot Rice Gallery, University of Edinburgh
2013 Kunsthaus Baselland, Basel
2012 Nomas Foundation, Rome
IBID Projects, London

Select group shows
2011 'The Fire Part of Fire', Fife Gallery, Pittenweem
2010 'BIGMINIS. Fetishes of Crisis', CAPC Musée d'art contemporain, Bordeaux
'Memories of the future', Sean Kelly Gallery, New York
'Order to see', Galerie Praz-Delavallade, Paris

Further reading
Fisher, P. et al., *Christopher Orr: Paintings*, Cornerhouse, 2014
Wilson, M., 'Christpher Orr', *Artforum*, Sep 2008

Contact
www.hauserwirth.com

GRAYSON PERRY / 158

Born Chelmsford, England
Lives and works in London, England
Art Foundation Course, Braintree College of Further Education, England
BA (Fine Art) Portsmouth Polytechnic, England

Select solo shows
2014 National Portrait Gallery, London
2013 Sunderland Museum and Winter Gardens, Tyne and Wear, and touring
2012 Victoria Miro Gallery, London
2011 British Museum, London
Manchester Art Gallery, Manchester

Select group shows
2013 'Painting and Philosophy', Fondation Maeght, Saint-Paul de Vence
'Labour and Wait', Santa Barbara Museum of Art, California
'Hand Made', Boijmans van Beuningen Museum, Rotterdam

2012 'Tea with Nefertiti', Qatar Museums Authority

Further reading
Moore, S. et al, *The Vanity of Small Differences*, Hayward Publishing, 2013
Charlesworth, J. J., 'British art's new establishment figurehead', *Art Review*, Dec 2013
Klein, J, *Grayson Perry*, Thames & Hudson, 2013

Contact
www.victoria-miro.com

MAGNUS PLESSEN / 34

Born 1967, Hamburg, Germany
Lives and works in Berlin, Germany

Select solo shows
2014 Rose Art Museum, Waltham MA
2013 Gladstone Gallery, Brussels
2012 Gladstone Gallery, New York
White Cube, London
2010 Mai 36 Galerie, Zürich

Select group shows
2014 'Fruits de la Passion: La Collection du Centre Pompidou', The Hyogo Prefectural Museum of Art, Kobe
2008 'You Dig the Tunnel, I'll Hide the Soil', White Cube, London

Further reading
Buhmann, S., 'Magnus Plessen', *The Brooklyn Rail*, Mar 2013
Luard, H. (ed.), *Magnus Plessen: Riding the Image*, White Cube London, 2012
Turvey, L., 'Magnus Plessen', *Artforum*, Nov 2009

Contact
www.whitecube.com
www.gladstonegallery.com

GED QUINN / 102

Born 1963, Liverpool, England
Lives and works in Cornwall, England
Rijksakademie Amsterdam, Amsterdam, the Netherlands, 1993–94
Kunstakademie Dusseldorf, Dusseldorf, Germany, 1988–90
Slade School of Fine Art, London, England, 1985–87
Ruskin School of Drawing, Oxford, England, 1982–85

Select solo shows
2014 Stephen Friedman Gallery, London
2013 New Art Gallery Walsall
2012 Bass Museum, Miami FL
2012 Modern Art Museum of Fort Worth TX

Select group shows
2013 'Landscape 2000', Osnabrück Cultural History Museum and Felix Nussbaum Haus, Osnabrück
'Looking at the View', Tate Britain, London
'Disaster/The End of Days', Galerie Thaddaeus Ropac, Paris
2012 'Beyond Reality: British Painting Today', Galerie Rudolfinum, Prague

Further reading
Bracewell, M. et al, *Ged Quinn*, exh. cat., New Art Gallery Walsall, 2013
Wright, K., 'In the Studio: Ged Quinn', *The Independent*, 12 Jan, 2013

Contact
www.stephenfriedman.com

IMRAN QURESHI / 170

Born 1972, Hyderabad, India
Lives in Lahore, Pakistan
BA (Fine Art) National College of Arts, Lahore, Pakistan, 1993

Select solo shows
2015 Galerie Thaddaeus Ropac, Paris
2014 Ikon Gallery, Birmingham
Gandhara Art, Pao Galleries, Hong Kong
2013 The Metropolitan Museum of Art, New York
Zahoor Al Akhlaq Gallery, National College of Arts, Lahore

Select group shows
2014 'Garden of Ideas: Contemporary Art from Pakistan', Aga Khan Museum, Toronto
'Don't you know who I am?', The Museum of Contemporary Art Antwerp
2013 'The Encyclopedic Palace', 55th Venice Biennale, Venice
2012 'No Borders', Bristol Museum & Art Gallery, Bristol

Further reading
Elliot, D., *Art from Elsewhere, International Contemporary Art from UK Galleries*, Hayward Publishing, 2014
'God of small things', www.apollo-magazine.com, Nov 2014
'In Conversation with Pakistan's Genius Artist: Imran Qureshi', www.ismailimail.com, 23 Sep 2014

Contact
www.corvi-mora.com

GIDEON RUBIN / 54

Born 1973, Tel Aviv, Israel
Lives and works in London, England
MFA Slade School of Art, London, England 2000–2
BFA School of New York, USA 1996–99

Select solo shows
2013 Hosfelt Gallery, San Francisco
Galerie Karsten Greve, Cologne
2012 Rokeby, London
2011 Alon Segev Gallery, Tel Aviv

Select group shows
2014 'Disturbing Innocence', FLAG Art
 Foundation, New York
2012 John Moores Painting Prize,
 Walker Art Gallery, Liverpool
2011 'To Have a Voice', Mackintosh
 Museum, The Glasgow School of Art,
 Glasgow
'Facelook', Tel Aviv Museum of Art

Further reading
Hoffman, C., 'Out from the shadow, away
 from the elephant', The Jerusalem Post,
 1 July 2011
Rotem, T., 'The social network redone,
 without the face (or the book)',
 www.haaretz.com, 5 Dec 2011
Rubin, G., 'Artist Gideon Rubin on how
 he paints', The Observer, 20 Sep 2009

Contact
www.gideonrubin.com
www.rokebygallery.com

LISA RUYTER / 90

Born 1968, Washington, DC, USA
Lives and works in Vienna, Austria and
 New York, USA
Hunter College Graduate Fine Arts
 Program, New York, USA 1991–92
BFA School of Visual Arts; New York,
 USA 1990
MCPS Art Center, Maryland, USA
 1982–86

Select solo shows
2012 Connersmith Gallery,
 Washington DC
Alan Cristea Gallery, London
2011 Leeahn Gallery, Seoul and Daegu

Select group shows
2012 'Cancer', Galerie de Multiples, Paris
2011 'Pop Art 1960s–2000s',
 Kawaguchiko Museum, Yamanashi
 prefecture
2010 'Eleven', Alan Cristea Gallery,
 London
2009 'Alpha Exotica', Hydra School
 Projects, Hydra

Further reading
Michael Bracewell, 'An introduction to the
 art of Lisa Ruyter' in Let Us Now Praise
 Famous Men, exh. cat., Alan Cristea
 Gallery, London, 2012
Lee, H.-Y., 'Lisa Ruyter; Alienated world
 in Your Life' in Lisa Ruyter, exh. cat.,
 Leeahn Gallery, Daegu, Korea, 2011

Contact
www.lisaruyter.com
www.alancristea.com

SERBAN SAVU / 76

Born 1978, Sighişoara, Romania
Lives and works in Cluj, Romania
University of Art and Design, Cluj,
 Romania, 2001

Select solo shows
2014 Monica de Cardenas Gallery, Milan
2012 Mihai Nicodim Gallery, Los Angeles
Galeria Plan B, Berlin

Select group shows
2015 'Tracing Shadows', PLATEAU,
 Samsung Museum of Art, Seoul
2014 'Defaced', Boulder Museum of
 Contemporary Art, Colorado, 'A Few
 Grams of Red, Yellow and Blue: New
 Romanian Art', Center for Contempo-
 rary Art Ujazdowski Castle, Warsaw
Hotspot Cluj, New Romanian Art, Arken
 Museum, Copenhagen

Further reading
Obourn, N., 'The Edge of the Empire',
 Art in America, June/July 2009
Wise, L., 'Serban Savu', Artforum, Dec 2011
'Artist to Watch', The Art Economist, Feb 2011

Contact
www.davidnolangallery.com
www.plan-b.ro

CINDY SHERMAN / 174

Born 1954, Glen Ridge NJ, USA
Lives and works in New York, USA
BA State University College at Buffalo,
 New York, USA, 1976

Select solo shows
2015 Sammlung Goetz, Munich
2013 Astrup Fearnley Museum, Oslo
 and touring
2012 Portland Art Museum, Oregon
Gagosian Gallery, Paris
Metro Pictures, New York
The Museum of Modern Art, New York
 and touring

Select group shows
2014 'Urban Theater: New York Art in
 the 1980s', The Modern Art Museum
 of Fort Worth, Texas
'Manifesta', St Petersburg
2013 'Reading Cinema, Finding Worlds:
 Art After Marcel Broodthaers',
 The National Museum of Modern
 Art, Kyoto and touring

Further reading
Dressen, A., 'Best of 2013: #4 Cindy
 Sherman (55th Venice Biennale)',
 Artforum, Dec 2013

Heartney, E., 'Cindy Sherman: The
 Polemics of Play' in After the Revolution:
 Women Who Transformed Art, 2nd edn,
 Prestel, 2013
Moorhouse, P., Phaidon Focus: Cindy
 Sherman, Phaidon, 2014

Contact
www.metropictures.com

LORNA SIMPSON / 172

Born 1960, Brooklyn, USA
Lives and works in Brooklyn, USA
MFA (Visual Arts) University of
 California, San Diego, CA, USA, 1985
BFA Photography School of Visual Arts,
 New York, NY, USA, 1983

Select solo shows
2013–2015 Jeu De Paume, Paris
 and touring
2014 Photographer's Gallery, London
2013 Aspen Art Museum, Aspen CO

Select group shows
2015 'Represent: 200 Years of African
 American Art', Philadelphia Museum
 of Art, Philadelphia PA
2014 'Body Doubles Exhibit', Museum
 of Contemporary Art, Chicago
2012 'Blues for Smoke', The Geffen
 Contemporary at MOCA, Los Angeles
 and touring
2012 'This Will Have Been: Art, Love
 & Politics in the 1980s', Museum
 of Contemporary Art Chicago
 and touring

Further reading
O'Neill-Butler, L., 'Lorna Simpson,
 Salon 94/Salon 94 Freemans',
 Artforum, Jan 2009
Mirlesse, S., 'Interview with Lorna
 Simpson', www.aperture.org,
 25 June 2013
'Lorna Simpson au Jeu de Paume',
 Connaissance des arts, June 2013

Contact
www.salon94.com

JOHN STEZAKER / 58

John Stezaker
1949 Worcester, England
Lives and works in London, England
Slade School of Art, London,
 England, 1973

Select solo shows
2014 Anna Schwartz Gallery, Sydney
2013 Centre de la Photographie Genève
Les Rencontres Arles Photographie, Arles
Capitain Petzel, Berlin
The Approach, London
Tel Aviv Museum of Art

Select group shows
2014 'Mirrorcity', Hayward Gallery,
 London
'Ruin Lust', Tate Britain, London
2013 'Frank Egloff & John Stezaker:
 Visible Merge', Barbara Krakpw
 Gallery, Boston MA
'Crystal Maze IV – 1 + 2 + £ = 3',
 Centre Pompidou, Paris
2012 'Deutsche Börse Photography Prize',
 The Photographers' Gallery, London

Further reading
Bush, D. et al. (eds), The Age of Collage:
 Contemporary Collage in Modern Art,
 gestalten, 2013
Higgins, J., Why it does not have to be in
 focus: Modern photography explained,
 Thames & Hudson, 2013
O'Hagan, S., 'John Stezaker: Cutting
 a photograph can feel like cutting
 through flesh', www.guardian.com,
 27 Mar 2014

Contact
www.theapproach.co.uk

TIM STONER / 24

Born 1970, Essex, England
Lives and works in London, England
 and Málaga, Spain
Rijksakademie, Amsterdam, the
 Netherlands 1997–98
Royal College of Art, London,
 England 1992–94
Norwich School of Art and Design,
 England 1989–92

Select solo shows
2013 Purdy Hicks, London
2007 Alison Jacques Gallery, London

Select group shows
2014 'Live and Let Die', Modern Art,
 London
2013 'Speak, Clown!', Fold Gallery,
 London
2013 'Scary', Neue Froth Kunsthalle,
 Brighton
2012 'Seduction', Simon Oldfield
 Gallery, London

Further reading
Mar, A., 'Tim Stoner', Frieze, Jan/Feb 2003
Art Works, Deutsche Bank, 2011
The Triumph of Painting, exh. cat.,
 Saatchi Gallery, 2005

Contact
www.timstoner.co.uk

MIRCEA SUCIU / 74

Born 1978, Baia Mare, Romania
Lives and works in Bucharest, Romania
Cluj Visual Arts University (Painting),
 Cluj Napoca, Romania, 2003

Select solo shows
2015 Zeno X Gallery, Antwerp
2012 Aeroplastics Contemporary, Brussels
2011 Brandt Gallery, Amsterdam
2011 Laika gallery, Cluj
2010 Slag Gallery, New York

Select group shows
2014 'Burning down the house', Gwangju Biennale, Gwangju
2013 'Viewing Room', All Visual Arts, London
'Nightfall: New Tendencies in Figurative Painting', Galerie Rudolfinum, Prague
'Sex, Money and Power', Maison Particulière Art Centre, Brussels

Further reading
Bogdan I., *Mircea Suciu: Full Moon*, exh. cat., Laika Gallery, Cluj, 2011
'Mircea Suciu', www.artnau.com, 28 May 2014

Contact
www.zeno-x.com

ANNELIES ŠTRBA / 144

Born 1947, Zug, Switzerland
Lives and works in Richterswil and Melide, Switzerland
Federal Grant for Applied Art, 1971–73

Select solo shows
2013 Galerie Eigen + Art, Leipzig Kunsthaus Zug
2011 Museum Langmatt, Baden
2010 Centre artistique & culturel, Sion

Select group shows
2014 'Fotografie Europea 2014', Reggio Emilia
2012 'Künstlerkinder: Von Runge bis Richter, von Dix bis Picasso', Kunsthalle Emden
2011 'Alice in Wonderland', Tate Liverpool
2010 'Mutter', Kulturzentrum bei den Minoriten, Graz

Further reading
Fricke, H., 'The Light Shadows of Time: Annelies Štrba's Photographic Family Excursions', *Deutsche Bank artmag*, 2006
Voorhies, J., 'Annelies Strba', *Frieze d/e*, Apr/May 2013

Contact
www.strba.ch
www.eigen-art.com

ALEXANDER TINEI / 78

Born 1967, Caushani, Moldova
Lives and works in Budapest, Hungary
Chisinau Repin State College of Fine Art, Moldova, 1991

Select solo shows
2014 Galerie Dukan, Paris
2013 Erika Deák Gallery, Budapest
2012 Galerie Hussenot, Paris
Frissiras Museum, Athens

Select group shows
2013 'Body language', Saatchi Gallery, London
'Nightfall: New tendencies in figurative painting', Galerie Rudolfinum, Prague
2011 'East Ex East', Brand New Gallery, Milan
Prague Biennale 5, Prague
'Lost', Galerie im Park, Bremen

Further reading
Casavecchia, B., 'East ex East', *Art Review*, Oct 2011
Street, B., *Body language*, exh. cat., Saatchi Gallery, 2013
Tagliaferro, M., 'East ex East', *Artforum*, Oct 2011

Contact
www.galeriedukan.com

MICKALENE THOMAS / 92

Born 1971, Camden, NJ, USA
Lives and works in Brooklyn, USA
MFA (Painting) Yale University School of Art New Haven, USA, 2002
BFA (Painting) Pratt Institute, Brooklyn, USA, 2000
Southern Cross University, Lismore, Australia, 1998

Select solo shows
2014 Kavi Gupta Gallery, Chicago
Galerie Nathalie Obadia, Paris
Lehmann Maupin Gallery, New York
George Eastman House, Rochester NY
2012 The Institute of Contemporary Art, Boston MA
Santa Monica Museum of Art, Santa Monica CA and touring

Select group shows
2014 'Pop Departures', Seattle Museum of Art, Seattle WA
'Domestic Unrest', Pippy Houldsworth Gallery, London
'Shakti' Brand New Gallery, Milan
2013 'Expanding the Field of Painting', The Institute of Contemporary Art, Boston MA

Further reading
Goldstein, A. M. and Clotten, B., 'Studio Visit With Mickalene Thomas', *Artspace*, 22 Feb 2014
Hudson, S., 'Mickalene Thomas', *Artforum*, Nov 2012
Tinson, T., 'Making Up with Mickalene Thomas', *Interview*, 25 June 2014

Contact
www.mickalenethomas.com
www.lehmannmaupin.com

YUMA TOMIYASU / 42

Born 1983, Hiroshima, Japan
Lives and works in Tokyo, Japan and London, England
PhD University of the Arts, Tokyo, Japan, 2013–16
MFA Chelsea College of Art and Design, London, England, 2011–12
BFA Chelsea College of Art and Design, London, England, 2006–9

Select solo shows
2012 Chelsea College of Art, London (MFA degree show)

Select group shows
2014 'First Attacks!', Space Wunderkammer, Tokyo
2013 'Occultus: Hidden Things', Art Center Ongoing, Tokyo
'Don't Mind the Gap: Beyond Language', University of the Arts, Tokyo
2012 'Painting in Conversation', The Bussey Building, London

Further reading
Her Name Is, exh. cat., Parco Museum, Tokyo, 2013
Jerwood Drawing Prize, exh. cat., Jerwood Gallery, London, 2010

Contact
www.yumatomiyasu.com

KAORU USUKUBO / 148

Born 1981, Tochigi, Japan
Lives and works in Tokyo, Japan
PhD (Painting) Tokyo University of the Arts, Japan, 2010
MFA (Painting) Tokyo University of the Arts, Japan, 2007
BFA (Painting) Tokyo Zokei University, Japan, 2004

Select solo shows
2012 Kunstverein Friedrichshafen, Friedrichshafen
2011 LOOCK, Berlin
taimatz, Tokyo, Japan
2010 Wohnmaschine, Berlin

Select group shows
2013 'Minimal/Posto Minimal: Contemporary Japanese Art from 1970s'
Utsunomiya Museum of Art, Utsunomiya
'The 9th formative artist exhibition', Zokei University Museum, Tokyo
2011 'Tokyo Frontline', Arts Chiyoda 3331,Tokyo
'Yokohama Triennale 2011', Yokohama Museum of Art

Further reading
'Artist Interview no. 1: Kaoru Usukubo', www.artlifepress.com, 2011
'Kaoru Usukubo: Chrystal Moments', *Monopol*, 2011

Contact
www.kaoru-usukubo.com

JOHAN VAN MULLEM / 46

Born 1959, Isiro, Democratic Republic of the Congo
Johan Van Mullem lives and works in Waterloo, Brussels, Belgium
l'Institut Supérieur d'Architecture, Brussels, Belgium, 1978–85
Ecole des Arts d'Ixelles (engraving), Elsene, Belgium, 1990–91

Select solo shows
2014 Macadam Gallery, Brussels
C24 Gallery, New York
2013 Hus Gallery, London
Hus Gallery, London
2012 Hus Gallery & Andipa Gallery, London

Select group shows
2012 'Group Exhibition', Hus Gallery, Gstaad
2011 'Group Exhibition', Hus Gallery and SEM-ART, Monaco
2010 'Group Show', Art Gallery 826, Knokke
'L'Eté Contemporain', Draguignan

Further reading
Gamand, G., 'Johan Van Mullem: Explore les portes de l'âme', *Azart*, June 2011
Mattos, J., 'Altered States: Transitional Space in Johan Van Mullem', *Manhattan Digest*, 18 Jan 2014
McVey, K., 'The Luminous Johan Van Mullem', *Interview*, Jan 2014

Contact
www.johanvanmullem.com
www.husgalleries.com

JAN VANRIET / 64

Born 1948, Antwerp, Belgium
Lives and works in Antwerp, Belgium
Royal Academy of Antwerp, Belgium, 1972

Select solo shows
2015 Roberto Polo Gallery, Brussels
2014 Cultuurcentrum Hasselt Interartcenter, Hasselt
2013 Museum Kazerne Dossin, Mechelen
2012 Galerie Wansink, Maastricht

Select group shows
2013 'Museum to Scale 1/7', Koninklijke Musea voor Schone Kunsten van België, Brussels

'Oorlog en Trauma', Museum
Guislain, Ghent
2012 'Ecce Homo', Museum van Deinze
en de Leiestreek, Deinze
2010 'Uit het geheugen 2', Museum Dr.
Guislain, Ghent

Further reading
Mullins, C., *Jan Vanriet: Vanity*,
Lannoo, 2015
Vanriet, J., *Closing Time*, exh. cat.,
Koninklijk Museum Voor Schone
Kunsten, 2010
Vanriet, J., and Rinckhout, E., *Closed
Doors*, exh. cat., Roberto Polo
Gallery, 2012

Contact
www.janvanriet.com
www.robertopologallery.com

KARA WALKER / 100

Born 1969, Stockton CA, USA
Lives and works in New York, USA
BFA Atlanta College of Art, USA, 1991
MFA Rhode Island School of Design,
Providence RI, USA, 1994

Select solo shows
2015 Denison Museum at Denison
University, Granville OH
2014 Domino Sugar refinery in
Williamsburg, Brooklyn
Saint Louis Art Museum, St Louis, MO
2013 Camden Arts Centre, London
and touring
Art Institute of Chicago

Select group shows
2015 'La Parole Aux Femmes (Women
speak out)', Centre d'Art Contemporain
Africain, Apt
'Represent: 200 Years of African American
Art', Philadelphia Museum of Art,
Philadelphia PA
2014 'When the Stars Begin to Fall:
Imagination and the American South',
Studio Museum in Harlem, New York
and touring
'Animated Bodies', Museo d'Arte
Provincia di Nuoro, Nuoro
2013 'For the Time Being: Wall Painting/
Painted Walls', Kunsthalle Bielefeld,
Bielefeld

Further reading
Als, H., 'The Sugar Sphinx',
www.newyorker.com 8 May 2014
Ballard, T., 'Studio Check: Kara Walker',
Modern Painters May 2014
Rooney, K., 'A Sonorous Subtlety:
Kara Walker with Kara Rooney',
The Brooklyn Rail May 2014
Walker, K. et al, *Dust Jackets for the
Niggerati*, Gregory R. Miller & Co.,
2013

Contact
www.sikkemajenkinsco.com

GILLIAN WEARING / 176

Born 1963, Birmingham, England
Lives and works in London, England
BA Goldsmiths College, University of
London, England, 1987–90
B.Tech (Art & Design) Chelsea School
of Art, London, England, 1985–87

Select solo shows
2014 Regen Projects, Los Angeles
The Rose Art Museum of Brandeis
University, Waltham
Maureen Paley, London
The New Art Gallery Walsall, Walsall
2013 Museum Brandhorst, Munich

Select group shows
2014 'Body Doubles', MCA Chicago
'The Vincent Award 2014',
Gemeentemuseum Den Haag,
The Hague
'(Mis)Understanding Photography:
Works and Manifestos', Museum
Folkwang, Essen
'Nouvelle Génération', Frac Nord-Pas
de Calais, Dunkerque
2013 'Alien & Familiar', Galerie im
Taxipalais, Innsbruck
'Assembly: A Survey of Recent Artists'
Film and Video in Britain 2008–13',
Tate Britain, London

Further reading
Aspden, P., 'People Person', *FT Weekend
Magazine*, 19 July 2014
Hall, F., 'Gillian Wearing: Tanya
Bonakdar Gallery', *Artforum*, Sep 2011
Pohlen, A., 'Gillian Wearing
Retrospektive', *Kunstforum*, 1 Jan 2013
Somers, T., 'In conversation with Gillian
Wearing', 200percentmag.wordpress.
com, 30 Aug 2011

Contact
www.maureenpaley.com

KEHINDE WILEY / 96

Born 1977, Los Angeles USA
Lives and works in New York, USA
and Beijing, China
BFA San Francisco Art Institute USA,
1999
MFA Yale University School of Art,
New Haven CT, USA, 2001

Select solo shows
2015 The Brooklyn Museum, Brooklyn
2014 Roberts and Tilton, Los Angeles
2013 Stephen Friedman Gallery, London
Boise Art Museum, Boise, ID
Phoenix Art Museum, Phoenix
The Contemporary Jewish Museum,
San Francisco

Select group shows
2014 'The Beautiful Game', Los Angeles
Museum of Art
'Face to Face, Wall to Wall', Yellowstone
Art Museum, Billings MT
2012 'Looped', Utah Museum of
Contemporary Art, Salt Lake City
2011 'Beyond Bling: Voices of Hip-Hop
in Art', Ringling Museum of Art,
Sarasota FL

Further reading
Guilleminot, A., 'Kehinde Wiley',
Arts Magazine, Nov 2012
Luke, B. 'Kehinde Wiley on his first UK
solo show for Frieze week', *Evening
Standard*, 11 Oct 2013
Mason, W., 'Kehinde the First', *GQ*,
Apr 2013

Contact
kehindewiley.com
www.skny.com

UWE WITTWER / 62

Born 1954, Zürich, Switzerland
Lives and works in Zürich, Switzerland
Self-taught

Select solo shows
2013 Abbot Hall Art Gallery, Kendal
2012 SMAC Gallery, Cape Town
VOID, Derry
2011 Nolan Judin Berlin
Haunch of Venison, London

Select group shows
2013 'Das Dopplete Bild', Kunstmuseum
Solothurn
2012 'Swiss Art from the Mobiliare
Collection', Museo cantonale d'Arte,
Lugano
'Look, I am blind, look', Centre
Pasquart, Biel
'The Observer' Haunch of Venison, London
2011 'Watercolour', Tate Britain, London

Further reading
Dillon, B. and Judin, J., 'Uwe Wittwer:
Paintings', Hatje Cantz Verlag, 2012
Kent, S., 'Public Pictures, Private Lives' in
Hail and Snow: watercolours, exh. cat.,
Haunch of Venison, 2007

Contact
www.uwewittwer.com
www.nolan-judin.de

YANG SHAOBIN / 28

Born 1963, Tangshan, Hebei Province,
China
Lives and works in Beijing, China
Hebei Light Industry Institute, China, 1983

Select solo shows
2013 Alexander Ochs Gallery, Berlin

Arken Museum of Modern Art,
Denmark, Ishøj
2010 Ullens Center for Contemporary
Art, Beijing
2009 Museu de Arte de São Paulo,
São Paulo

Select group shows
2014 'China Arte Brasil', São Paulo, Brazil
'Re-View', Long Museum West Bund,
Long Museum, Shanghai
'Portrait of the Times: 30 Years of
Chinese Contemporary Art', Power
Station of Art, Shanghai
'Sharjah Biennial', Sharjah
'Re-Coding: Reconstruction of rhetoric
and narration', China Millennium
Monument, Beijing

Further reading
Grosenick, U. and Ochs, A. (eds), *Yang
Shaobin*, DuMont Buchverlag, 2010
Yang, S., *Blue Room*, exh. cat., UCCA
(Beijing), 2010
'Interview: Yang Shaobin',
www.artrealization.com

Contact
www.longmarchspace.com

YUE MINJUN / 86

Born 1962, Daqing, Heilongjiang
Province, China
Lives and works in Beijing, China
Hebei Normal University, China

Select solo shows
2014 Nanjing University of the Arts
2012 Fondation Cartier, Paris
Yang Zi Modern Art Center, Chong Qing
2011 Pace Beijing
2010 Shanghai Gallery of Art
2009 Daily Museum, Beijing

Group shows
2014 'China New Expression: 1980-2014',
China Art Museum Shanghai, China
2012 'Scene 2012: Chinese New Art',
Shanghai Art Museum, Shanghai,
China
2011 'Pure Views: New Painting from
China', Asian Art Museum of San
Francisco, USA

Further reading
Cohen, A., 'The Shadow of Laughter',
Art Asia Pacific, July/Aug 2013
Mackenzie, C. et al, *The Chinese Art Book*,
Phaidon, 2013
Tsui, E., 'Yue Minjun: behind the painted
smile', www.ft.com, 2 Nov 2012,
accessed 3 Apr 2014

www.yueminjun.com.cn
www.pacegallery.com

Notes

Introduction, pp. 6–16

1. R. Rugoff, 'Painting Modern Life', in *The Painting of Modern Life*, exh. cat. (London: Hayward Gallery, 2007), pp. 10–17 (16).

2. A. Schopenhauer, *The World As Will and Representation*, 1818, trans. E. F. J. Payne (New York: Dover Publishing, 1966), vol. 2, pp. 367–71. See also Julian Bell, *What is Painting? Representation and Modern Art* (London: Thames & Hudson, 1998), p. 77. My emphasis.

3. See J. Crary, *Techniques of the Observer: On Vision and Modernity in the Nineteenth Century* (Massachusetts: The MIT Press, 1992).

4. G. Brown, 'Glenn Brown in conversation with Rochelle Steiner', 2004, in *Painting: Documents of Contemporary Art*, ed. Terry R. Myers (London/Cambridge, MA: Whitechapel Gallery/The MIT Press, 2011), p. 168.

5. G. Richter, 'Interview with Peter Sager', 1972, in *The Daily Practice of Painting: Writings 1962–1993*, ed. Hans-Ulrich Obrist (London: Thames & Hudson, 1995), p. 66

6. Art photography is an awkward term. I only use it to distinguish the photographs artists take from those we all post on Instagram or Twitter. I use it to mean photographs that have been carefully constructed and crafted; that can provoke or draw out truths in comparable ways to painting and drawing.

7. J. Saltz, 'The Richter Resolution', 2005, in *Painting*, ed. Myers, pp. 183–85 (185).

8. H. Bergson, *Matter and Memory* (1896), translated by N. M. Paul and W. S. Palmer (New York: Zone Books, 1988) p. 137.

9. Artist statement, used as wall text in 'Dorothea Tanning: Web of Dreams' exhibition, Alison Jacques Gallery, July 2014.

10. J. Kantor, 'The Tuymans Effect', 2004, in *Painting*, ed. Myers, p. 174.

11. G. Richter, in conversation with Nicholas Serota, *Time Out* (London), 13–19 October 2011, pp. 16–19 (17).

12. J. Saltz, 'The Richter Resolution', 2005, in *Painting*, ed. Myers, pp. 183–85 (184).

13. Julian Stallabrass, 'Sixty Billion Sunsets', in Stallabrass, *Gargantua: Manufactured Mass Culture* (London: Verso, 1996), pp. 13–39 (13).

14. Richard Hamilton, 'Photography and Painting', *Studio International*, March 1969, p. 120.

15. E. Ruscha, 'Looking Down From Above', *Tate Etc*, issue 21, spring 2011, www.tate.org.uk, accessed 16 October 2014.

Select Bibliography

Bell, J., *What is Painting? Representation and Modern Art*, Thames & Hudson, 1999

Berger, J., *Understanding a Photograph*, Penguin, 2013

Bois, Y. A., *Painting as Model*, The MIT Press, 1990

Bright, S., *Art Photography Now*, Thames & Hudson, 2006

Bürgi, B. M. et al., *Painting on the Move* (exh. cat.), Kunstmuseum/Kunsthalle Basel, 2002

Carey-Thomas, L. et al., *Painting Now* (exh. cat.), Tate Publishing, 2013

Cumming, L., *A Face to the World*, Harper Press, 2010

Doyle, M. et al., *Drawing on Space* (exh. cat.), The Drawing Room, 2002

Edwards, E. and Hart J., *Photographs Objects Histories: On the Materiality of Images*, Routledge, 2004

Elkins, J., *What Painting Is*, Routledge, 2000

Fogle, D. (ed.), *Painting at the edge of the world* (exh. cat.), Walker Art Center, Minneapolis, 2001

Foster, H., *The Return of the Real*, The MIT Press, 1996

Fried, M., *Why Photography Matters as Art as Never Before*, Yale University Press, 2008

Gamboni, D., *Potential Images: Ambiguity and Interdeterminacy in Modern Art*, Reaktion, 2002

Gingeras, A. M. et al., *Dear Painter, Paint Me…: Painting the Figure since Late Picabia* (exh. cat.), Centre Georges Pompidou, 2002

Godfrey, M., Schimmel, P., and Todolí, V. (eds), *Richard Hamilton* (exh. cat.), Tate Publishing, 2014

Godfrey, T., *Painting Today*, Phaidon, 2009

Hall, J., *The Self-Portrait: A Cultural History*, Thames & Hudson, 2014

Harris, J. (ed.), *Critical Perspectives on Contemporary Painting: Hybridity, Hegemony, Historicism*, Liverpool University Press, 2003

Herbert, M., 'Rehearsing Doubt: Recent Developments in Painting-After-Photography', in *The Painting of Modern Life: 1960s to Now* (exh. cat.), Hayward Gallery (London) 2007

Hickey, D., *Pirates and Farmers*, Ridinghouse, 2013

Holzwarth, H. W. (ed.), *Art Now: Vol 4*, Taschen, 2013

Joachimides, C. M. et al., *A New Spirit in Painting* (exh. cat.), Royal Academy of Arts (London), 1981

Joselit, D., 'Painting Beside Itself', *October*, no. 130, Autumn 2009

Kantor, J. 'The Tuymans Effect', *Artforum*, November 2004

Kelsey, R., and Stimson, B., *The Meaning of Photography*, Clark Studies in the Visual Arts, 2008

Levine, C. and Posner, H, *If the Face Had Wheels: Dana Schutz*, Prestel, 2011

Mackenzie, C. et al., *The Chinese Art Book*, Phaidon, 2013

Mullins, C., *Painting People*, Thames & Hudson, 2006

Myers, Terry. R. (ed.), *Painting: Documents of Contemporary Art*, The MIT Press, 2011

Neri, L., and Aletti, V., *Settings and Players: Theatrical ambiguity in American photography* (exh. cat), White Cube, London, 2001

Obrist, H.-U. (ed.), *Gerhard Richter: The Daily Practice of Painting, writings 1962-1993*, Thames & Hudson, 1995

Petersen, A. R. (ed.), Contemporary Painting in Context, Museum Tusculanum, 2010

Pointon, M., *Portrayal and the Search for Identity*, Reaktion, 2013

Rattemeyer, C. et al., *Vitamin D2: New Perspectives in Drawing*, Phaidon, 2013

Rosenthal, S. (ed.), *Art of Change: New Directions From China* (exh. cat.), Hayward Gallery (London), 2012

Rugoff, R. et al., *The Human Factor: The Figure in Contemporary Sculpture* (exh. cat.), Hayward Gallery, London, 2014

Rugoff, R. et al., *The Painting of Modern Life* (exh. cat.), Hayward Gallery (London), 2007

Ruyffelaere, P., *On&By: Luc Tuymans*, Whitechapel Gallery/The MIT Press, 2013

Saltz, J., 'The Richter Resolution', *Modern Painters*, April 2005, pp. 28–29

Schwabsky, B. *The Triumph of Painting*, Jonathan Cape, 2005

Schwabsky, B. et al., *Vitamin P2: New Perspectives on Painting*, Phaidon, 2011

Staff, C., *After Modernist Painting: The History of a Contemporary Practice*, I. B. Tauris, 2013

Stallabrass, J., 'Elite Art in an Age of Populism', in Dumbadze, A. and Hudson, S., *Contemporary Art: 1989 to the Present*, John Wiley & Sons, 2013

Stallabrass, J., *Gargantua: manufactured mass culture*, Verso, 1996

Storr, R. *Gerhard Richter: Doubt and Belief in Painting*, Museum of Modern Art (New York), 2003

Todolí, V. (ed.), *Sigmar Polke: History of Everything: Paintings and Drawings 1998–2003* (exh. cat.), Dallas Museum of Art, 2003

Valli, M. and Ibarra, A., *Walk The Line: The Art of Drawing*, Laurence King, 2013

Sources of Quotations

p. 22 Susie Hamilton, artist statement, www.axisweb.org, accessed 30 June 2014.

p. 25 Tim Stoner, in correspondence with the author, 29 Sep 2014.

p. 29 Yang Shaobin, interview with Jérôme Sans, www.longmarchspace.com, 18 Mar 2011, accessed 9 July 2014.

p. 30 Justin Mortimer, interview by Paul Black, www.artlyst.com, 22 Aug 2013, accessed 30 May 2014.

p. 33 Adrian Ghenie in conversation with Charlotte Mullins, 9 June 2014 (unpublished).

p. 42 Yuma Tomiyasu, artist statement, www.noisefestival.com, accessed 25 Sep 2014.

p. 45 Laura Lancaster interview, www.johnjones.co.uk, accessed 30 June 2014.

p. 54 Gideon Rubin, 'Artist Gideon Rubin on how he paints', *The Observer*, www.guardian.co.uk, 20 Sep 2009, accessed 3 Apr 2014.

p. 57 Eleanor Moreton in 'Eleanor Moreton: I See the Bones in the River', by Yvette Greslé, www.fadwebsite.com, 24 Nov 12, accessed 22 July 2014.

p. 67 Lars Elling, 'London: Interview with Lars Elling', by Anna-Lena Werner, www.artfridge.de, 25 Mar 2011, accessed 28 Aug 2014.

p. 68 Johannes Kahrs, artist statement, *The Painting of Modern Life*, exh. cat. (London: Hayward Gallery, 2007), p. 163.

p. 72 Paulina Olowska in 'Design for Living', by Catherine Wood, *Parkett*, www.parkettart.com, issue 92, 2013, accessed 5 Sep 2014.

p. 76 Serban Savu, interview by Mihai Pop in *Daily Practice for the End of the World*, exh. cat. (Cluj: Galeria Plan B, 2012), www.plan-b.ro, accessed 25 Sep 2014.

p. 75 Mircea Suciu in 'Mircea Suciu: the only Romanian artist on the cover of ARTnews', by Daniel Nicolescu, *Ziarul de Duminica*, www.zf.ro, 17 Mar 2010, accessed 30 Sep 2014.

p. 85 Tom Hunter, *The Way Home* (Berlin: Hatje Cantz, 2012).

p. 86 Yue Minjun in 'Interview with Yue Minjun', by Shen Zhong, *Yue Minjun: L'Ombre du fou rire*, exh. cat. (Paris: Fondation Cartier, 2012).

p. 88 Vik Muniz interview by Maria Zagala, *Imaginary Prisons*, exh. cat. (Melbourne: National Gallery of Victoria, 2007), www.vikmuniz.net, accessed 28 Aug 2014.

p. 90 Lisa Ruyter in *Let us now Praise Famous Men*, exh. cat. (London: Alan Cristea Gallery, 2012).

p. 93 Mickalene Thomas, 'Making Up with Mickalene Thomas', by Teddy Tinson, *Interview*, www.interviewmagazine.com, Aug 2014, accessed 03 Sep 2014.

p. 95 Kerry James Marshall, artist talk at David Zwirner London, 10 Oct 2014.

p. 109 Ali Banisadr in 'Conversation with Ali Banisadr', by Julie Chae, www.huffingtonpost.com, 09 Apr 2012, accessed 30 Sep 2014.

p. 110 Yun-Fei Ji in 'Interview: Yun-Fei Ji' by Carnelia Garcia, *Modern Painters*, Apr 2010, pp. 20–21.

p. 118 Charles Avery in 'Cosmology of an Island: Charles Avery on The Islanders', by Tom Morton, *Metropolis M*, www.metropolism.com, Oct/Nov 2007, accessed 30 Sep 2014.

p. 122 Nigel Cooke, 'Artist Nigel Cooke on how he paints', *The Observer*, www.guardian.co.uk, 20 Sep 2009, accessed 18 Sep 2014.

p. 129 Marius Bercea, 'Conversation between Ciprian Muresan and Marius Bercea', *Marius Bercea*, exh. cat. (London: Blain Southern, 2014), p. 21.

p. 140 Ruprecht von Kaufmann, 'Ruprecht Von Kaufmann LCAD Slideshow Lecture', www.youtube.co.uk, 23 Feb 2014, accessed 25 Sep 2014.

p. 144 Annelies Štrba, interview by Abigail Christenson, www2.tate.org.uk, 3 Nov 2011, accessed 23 Sep 2014.

p. 143 Simone Haack in 'Alla Prima Painting made of Realism, Terror and the Everyday', by Christoph Tannert in *Simone Haack: The Others*, Galerie Beim Steinernen, exh. cat. (Berlin: Kerber, 2012), p. 34.

p. 155 Jessica Craig-Martin in 'Jessica Craig-Martin shoots Cindy Sherman show', by Clare Davies, *The New Yorker*, www.newyorker.com, 28 Feb 2012, accessed 22 Sep 2014.

p. 160 Liu Xiaodong, interview by Wu Hung, www.xiaodongstudio.com, 4 July 2009, accessed 24 Sep 2014.

p. 162 Jitish Kallat, interview by Rajesh Punj, *The Asian Art Newspaper*, www.arndtberlin.com, Feb 2010, accessed 28 Aug 2014.

p. 164 Nermine Hammam, artist statement, 'witeko… cowboys and indigenes', www.nerminehammam, 2014, accessed 15 Oct 2014.

p. 173 Lorna Simpson, video interview, Deutsche Börse Photography Prize 2014, www.thephotographersgallery.org.uk, accessed 25 Sep 2014.

p. 175 Cindy Sherman in 'Cindy Sherman: Interview with a chameleon', by Kenneth Baker, *San Francisco Chronicle*, www.walkerart.org/magazine, 8 July 2012, accessed 24 Sep 2014.

Sources of Illustrations

Index